Creative Communities

GEORGIAN COLLEGE LIBRARY

DISCARD

Creative Communities
Regional Inclusion & the Arts

Edited by Janet McDonald and Robert Mason

intellect Bristol, UK / Chicago, USA

First published in the UK in 2015 by
Intellect, The Mill, Parnall Road, Fishponds, Bristol, BS16 3JG, UK

First published in the USA in 2015 by
Intellect, The University of Chicago Press, 1427 E. 60th Street,
Chicago, IL 60637, USA

Copyright © 2015 Intellect Ltd

All rights reserved. No part of this publication may be reproduced,
stored in a retrieval system, or transmitted, in any form or by
any means, electronic, mechanical, photocopying, recording, or
otherwise, without written permission.

A catalogue record for this book is available from the
British Library.

Copy-editor: MPS Technologies
Cover designer: Stephanie Sarlos
Production manager: Claire Organ
Typesetting: Contentra Technologies

Print ISBN: 978-1-78320-512-7
ePDF ISBN: 978-1-78320-513-4
ePUB ISBN: 978-1-78320-514-1

Printed and bound by Short Run Press Ltd, UK

Contents

List of Figures	vii
List of Abbreviations	ix
Introduction Janet McDonald and Robert Mason	1
Rethinking Regionalism	11
Chapter 1: Common Patterns: Narratives of 'Mere Coincidence' and the Production of Regions Paul Carter	13
Chapter 2: Creative and Destructive Communities of Lake Condah/Tae Rak, Western Victoria Louise Johnson	31
Chapter 3: Creativity and Attenuated Sociality: Creative Communities in Suburban and Peri-Urban Australia Mark Gibson	47
Chapter 4: Learning from Inland: Redefining Regional Creativity Margaret Woodward and Craig Bremner	63
Returning Creativity	79
Chapter 5: Getting to Know the Story of the Boathouse Dances: Football, Freedom and Rock 'n' Roll Tamara Whyte, Chris Matthews, Michael Balfour, Lyndon Murphy and Linda Hassall	81
Chapter 6: 'The Artists Are Taking Over This Town': Lifestyle Migration and Regional Creative Capital Susan Luckman	99

Chapter 7: Art in Response to Crisis: Drought, Flood and the Regional Community 121
Andrew Mason

Chapter 8: 'Now We Will Live Forever': Creative Practice and Refugee Settlement in Regional Australia 135
Wendy Richards

Restoring Community 155

Chapter 9: Making Stories Matter: Using Participatory New Media Storytelling and Evaluation to Serve Marginalized and Regional Communities 157
Ariella Van Luyn and Helen Klaebe

Chapter 10: Vicarious Heritage: Performing Multicultural Heritage in Regional Australia 175
Robert Mason

Chapter 11: Practising for Life: Amateur Theatre, Regionalism and the Gold Coast 189
Patrick Mitchell

Chapter 12: Artist-Run Initiatives as Liminal Incubatory Arts Practice 205
Janet McDonald

Chapter 13: Same but Different: Growing New Audiences for the Performing Arts in Regional Australia 219
Rebecca Scollen

List of Figures

Figure 1:	Conceptual map of agri-tivity	113
Figure 2:	Creative occupations in New South Wales by Local Government Area using 2011 Australian Bureau of Statistics Census Data	113
Figure 3:	The Boathouse	114
Figure 4a&b:	'The Artist's Lounge', Healesville, Victoria, Australia	115
Figure 5a&b:	Trends in location of resident art professionals, Victoria (Source: Australian Bureau of Statistics 2011)	116
Figure 6a&b:	Trends in location of resident art professionals, South Australia (Source: Australian Bureau of Statistics 2011)	117
Figure 7:	Jennifer Wright (Summers)'s *Mutant Diversity* used recycled items, papier-mâché and expanding foam to create colourful faux gardens in disused water fountains	118
Figure 8a&b:	Sandra Jarrett's *The Poetry Within* (2008) is a steel water tank, with its emptiness exposed through decorative plasma-cut floral design	118
Figure 9:	Charlton's *Forlawn* (2008) – model developed in planning stage; on display at the Toowoomba Regional Art Gallery	118
Figure 10:	Charlton's *Forlawn* (2008) – completed artwork in the botanical gardens during the 2008 Carnival of Flowers	118
Figure 11:	A 2007 publicity shot of Mary-Kate Khoo at the empty water feature that her sculpture would fill	118
Figure 12a&b:	Mary-Kate Khoo's Bed Of Roses (2007) and detail	118
Figure 13:	Mayor Peter Taylor opening the 2008 exhibition in Gallery M	119
Figure 14:	Deborah Beaumont's plan for 'Four Worlds', constructing fish patterns from discarded aluminium plates used in newspaper printing	119
Figure 15:	Beaumont's completed work installed in a fountain for the 2008 Carnival of Flowers	119
Figure 16:	Sister Angela Mary's scanned baggage tags	120

Introduction

Janet McDonald and Robert Mason
The University of Southern Queensland
Griffith University

Approximately 86 per cent of Australians live in the large cities that cling to the coastal periphery of the arid continent (Australian Bureau of Statistics 2008). Each of these cities is assumed to act as the administrative and cultural hub of their respective state and territory. This metropolitan focus is replicated in many countries throughout the Global North. Over 80 per cent of Canadians (Human Resources and Skills Development Canada [HRSDC] 2014) and Americans (United States Census Bureau 2010) live in major cities and conurbations; similar patterns underpin most of the modern nation-states of the Global North. Simultaneously, these highly urbanized societies continue to extol the rural lifestyle as central to the nation's moral and historical compass. Within Australia, cultural knowledge of the country's rural and regional areas remains axiomatic to citizens' sense of self and national community. This is reflected in the creative practice of those in the major metropolitan centres. While creative products connect audiences with global trends, urban populations retain an intense emotional affinity with those who live what are imagined to be wholesome lives in regional and rural settings.

In this book, we challenge the metropolitan focus in much of the scholarship regarding regional arts, along with the assumption that creative practice in the regions is necessarily a pale reflection of the cities. Instead, we argue that patterns of creative practice in regional communities are sustainable and innovative in distinct ways. Rather than compare regional and metropolitan experiences, we foreground the non-metropolitan as central to a broader understanding of self and community. In this way, this book's contributors use the Australian example to suggest ways to re-imagine how regionalism might be constituted in the Global North, and explore new ways in which the creative arts can strengthen and refashion inclusive communities.

Regional Creativity

Regional communities are at the centre of Australia's successful export economy, which has sustained the country's buoyant economic growth through successive global economic crises. Most regional communities are heavily dependent on industries associated with agriculture and mining, making their inhabitants vulnerable to fluctuations in the market. Nonetheless, regional Australia continues to contribute a sizeable majority of the country's export income through mining and agriculture. Despite this, regional Australians frequently feel that they are marginalized in the decision-making processes that affect them

(Charters et al. 2011). Rather than benefit from their centrality in the national economy, many feel their communities are marginalized and threatened by accelerating change.

A close association with the land, and familial connections that frequently span multiple generations, are at the heart of regional communities' sense of self. This is particularly the case for the large numbers of Indigenous Australians, who form a significant proportion of rural and regional communities, and whose connections to the land are profound and enduring. Rather than the common depiction of communities in terminal decline, there are emerging patterns of people seeking to join regional communities. These range from those returning to childhood homes in order to raise young families, professionals seeking less stressful lives (Regional Australia Institute 2014) and newly arrived refugees and migrants (Schech 2013). The phenomenon of fly-in fly-out workers also continues to redefine regional families and society (Meredith et al. 2014). Communities beyond the metropolitan fringe should properly be considered as dynamic, fluid and forward-thinking.

This reality is not represented in the cultural mythology of regional Australia. Creative products, such as films, rarely depict the vibrant creativity in regional communities. Instead, they reproduce the dichotomy between a supposedly cultured metropolis and rugged frontier. Many replicate images of hardy resilience, which focus on heavily gendered stereotypes of alcohol-fuelled violence exacerbated by a hostile untameable landscape. In this tradition, people in regional settings are frequently bored and suicidal, suffering intellectual atrophy, a dark secretive loneliness, murderous intent and high levels of conservatism. While other products depict a romantic idealism, it is generally achieved through an almost total erasure of the contemporary Indigenous presence.

In line with many countries in the Global North, Australia's intellectuals, policy makers, creative thinkers and practitioners predominantly reside in the country's major metropolitan centres. A population of approximately 24 million in a geographical area the size of the continental United States means that many services are inevitably centralized, with creative activity similarly affected. Yet, the assumption that metropolitan culture provides a default model for others to aspire towards continues to influence the formation of policy and the creation of artistic opportunity. One recent government initiative in the state of Queensland created the 'Super Star Fund' to provide substantial financial support for productions that feature internationally renowned artists. Regional centres are unlikely to have the 'history of staging large-scale… work' (Arts Queensland 2013) that the application requires, and are instead encouraged to develop joint proposals with larger companies and producers. Although other smaller grants are available, the deep social connections and organic development of the regional arts are rarely incorporated in such opportunities or policy development.

In part, governments' emphasis on initiatives such as the Super Star Fund reflects a desire for productions that have substantial economic (and social) impacts. Indeed, there is a strong movement in associated federal government networks to broaden the economic value of the arts in the regions further, given their impact on social well-being. Researchers, such as Deborah Mills, have successfully pioneered a national arts and health policy. Recently, the

Australian Government's Standing Council on Health developed a national arts and health framework, which has now been adopted by all states across the Commonwealth. Many of the case studies collected by Mills (Institute for Creative Health 2014) indicates the effectiveness of arts-based activity and creative endeavour in bringing communities together, and uses the arts to examine critical regional issues such as health and communities' social and physical well-being, arguing that such measures be adopted by all states across the Commonwealth.

This has yet to be applied systematically in terms of regional arts. Regional communities have an acknowledged 'rich "bush tradition" of innovation' (Charters et al. 2011), but this social entrepreneurship is often assumed to lie primarily in commercial endeavour. Without detracting from the arts' very real economic benefits, there is nonetheless an imperative to recognize that these are often secondary to (or, at the least, inseparable from) the social outcomes. We assert that what differentiates creative practice in regional centres is its role in the formation and maintenance of inclusive communities.

Creative Communities

The Creative Communities book is divided into three sections: 'Rethinking Regionalism', 'Returning Creativity' and 'Restoring Community'. Contributors in the first section question what regionalism means in a rural and regional creative context of contested local spaces. Chapters in the second section explore the refashioning of communities through creativity, and look at case studies of environmental crisis, population movement and Indigenous community. The group of chapters in the final section investigate how communities engage in cultural experience, and the performance of inclusive narratives within this context.

This book highlights examples of the uniqueness of creative practice in regional Australia. The chapters refute prevailing metropolitan assumptions in order to reveal vibrant communities that capitalize on sustaining effective relationships through knowledge of place and creative endeavour. There are four key recurring themes that have evolved in the process of developing the collection, and which are all featured in various aspects through the chapters; namely, transformation, connectivity, storytelling and liminality. These themes formed as authors and editors worked together in the various iterations of drafts. They are embedded and woven throughout the methodology, data and outcomes of the projects discussed in the chapters.

The chapters in this book include contributions from Australia's leading theorists in the creative industries, as well as applied case studies from established and emerging practitioners in the creative and performing arts. The book developed organically from an initial research project at the University of Southern Queensland, which is located in regional Australia. The University of Southern Queensland is one of the country's oldest tertiary-level trainers of creative artists, and is unique to regional Australia. In addition to its teaching and research activities, the school runs creative arts events that bring over 25,000 community members

to the university's campuses every year. As editors, we sought a collection that reflected this long-standing commitment to the communities of regional Australia.

The chapters do not directly address commercial art-making or mainstream examples of creativity, whose metropolitan expressions are well studied. Instead, contributors use germane and ongoing regional experiences to introduce multiple interpretations of terms such as 'creativity', 'regionalism' and 'culture'. We do not seek to posit this as a point of difference from the city, but rather present the liminal or threshold stories of the vibrancy and innovation of creative cultural practice in regional and metropolitan centres. In this way, this book debunks the assumption that regional areas have little or poor opportunities for creative and cultural development. Instead, contributors explore what regional creativity might mean for the individuals and communities at the centre of dynamic networks of creative practice.

Rebecca Scollen's chapter, 'Same but Different: Growing New Audiences for the Performing Arts in Regional Australia', is one of a number of contributions that engages with the key theme of connectivity to explore community in the regional arts. She addresses the difficult development of audiences for the performing arts in regional areas. In doing so, she argues in favour of increased community-based strategies that break down barriers that can prevent regional people from participating in the arts. Scollen's work explores the widespread perception among regional communities that artistic products and processes are isolated from the people they seek to engage. Scollen argues cogently for a deeper relationship between non-theatregoers and arts organizations through a genuine sharing of needs, assumptions, products and objectives. Intersecting with the work of other contributors, her chapter focuses on the important processes by which audiences (and arts organizations) construct stories regarding their experiences of performances. The chapter is particularly important for this book as it aims to strategize how the pervasive and enduring ignorance about regional living might be undone to the benefit of both rural and metropolitan dwellers. This phenomenon is not unique to Australia and is demonstrated in other post-settler societies in the Global North.

Margaret Woodward and Craig Bremner's chapter similarly engages with the themes of connectivity and transformation. Entitled 'Learning from Inland: Redefining Regional Creativity', their chapter focuses on creating new language about the interface between creativity, innovation, technologically advanced forms of production and high-value services in regional settings. Their concept of 'Agri-tivity' evokes a powerful creativity and ingenuity in the national imagination, which originates from inland regional communities. In doing so, they re-frame the concept of creative regions to better represent inland Australia's diverse and long-standing sites of creative ingenuity. Like Scollen, Woodward and Bremner advocate for the connectivity between human and spatial dimensions, and embed this into an Agri-tivity Index in order to map shifts in perspectives around regional resources.

As editors, we encouraged contributors to engage critically with notions of regionality and regionalism. Mark Gibson's chapter, 'Creativity and Attenuated Sociality: Creative Communities in Suburban and Peri-Urban Australia', challenges these terms through critical

reflection on the nature of connectivity. He explores the often porous 'borderlands' of areas that lie on the cusp of metropolitan cities and rural locales. As Gibson discusses, the advent of 'clusters' to engage creativity and business success can supersede geographical location, yet spatial proximity remains central in the transfer of tacit knowledge and is an important consideration in what and where 'regional' influences are occurring. Gibson coined the term 'law of creative concentration' to describe the prospects for creativity increasing in proportion to density of population, and he applies this to the outer-suburban (or peri-urban) areas and the 'in-between-ness' of the visibly rural and visibly urban.

Patrick Mitchell's chapter similarly disrupts accepted notions of what constitutes regionalism, in order again to explore themes of connectivity as well as the transformation of communities and creative practice. 'Practising for Life: Amateur Theatre, Regionalism and the Gold Coast' explores the phenomenon of the 'Little Theatres' that are often part of the community-arts cache in regional centres. As Mitchell explores, there is a direct correlation in attitudes that perceive amateur theatre activity as synonymous with regional living and an 'in-between-ness' of being outside the realm of metropolitan innovation. Mitchell uses the lens of amateur theatre to disrupt the distinction between regional and metropolitan identities, and concentrates on the stories and experiences of participants in the amateur theatre activity as transformative in (and to) communities. He concludes that the re-framing of amateur theatre as a stable enterprise of connecting humans to social and cultural growth in peri-urban communities is desirable, and opens windows to understand the value of amateur theatre and the arts.

The chapter by Tamara Whyte, Chris Matthews, Michael Balfour, Lyndon Murphy and Linda Hassall, 'Getting to Know the Story of the Boathouse Dances: Football, Freedom and Rock 'n' Roll', offers a very different interpretation of the transformative power of creative practice and storytelling. The authors' discussion is initially situated in the city of Brisbane during the 1950s and 1960s. Using oral history and verbatim theatre, they explore historical memories of regionalism in cities before they become metropolitan areas. They also foreground the white privilege of history that often ignores city-dwelling Indigenous people and frames their connections to country through a European distinction between 'urban' and 'country'. The researching and retelling of Indigenous stories reclaims the significance of the cultural transformations that took place at a mid-twentieth century dance site within the domain of white, urbanized people in a major city. Their definition of regionalism extends to attitudes about inclusion and exclusion, and access to privileged spaces. In this manner, the boathouse dances provide connectivity through which to explore and expose historical accounts of regional and urban cultural values, memory, storytelling and challenge to authority.

Paul Carter's chapter also considers the interconnectedness of Indigenous and non-Indigenous presence in regional communities. Carter focuses on the deserts of central Australia in his work, entitled 'Common Patterns: Narratives of "Mere Coincidence" and the Production of Regions'. He explores how storytelling and place-making affect sociability and community in profound ways. His chapter opens a window to ways in which change

might be achieved through negotiation across time and space to connect people from both Indigenous and non-Indigenous communities. Based on a collaborative project with community members, Carter traces the transformation of stories into places and services that reflect community identities and needs.

Louise Johnson also explores non-European concepts of creativity and connectivity in her chapter, 'Creative and Destructive Communities of Lake Condah/Tae Rak, Western Victoria'. Her study focuses on the Gunditjmara people as a creative community, whose presence has been transformed and articulated in the land for centuries. Using the community's highly unusual eel harvesting system as a case study, she explores how landscape is variously created, destroyed and interpreted by both Indigenous and colonizing groups. As with a number of the chapters in this book, place-based social and economic practices are supported by the stories she explores. The connectivity is a connection between the past and present, but also the coming together of people at the sites as meeting places. Johnson's analysis discusses the roles of contestation and coloniality within the landscape, and considers it to be inherent to the sites' contemporary meaning as a creative and productive landscape.

The themes of transformation through storytelling continue in Wendy Richards' chapter. In 'Now We Will Live Forever: Creative Practice and Refugee Settlement in Regional Australia', Richards gives insight into how Sub-Saharan African refugees in regional Australia developed an anthology of stories about their experience of multi-generational displacement. The processes of taking oral histories and committing them to a book provide a means to explore the multiple literacies that were engaged by participants and project managers. Richards' account speaks directly to the role of creative activity in the development of community well-being in regional settings. The negotiation of literacy between oral and written language, and between members of the project team, are the 'in-between' factors that illuminate the transformational potential of creativity among those who feel ill at ease with traditional practices of culture knowledge in the Global North.

Susan Luckman's chapter explores another kind of transformation through migration and population movement. 'The Artists Are Taking Over This Town: Lifestyle Migration and Regional Creative Capital' discusses the spatial dimensions of story and place through what are known as 'tree-change' migrants. According to Luckman, creative workers are one of the most common groups attracted to living and working in regional settings. Her piece examines relatively privileged regional sites to demonstrate how the flow of people brings new cultural practices and creative literacies to communities. The ingrained narratives of population loss (especially of young people) from regional areas are challenged here, as Luckman transforms the narrative into the return of regional capacity that affects the well-being of the whole community. In common with Richards, Luckman investigates transformational activity at the community level and at the site of relationships between people and place.

Storytelling is a central theme throughout this book, and perhaps the most explicit engagement with this is offered in the chapter by Ariella Van Luyn and Helen Klaebe. Van Luyn and Klaebe discuss innovative use of digital technologies to enhance storytelling

from regions that have experienced crisis. In this way, they point to new ways to improve community resilience and inclusion. 'Making Stories Matter: Using Participatory New Media Storytelling and Evaluation to Serve Marginalized and Regional Communities' explores a project that connected a cyclone-damaged regional community with a wider audience (locally, geographically distant, and for posterity) by using digital technologies. Partnering with non-governmental organizations and public institutions, the researchers designed workshops to close the gap between regional communities and technological infrastructure and knowledge. The pedagogy embedded in the workshops facilitated a self-actualizing awareness among participants that enabled them to more readily collect, store and disseminate stories. This transformed the relationship between oral story and local knowledge, participant and audience, regional isolation and connectivity.

The tensions between storytelling and community transformation is explored by Robert Mason. His chapter, 'Vicarious Heritage: Performing Multicultural Heritage in Regional Australia', recounts a heritage tourism project that connected geographical locales and historical data into a single actor performance narrative for tourists and locals. The performance of regional heritage is necessarily a negotiation between stakeholders as well as with audiences that experience it. For the latter, the creative product relies on a reflexivity to engage with the historical story as well as the dynamics of the performance itself. The chapter explores the balance between tourists' desire for information, the creation of an engaging narrative and the commercial needs of regional and heritage tourism. In this way, it discusses the role of the past in the present and its influence on social connectivity, inclusion and creative practice.

Tensions between perceived metropolitan bias and regional ingenuity form the basis for Janet McDonald's chapter. Her chapter, 'Artist-Run Initiatives as Liminal Incubatory Arts Practice', examines the numerous young artist enclaves (known as artist-run initiatives [ARIs]) in a regional centre. Focussing on their embedded presence in the community, she explores how articulating difference from metropolitan ARIs re-frames their sociocultural practice as liminal rather than marginal. Moreover, she argues that the positioning of ARIs as liminal practices, outside of traditional or commercial artistic practice, is a strength to the communities. Demonstrating that regional ARIs are by their very nature short-term, intensely active, and innovative, McDonald argues that this allows for up-skilling and mentoring that is somewhere in-between, or on the threshold between, formal training and industry models. The ARIs provide a metaphor for regional creative practice as somewhere that has the potential to be on the threshold between innovation and traditional or heritage arts practices.

Andrew Mason's chapter, 'Art in Response to Crisis: The Drought and Regional Community', intersects with Van Luyn and Klaebe's piece on the role of the arts in response to natural disaster. Mason analyses the liminal position of visual arts during the worst drought recorded in a regional centre since European settlement. 'Avant Garden' was created by local and nationally renowned artists to celebrate the innovation of a regional 'garden city' without water. Artists told their stories through public works that could interact with festivalgoers, some critiquing the notion of gardens, and others presenting the memory of flowers. Like

McDonald, Mason considers the community as embedded in the creative practice, rather than as temporary creative practitioners. The sustainability of such an initiative is reliant on the climate, and so the artistic and cultural practices developed in a drought are always in the threshold of change and transformation.

Conclusion

Profound connections abound in regional communities not only out of necessity but also because connectivity is more innovative where there is scarce mobile coverage, hundreds of kilometres between neighbours, and vast differences in the make-up of the population through chosen and non-chosen immigration and settlement. Through the interwoven themes of transformation, connectivity, storytelling and liminality, this book explores the capacity of arts to transform communities' sense of self. It demonstrates the unique nature of arts practice outside metropolitan centres, and, in doing so, the enduring resonance of the regions to contemporary artistic experiences throughout the Global North.

References

Arts Queensland (2013), 'Super star fund: Overview', accessed 25 May 2014, available at http://www.arts.qld.gov.au/funding/superstarfund.html

Australian Bureau of Statistics (2008), 'Population distribution', accessed 25 May 2014, available at http://www.abs.gov.au/AUSSTATS/abs@.nsf/Lookup/4102.0Chapter3002008

Charters, K., Vitartas, P. and Waterman, P. (2011), 'Identifying and communicating current issues for regional Australia', *Journal of Economic and Social Policy*, 14(3), 5–19.

Human Resources and Skills Development Canada (2014), 'Canadians in context-geographic distribution', accessed 25 May 2014, available at http://www4.hrsdc.gc.ca/.3ndic.1t.4r@-eng.jsp?iid=34

Institute for Creative Health (2014), 'Evidence', accessed 25 May 14, available at http://instituteforcreativehealth.org.au/proving/

Meredith, V., Rush, P. and Robinson, E. (2014), 'Fly-in fly-out workforce practices in Australia: The effects on children and family relationships', Australian Institute for Family Studies, accessed 25 January 2014, available at http://www.aifs.gov.au/cfca/pubs/papers/a146119/index.html

Regional Australia Institute (2014), 'There's no place like home (in regional Australia)', accessed 25 May 2014, available at http://www.regionalaustralia.org.au/archive-blog/blog-regional-returners-theres-no-place-like-home/

Schech, S. (2013), 'Silent bargain or rural cosmopolitanism? Refugee settlement in regional Australia', *Journal of Ethnic and Migration Studies*, 40(4), 601–618.

United States Census Bureau (2010), 'Urban and rural classification and urban area criteria', accessed 25 May 2014, available at http://www.census.gov/geo/reference/ua/urban-rural-2010.html

Rethinking Regionalism

Chapter 1

Common Patterns: Narratives of 'Mere Coincidence' and the Production of Regions

Paul Carter[1]
RMIT University

In this account of place-making in Central Australia, a contrast is made between creative community and regulatory authority. A creative community resembles a revolutionary council of the kind influentially discussed by Hannah Arendt (2000); it is convened to manage change. In contrast, a regulatory authority (represented in Central Australia, and elsewhere, by local councils and regional governments) is constitutionally opposed to innovation. At issue are different models of democratic governance. Associated with these differing models are different conceptions of place and place stewardship. In Alice Springs, which furnishes the case study of this article, those actively engaged in nurturing a new space of sociability, or meeting place, understood place discursively (as a talking place). In contrast, the planning culture sought to eliminate storytelling mechanisms for social innovation, associating a plurality of voices and histories with the undermining of administrative authority and the ideological status quo. My argument is that the discourse of creative place-making is mythopoetic in its purpose: by way of identifying cross-cultural narratives of place-making that display analogies, it seeks common ground between different cultural patternings of place. Mythopoetic, story-based strategies of this kind can overthrow fixed and often divisionist myths of origin, replacing them with co-devised narratives. The chapter concludes with an acknowledgement that the creative place-making process outlined here redefines what is meant by place, which ceases to be an administrative convenience (static and void) and becomes an analogue of the performative techniques that conjure it into being. Place may be reconfigured as a network of passages or creative regions, comparable to a string figure or network, whose governance, it is suggested, is vested in the creative communities that bring it alive and maintain it.

Talking Place

The relationship between storytelling and place-making is a strained one. While plentiful evidence exists to demonstrate the role that foundational myths play in building local and regional identity, public planning understands procurement of the public good in terms of service provision and design functionality. A 'meeting place' initiative in Alice Springs, Central Australia, in which I was engaged between 2007 and 2011, illustrates these points. A bifurcation occurred early in the process between a community interested in discourse and a professionalized culture of planning interested in project management and delivery. Different community groups concerned to rebuild Alice Spring's social and

environmental capital were engaged in *plotting*. Engineers and managers were signed up to a *narrative*. While the famous distinction that E.M. Forster made in *Aspects of the Novel* between story and plot may be simplistic in a literary context, in the context of developing regional literacy it is strictly accurate. To discuss sociability in terms of the protocols, location and content of meeting is to plot relationships. It involves holding together a region of reciprocities. In contrast, the story of a new public space, which originates in a planning brief and concludes in the delivery of a newly designed precinct, is purely linear. Instead of holding multiple senses of place, it eliminates these in the interests of progress. While stories relate, plans connect, and connectivity, as will emerge, is not necessarily an unqualified good.

The novelty of our 'meeting place' project lay partly in the fact that it originated outside the planning departments. The Uniting Church's proposal to create a place of intercultural reconciliation adjacent to the John Flynn Church on Todd Mall had written into it certain assumptions about social planning; however, it was put forward circumspectly, as a catalyst of new dialogue rather than as a device to satisfy community consultation expectations ahead of building. For example, it was appreciated that the Indigenous landscape of Alice Springs did not resemble the centripetal construction of place characteristic of colonial planning. The physical expression of Indigenous song lines or dreaming tracks is enigmatic: while sacred sites and their connecting stories are marked in the Alice Springs landscape, the sense in which their linking tracks exist is unclear. Of these song lines, noted Alice Springs historian Dick Kimber writes irreverently, 'a plan of all of them would begin to look like a bowl of spaghetti!' (Kimber 2000). The labyrinth of interwoven passages and meanings conjured up here may not be susceptible to visualization in this way; however, the place sung, drawn and narrated into being is evidently centrifugal, radiant and active. In contrast with a centralized model of the meeting place, which has its origins in Europe, the Indigenous constitution of sociability focuses solely on relations at a distance. In this context, a new meeting place would not necessarily be an enclosure: it might be a place of disclosure.

Members of the Lhere Artepe Corporation alluded to this distinction when they suggested that what was needed was a 'talking place', not a 'meeting place'. The significance of this distinction is discussed in my book *Meeting Place* (2013). A meeting place cannot be assumed to exist apart from the discourse that produces it; therefore, ahead of meeting, an agreement to meet has to be negotiated. Prior to the institution of new social relations, an encounter occurs. The encounter involves the improvisation of communicational strategies that will form the basis of stable social relations in the future. The encounter is the creative matrix out of which the forms and conventions of a meeting place can emerge. If the agency that participants exercise in the encounter, and thus the meeting place established by planning fiat, is overruled, the result is a further deterioration of sociability – another non-meeting place. Additional intercultural issues arise when a meeting place is recast as a talking place. The most fundamental is the discovery that, after all, different communities may not want to meet, at least not in a whitefella way. In centralian Indigenous cultures,

meetings between different communities are the exceptional, rather than normal, state of affairs. Such observations did not invalidate the Uniting Church initiative; however, they foregrounded the performative nature of what was being solicited. Common ground could not be assumed: it had to be discovered – or rediscovered.

To find common ground, community members had to be encouraged to meet in a way that relived the archetypal (but also everyday) experience of encounter. This is a complex and nuanced process. It is not sociologically essentialist: Indigenous and non-Indigenous interests in Alice Springs do not represent antithetical understandings of place and purpose. Obvious and profound historical, cultural and social experiences of difference exist; however, partly as a consequence of this, there is an equally strong desire for better communication. The Uniting Church initiative channelled this desire. As a result, my role was not to initiate dialogue where no call for it existed; it was to act in the role of dramaturg, listening to what the convening parties said and (I hope subtly) stirring into the discourse certain stories of my own, some locally sourced, some anecdotal, whose object was to thicken the talking, to open up the conversation to the social possibilities of metaphor and story in general. To encourage encounter was to use the poetic power of storytelling to elicit identifications (rather than entrench oppositional identities). Unlike the 'community consultation' process – associated in Alice Springs with 'consultation fatigue' – drawing out senses of place in story quickly builds group energy. Staging encounter is, in this regard, a form of psychic revitalization.

The community convened in this way is not the imagined community of national or regional myth: it is a concretely self-realizing creative community, united, in fact, by its capacity to imagine change as a negotiation between past, present and future. The talking that occurs in these forums is creative; that is, it evolves mimetically and responsively. As a result, the topic that emerges is not distinct from the dramaturgy of the discourse and the idea that emerges from the session is not separate from the fact of something having *taken place*. The value of this approach in reconciling differences soon emerged in Alice Springs. One discussion, I remember, quickly turned to the separation of the township from the river. A desire was expressed for better connectivity. In planning terms, this would mean reversing the mistakes of planning in the past; however, what was meant by connectivity here was emotional as well as physical. Indigenous and non-Indigenous participants remembered playing together as children in the Todd River bed; they remembered the individual trees and their names and associations; they remembered being related to each other before the 'prison house' of racialized prejudice and separatist acculturation closed down that common space of encounter. Connectivity here meant the act of relating. Relating (storytelling) was not only a form of recollection: it was building a new context for meeting. A new region of care was being discovered where (again) no one was outside it. The sense of collective empowerment recalled Jacques Rancière's (n.d.) description of the 'emancipated spectator': 'the theatrical privilege of living presence' was questioned and all were brought back 'to a level of equality with the telling of a story'. It promised 'the institution of a new stage of equality, where the different kinds

of performances would be translated into one another'. In such performances, Rancière writes:

> it is a matter of linking what one knows with what one does not know, of being at the same time performers who display their competences and visitors or spectators who are looking for what those competences may produce in a new context, among unknown people.

Taking Place

The emphasis that Rancière places on *not* knowing is important in developing a regional sense of place. As he implies, returning creative control of the encounter to the 'spectator' – now recast as self-actuating – makes room for the 'stranger' to appear. The efficacy of storytelling in the context of making place (as opposed to a generalized place-making) is measured by its success in revitalizing techniques of welcome, incorporation and care. Encouraging the creative retelling and evolution of place-making, stories draw the future into the present: the linear narrative of public planning, which prescribes sociability rather than ceding power over the script to the players themselves, is replaced by a discourse based on continuous translation and mutual adjustment. These effects are spatial as well as temporal. When common ground is opened up through the discovery of shared concerns – a process that the symbolic language of story mediates – the temporal present and the spatial present fuse in the idea of presence. According to Stanley Rosen (1999: 31), when we care, the 'present' is experienced as 'being by or next to': 'We produce the lived present, not as a synthesis of temporal points, but as the self-orientation of erotic striving'. The meeting place produced in this way is thus a disclosure (rather than an enclosure) – 'if the present is like a place, then it must be a place that we are always in' (Rosen 1999: 16). By the same token, it cannot be fully plotted: it is always immanent. As it depends on other presences, it is always a region of possible meetings; to be in it is to know that one cannot be everywhere. The idealized plans, elevations and perspectives of architectural and landscape design can give no idea of this experience.

This last point became important when our project was taken up by the Northern Territory Government and the Alice Springs Town Council and absorbed into the 'Moving Alice Ahead – Lifestyle, CBD Revitalization' initiative, announced by the Northern Territory Government in 2007. The meeting place project soon became identified with physical modifications to the spatial syntax of the centre of town. 'Revitalization' was, in the hands of the planners, engineers, councillors and media, construed purely in terms of improved 'connectivity', embodied in revised streetscapes and the provision of public art, offering a symbolic overlay or interpretation of the town's heritage. It should be stressed that there is no necessary rift between place-making and storytelling: we had shown this at Federation Square, where the public artwork 'Nearamnew' mediated successfully between

these different modalities of time in space. Writing about that work, I referred to Jean-Luc Nancy's conception of community as 'not simply an empirical reality or presence, but rather an advent or a calling or something lying in wait' (Dallmayr 1997: 174–196, 179). This 'lying in wait' characterizes a social experience that is primarily rooted in a sense of relative placing and relative timing. Nancy speaks of a community of 'singular beings', whose finitude emerges relationally 'in a shared space or world'. 'What is involved in this originary sociality is not fusion or exclusion but a kind of "communication" that is vastly different from a mere exchange of information or messages' (Dallmayr 1997: 181). In a similar way, Rosen (1999: 32) characterizes architectural space as an opening towards the other.[2] To put this in another way, the meeting place is not a destination – it is a passage.

When these thoughts are transposed from the somewhat abstract plane of social theory to the concrete situation of social fragmentation in Alice Springs, something else emerges. The new region of possible relations opened up through story is not a future meeting place in an earlier stage of development. If it is a network, its nodal points can never be synthesized to produce a territory. Further, against a background of violent colonization and its aftermath, the region will be composed of negative spaces as well as positive ones: there will be as many no-go zones as there are passages. A Gumatj elder from East Arnhem Land explains:

> Some parts of this country are not to be lived on. In our culture we recognize that that there are places we can't go to because of a powerful event, places that are so powerful that you can become cursed by the land, you get sick from it. It is recognized as sickness country for all time […] They have a mystical power and if you venture too close something will happen. That's why we don't go to these places. We always go around them, asking permission first from the people who know that country. Spirits talk to you. You can hear the land talk to you. People feel it.
>
> (McMillan 2007: 19)

These 'powerful events' may be ancient or modern. They include murders, massacres and other forms of violence. Not all prohibited places are sick: they may be extremely powerful and under exclusive guardianship (Strehlow 1971: 585–586). The point, though, is that this understanding of country fuses social existence and regional literacy.

In exploring senses of place through story with a view to establishing grounds for meeting, plotting elided with passage: it was as if we were making a labyrinth composed entirely of threads – not so different, after all, from Kimber's bowl of spaghetti. We had to see that every passage had its shadow path. Alice Springs is a profoundly traumatized community; it is also comprehensively globalized. It concentrates a history of social and environmental exploitation and adaptation; it communicates to the world the concentrated essence of 'Australia', a dehistoricized compound of ochre landscapes, outback hospitality and Aboriginal art. It has a remarkable nucleus of creative artists, entrepreneurs and activists; it also experiences extremes of social alienation and fragmentation.[3] In a symbolic way, our 'meeting place' represented a process for bringing distant things near. In connecting, it also

gave expression to radiating areas of concern that were both psychological and geographical. This centripetal/centrifugal character is found in two of Alice Springs' iconic and defining historical agencies: the Overland Telegraph Line and the John Flynn Flying Doctor Service. The architect of the Telegraph Line, Charles Todd (whose daughter's name is commemorated in the name Alice Springs), oversaw the construction of a system of communication that brought distant communities close. For his part, Flynn developed the twin technologies of flying and radio transmission to service isolated communities, in this way building a networked region of care. However, we had to remember that this drive to connect, while it mediated between near and far, largely treated Indigenous people, their laws, society and culture as a no-go zone; not from respect, but from indifference (Trudinger 2010).

Symbolic Zones

Stories and communities are symbiotic: imagined communities and imagined histories go together. If, as Geoffrey Bardon argues in the context of artistic production at Papunya in 1971–1972, places are made after their stories, then the character of the story will shape the identity of the place. A 'regional story' may not be a story that represents a regional event: it may be a story that is plotted in such a way that it identifies a convergence or meeting of interests. Thought of like this, stories are acts of place-making in a primary sense. They are not received myths that consolidate the political, social and legal status quo. Rather, they operate mythopoetically, engaging the community creatively to imagine its coming into being again. A mythopoetically conceived storytelling concerns peoples and situations whose received myths no longer work. Instead of sweeping away what has been made in the past – which is the technique of the planned future place – it is revisionist: it reviews received ideas and extracts from them the sidelined significances or possibilities. It focuses on the sense-making or creative impulse informing past acts of collective imagination and materialization.

To integrate cultural heritage, cultural production and public planning in this way is not necessarily to advocate radical innovation. On the contrary, in the context of imminent change, it may provide the collective psychic ballast that allows a community to ride the waves of change more securely. In the context of a 'revitalization' programme, the discovery of a place-based symbolic lexicon that articulates the enigma of meeting may demonstrate that revitalization, renewal and the other terms dear to planning need not involve starting all over again: they may signify the poetic transformation of inherited and current institutions. A creative region is not one that regularly destroys its acquired symbolic capital. Instead, understanding it as generative (open to possibilities), its creative leaders and communities work to release hidden meanings, to discover new metaphors and to reinterpret what is given so that, again, it makes human sense.

The translation of these general propositions into actions is illustrated by the role that trees played in the Alice Springs discussions. At the heart of the 'reconciliation' proposed

by those promoting a new meeting place was the development of shared place values. These clearly only exist in a very fragile and localized way in Alice Springs. I remember Alice Springs journalist and writer Kieran Finnane relating her conversation with Aboriginal artist M.T. Turner. In Turner's account of the central business district, the location of food plants predominated. Finnane had the impression that Turner did not 'see' the overlay of buildings. That is, they formed no part of her story; they did not contribute to her symbolic capital, but instead depleted it. This brings us to a key issue in proposing symbolic renewal: it is by no means the case that symbolic production means the same thing across cultures and interests in Alice Springs. On the basis of the shared affection for the great red river gums that populate the Todd River bed and are also distributed through the township, we hypothesized that trees would provide a strong initial symbolic 'meeting place', where shared identifications could overcome historical and cultural differences. Long-time residents from a variety of backgrounds agreed in asserting the symbolic role that the red river gums played in the local imaginary: these trees, informally arranged in lines down the Todd River bed, shaping and shaped by the periodic floodwaters that inundate its sandy reaches, were associated with play, shelter and the natural cycles of life. The first revitalization was, in this sense, the recuperation of tree connections. However, the limitations to this story-based strategy for building a common understanding soon became apparent.

The meaning of these trees for the traditional owners was summed up by Mbantua Elder Doris Stewart. Referring to a time when red river gums were distributed more closely down the Todd, she said, 'You can trace your stories from the trees, but now there are only isolated pockets'. Reflecting on the fact that she had been chosen by her family to be its conscience, its historian, the one who had primary responsibility for protecting sacred sites, Mrs Stewart explained the psychic burden under which she laboured. Referring to Council tree mutilations associated with the desecration of sacred sites, she said, 'For every damage we have to lose a life' and 'after damage my ancestors come to me'. Indeed, it is easy to show that dendrophobia is endemic in the Alice Springs planning and public works department: we had plentiful evidence of pointless tree mutilation supported vociferously by Alice Springs councillors.[4] However, the issue here is not the psychology and practice of a colonialist culture committed to the unilateral 'taming' of nature. Rather, it is the question of what to do when a change of attitude occurs. The non-Indigenous discussants were as keen as their Indigenous counterparts to restore the meaning and significance of the red river gums, but this did not solve the question of what to do. This point was succinctly made by Mrs Stewart when, in response to a suggestion that a particularly gratuitous act of destruction be retrieved by establishing a new tree-planting programme, she observed, 'Why recreate when we already had the thing?'[5]

There is much behind this question. Of course she refers to the necessity to confront a history of environmental vandalism and cultural disrespect. However, she also alludes to questionable representational practices: can new trees symbolize a vanished tree or is there not something ersatz and hollow about such belated piety? A symbolic representation in this context merely runs down further the regional imaginary, as its mere presence makes it

harder to imagine the actual loss. Readers will recognize here a conundrum familiar to public artists who, commissioned to memorialize this or that local theme, find themselves complicit in an act of historical amnesia or aestheticization. The suspicion of this kind of symbolic repair was widespread. Mr Graham Piper told the Rev. Tracy Spencer (who collected much of the information on which this article is based), 'What's the point of me telling you where everything used to be, or even what people would like to see. If we don't have the stories, then we'll only have the can'ts and buts'. Here Mr Piper makes a clear connection between the loss of stories and the culture of planning: when the human region formed of intersecting stories and human/non-human associations is destroyed, a new theory of region, characterized by regulation, prohibition and separation, intervenes. Another contributor to our research, Mr Bruce Deans, put this in a historical perspective, reflecting how, 'In the 1980s, this small population was over commercialised, raped and pillaged […] it lost its heart and soul'.[6]

A distinction is made here between objects that embody a story and representations that only allude to it. Two different understandings of symbol (and therefore of symbolization) are involved. They are illustrated by the historian of classical myth Carl Kerenyi when he questions whether the stylized 'meander patterns' found on Greek vases were 'symbolic' representations of the labyrinth: 'Symbols demand an interpretation, whereas […] the meander is itself an explanatory sign that was immediately understood' (Kerenyi 1976: 91). Incidentally, this distinction throws light on the meaning of the 'dot-and-circle' paintings produced at Papunya in 1971–1972. Kerenyi distinguishes between a sign language that has an internal consistency and a repertoire of symbols whose logic is dependent on their external reference. In a related context, Geoffrey Bardon asserted that the Papunya art could be understood in terms of archetype and hieroglyphs, possessing a visual grammar. In other words, there are symbolic forms that acquire their symbolic meaning relationally (as members of a family, sentence or region), whereas other forms are to be read in isolation with their meaning demanding interpretation. In the context of tree care in Alice Springs, one can see that the fetishization of individual trees at the expense of the region to which they belong is already to place them in a disabling representationalist framework.

Writing Region

In Alice Springs, a storytelling was promoted that aimed to foster shared senses of place. A symbolizing activity was designed to create a new psychological and emotional meeting place. The story of the trees illustrates the conceptual and cultural challenges this entailed. Two dominant features of a mythopoetic place-making (or remaking) process emerged: placing and arrangement. Mr Piper's point is plain: nothing can usefully be remembered if it is removed from where it used to be. Mrs Stewart's reference to the trees in the Todd River bed is also unequivocal: it is not individual trees that count, but groups of them in relation to one another. The combination of placing and spacing is the patent of region. The region is not an administrative sector; it is a choreography of relationships, composed of endless passages.

As in a spider's web, so in the creative region, the removal of any of the anchor points or filaments seriously threatens the stability of the figure. As the region conjured up in this way is a human creation – an expression of a collective practice of storytelling (or relating) – it seemed to us that there was scope to re-narrate certain important foundational narratives to reflect these insights. The object would not be to invent new concepts (biodiversity, for instance) that sought to eliminate differences, but, working with the materials to hand, to identify 'mere coincidences': parallel instances of region-making that had, perhaps, been ignored because of the wrong kind of symbolizing. This approach proved fertile and one instance is given here: the relation of the Telegraph Line to the formation of region.

Eastern Arrernte Elder and artist Margaret Kemarre Turner likens her 'tie' to the Land to 'a big twirl of string that holds us there with our families' (Turner 2010: 15). The 'tie or string' is called *utyerre*, and its seed connotation appears to be that of tying. This connotation allows Turner to incorporate the telegraph (now the telephone) into an Arrernte ontology: 'that *utyerre* means a telephone. And when he's hearing on the telephone, that person can see – in his mind he knows it – what that line runs, they can see it, where the message's coming from, like a string' (16). Seizing on an extensive convergence of function, Turner finds a place for electrically mediated communication. However, her brilliant analogy has the effect of regionalizing the telephone. *Utyerre* is the concept of connecting, but '*utyerre* also is like a vein, a vein in yourself, and in your country' (16); it is the root of the yam that lead you to the root of another yam; and, on the same analogy, *utyerre* is the root that joins two adjoining homelands: 'The spirit of each country goes deep into the ground and joins up with the spirits of all those other countries in *apmereyanhe*[7] to make one big root down there' (18–19). To be related to someone else might be expressed as having a 'bloodstream or bloodline' inside you: '*Utyerre* contains something running through it' (16), it is both the vessel and the flow path. *Utyerre* connects you to country historically as well as spatially: 'You gotta follow your straight line, where your string is, where your bloodline lays in the country. Like what country you're really tied to. What is really your connection? What line, what stream runs in from you to there?' (17).

Kemarre Turner's analogical genius suggested a similarly adventurous reinterpretation of the regional meaning (the symbolic function) of the Overland Telegraph. The Alice Springs repeater station was one of eleven set up between Adelaide and Port Darwin in the early 1870s, and it occupies a site that has important ceremonial associations for Eastern Arrernte people. The publications of Frank Gillen (station master, magistrate and Aboriginal Sub-Protector from 1892 to 1899) and anthropologist Baldwin Spencer turned Alice Springs into the single most important influence on twentieth-century European social, psychological and cultural theorizing (their work included detailed photographic record of intertribal 'meetings' and their protocols). This said, the white insurgency associated with the Line's construction cut through Indigenous networks of care and reciprocity with little thought for the wreckage caused. The Line followed a path laid down by explorer John Mc'Douall Stuart. Much as he admired Stuart's bushmanship, T.G.H. Strehlow, whose work on Arrernte culture was fundamental in establishing the possibility of a bicultural Australian story,

faulted the explorer on one important point: Stuart failed to understand the fact that the land was occupied and governed by the strictest visiting protocols:

> The family groups of which each local group was made up kept in touch with each other by sending up smoke signals whenever their wanderings took them away from the main camps. Any visitors coming in from outside groups had the duty to announce their approach in the same way.
>
> <div align="right">(Strehlow 1967: 7)</div>

As soon as the camp came in sight 'the visitors would sit down, place their weapons with their backs turned towards the camp of their hosts, waiting for some of the local men to come forward and welcome them as visitors' (8). Writing 60 years ago, Strehlow (1967: 9) explained:

> Though this aboriginal visiting etiquette may appear strange to us at first, its purpose was exactly the same as our own: we too insist that visitors must not sneak upon us, but must announce their presence by knocking on the front door [...] Nothing would offend us more than if our visitors would rudely burst in upon the privacy of our homes uninvited.

These observations remain valid, going a long way to explaining why a revitalization strategy couched in terms of planned meeting places was bound to fail. In the present epoch of cultural relativism, Strehlow's anticipatory attempt to translate Indigenous protocols into whitefella terms also deserves respect.

However, to return to the Line, a fatal impact thesis, while important, ignores the regional telegraphic communities that sprang up around the repeater stations. More importantly, it overlooks the intentions of Charles Todd, its architect, who, it appears, considered the new technology of the telegraph as an instrument of *regional development*. At its maximum reach, the telegraph connected the edges of the continent and these to London. Prior to this, however, Todd had been working to develop the regional potential of the telegraph, establishing a network of telegraph or repeater stations in South Australia with the explicit purpose of collating meteorological data, received almost instantaneously from these, to build up weather maps. In other words, the distance inscribed into the telegraph could take the form of a front, a pressure differential or even a group of these maculating the regional air. In this case, the information afforded by the telegraph stations was omnidirectional and needed the central monitor to study the changes and organize these into evidence of a weather direction and a likely prediction of what was to come. Incidentally, when related (or relayed) in this way, there are striking parallels with the interests and techniques of Aboriginal rainmakers, as described by Charles Mountford in his book *Nomads of the Central Desert* (1976). It is intriguing that in their ceremonies the Pitjantjatjara use or used the *ringili* pearl shell, a device (obtained through inter-regional trade from the Dampier Peninsula in

north-west Australia) that is intriguingly inscribed with a tri-linear maze pattern that might signify lightning or rain, but which also bears a striking resemblance to the three wires of the telegraph line – a mere coincidence, of course (Mountford 1976: 275).[8]

This was not Todd's only regional vision. He was also an astronomer, and here his interests (so overwhelmingly inscribed toponymically into the Alice Springs landscape: the names MacDonnell, Heavitree, Todd, Charles and Alice all being derived directly from his own immediate line of command) bent strongly towards the mythopoetic revitalization of the town and community. Todd was interested in extrapolating the logic of systems from the study of particulars; he looked for the relative fixtures of things in their occasional conjunctions or meetings. His observations on the phenomena of Jupiter's satellites, for example, combine exact measurement with an appreciation of atmospheric effects:

> I was much impressed on some nights with the sudden and extensive changes in the cloud belts, as though some tremendous storm was in progress on the planet's surface, changing the form and dimensions of the cloud belts in an hour or two, or even less.
>
> (Todd 1877: 285)

Given these interests, it is not hard to make a mythopoetic argument for understanding the main north-south street of Alice Springs (Todd Street) regionally: simply calculate the places and orbits of satellites of Jupiter, another solar planet. By analogy, the 'transit' of Todd Mall is a minute segment of the solar regional body (the Red Centre) in whose measure we can discover principles governing the entire system. Similarly, the prevalence of Todd's name could be used to propose another *utyerre* or line – between street and river – the latter of which, in Indigenous thought, is associated with the Milky Way.

Mere Coincidence?

The remit of Material Thinking is to turn stories into places. If places are made after their stories, this is the logical corollary of the kind of mythopoetic enquiry summarized here. Common places emerge as passages between related points: this statement is both fictionally and topographically true. The parallel or mere coincidence we had found between an unrealized symbolic potential of the Todd legacy and extant understandings of the region as a network of long-distance writing evolved into a proposal for a ground pattern, an intuitive choreography of the public domain in the centre of Alice Springs.[9] Like Kerenyi's meander, the pattern did not symbolize gathering (it did not need to be interpreted): its regional associations would be sensed through the mere social act of traversing its gathering form. The proposed pattern was composed from a number of bicultural ideations of place, reconfigured through creative mediations of this kind. The 'triglyph' of the Telegraph Line (its three wires) has a physical as well as formal parallel in the three informal 'rows' of red river gums growing in the Todd River. We incorporated marks derived from the analogy

between the dots and dashes tapped out by the late-nineteenth-century telegrapher (where each telegrapher had her own style, transcribing messages at different speeds such that the individual dots and dashes could be longer or shorter) and the story notation techniques of the Papunya artists.

According to the historian of early Latin American culture James Lockhart, cultural interaction between the colonizing Spaniards and the Indigenous Nahuas was characterized by the process of 'Double Mistaken Identity, in which each side of the cultural exchange presumes that a given form or concept is functioning in the way familiar within its own tradition and is unaware of or unimpressed by the other side's interpretation' (Lockhart 1999: 99). Double Mistaken Identity was socially productive because 'extensive convergences' existed 'between European and central Mexican societies'. The example Lockhart offers of a 'convergence' that was not an 'identity' concerns socio-political organization. The Nahua city-state-sized entity (*altepetl*) presented 'many analogies to the Hispanic municipality-province'. Lockhart shows how this seeming similarity enabled both parties to interpret the changed distribution of powers in terms of continuities and modifications within their own traditional socio-political frameworks. In an odd way, the lack of mutual understanding fostered difference rather than leading to its suppression. While the Indigenous *altepetl* was organized in a 'cellular' way, being 'divided into a certain number of independent and equal subentities', the Spanish city-province was organized around a 'pronounced nucleus and was strongly hierarchical in the sense that the organizations of all kind stretched out from a dominant centre' (Lockhart 1999: 99).

This hypothesis is by its very nature hard to prove. Other colonial situations have been claimed to operate in the same way. Its application to the Australian situation is plausible. For example, Ian Keen has made a strong case for seeing Aboriginal Australia as a 'regional system', characterized by non-hierarchical interactions between localized groups (Keen 1997: 261–273),[10] while the Spanish 'governor' (and government) finds its exact mirror in Australia in the ultimate subordination of national sovereignty to a monarch overseas. However, in the context of describing a new approach to the production of regional literacies and attachments (social as well as environmental), of interest are the implications of Lockhart's thesis for *symbolic* production. In a way, his proposal rests on the same equivocation about the meaning of symbols discussed above. Put simply, each party was able to interpret the other's symbolic forms as mere representations. Both parties could then ignore the constitutive nature of the narratives they embodied. A double representationalist fallacy existed that enabled the true symbolic function of both cultural systems to operate more or less unimpeded. At the same time, the suspension of disbelief, in which both parties colluded, enabled the possibility of a cross-cultural meeting place, in which the encounter with difference was welcomed because it allowed for mutual recognition and seeming compliance.

It might be thought that this analysis reveals a cynical view of the potential of human relations. However, this judgement reflects intimist theories of communication that may have little place in the public domain and that may, in fact, as Richard Sennett has suggested, be sharply inimical to its well-being. At any rate, the model of symbolically mediated

place-making outlined here does not dissolve difference, nor does it reify it. Instead, it contributes to a discourse of passages, of approaches and encounters that revitalize the social landscape because they preserve a balance of possibilities open for future discovery. This balance is the regional symbolic capital held in reserve. The region opened in this way is not an enclosure, but a disclosure; it is wherever co-presencing occurs. The anthropologist Barbara Glowczewski (2001) writes of Warlpiri time and space:

> The number of trails between two places is infinite; there are as many itineraries as there are ways to travel, track game or collect food. Metric distance is not necessarily meaningful in the desert; people measure space in time rather than kilometres […]

However, scaled down to the meeting place, this is a description of sociability. There is no end to the meeting places that places made after their stories can plot. Arrangements are elastic in time and space, provided their placing is preserved. Observations like these operate at the urban scale as well. They offer new ways of understanding the urban landscape as a set of ties or as a microcosm of regional relations. When the fact that entities and subjectivities exist relationally is grasped, the call for connectivity can be relaxed. The connections already exist: the challenge is not to truncate them further. The symbol that is shared between and the metaphor that re-joins these connections are the clues to plotting regions that generate rather than waste their wealth.

References

Arendt, Hannah (2000), 'The revolutionary tradition and its lost treasure', in P. Baehr (ed.), *The Portable Hannah Arendt*, London: Penguin.

Carter, Paul (2013), *Meeting Places: The Human Encounter and the Challenge of Coexistence*, Minneapolis, MN: University of Minnesota Press.

Coghlan, Frances (1991), 'Aboriginal town camps and Tangentyere council: The battle for self-determination in Alice Springs', Master's thesis, La Trobe University, Melbourne.

Dallmayr, Fred (1997), 'An "inoperative" global community? Reflections on Nancy', in D. Shephard, S. Sparks and C. Thomas (eds), *On Jean-Luc Nancy: The Sense of Philosophy*, London: Routledge.

Glowczewski, Barbara (2001), 'Returning Indigenous knowledge in Central Australia: This CD-Rom brings everybody to mind', in AIATSAS (Australian Institute of Aboriginal and Torres Strait Islander Studies) Indigenous Studies Conference, *The Power of Knowledge, the Resonance of Tradition*, Canberra, ACT, 18–20 September, eprints.jcu.edu.au/7621/.

Keen, Ian (1997), 'A continent of foragers: Aboriginal Australia as a "regional system"', in P. McConvell and N. Evans (eds), *Archaeology and Linguistics: Aboriginal Australia in Global Perspective*, Melbourne: Oxford University Press.

Kerenyi, Carl (1976), *Dionysos: Archetypal Image of Indestructible Life* (trans. R. Manheim), Princeton, NJ: Princeton University Press.

Kimber, R.G. (2000), 'Tjukurrpa trails: A cultural topography of the western desert', in H. Perkins and H. Fink (eds), *Papunya Tula: Genesis and Genius*, Sydney: Art Gallery of New South Wales.

Lockhart, James (1999), 'Double mistaken identity: Some Nahua concepts in postconquest guise', in J. Lockhart (ed), *Of Things of the Indies: Essays Old and New in Early Latin American History*, Stanford, CA: Stanford University Press.

McMillan, Andrew (2007), *An Intruder's Guide to East Arnhem Land*, Nightcliff, NT: Niblock Publishing.

Mountford, Charles (1976), *Nomads of the Australian Desert*, Melbourne: Rigby.

Rancière, Jacques (n.d.), 'The emancipated spectator', available at http://www.chtodelat.org/index.php?option=com_content&view=article&id=952%3Ajacques-ranciere-the-emancipated-spectator&catid=234%3A07-31-theater-of-accomplices&Itemid=414&lang=en

Rosen, Stanley (1999), *Metaphysics in Ordinary Language*, New Haven, CT: Yale University Press.

Strehlow, T.G.H. (1967), *Comments on the Journals of John McDouall Stuart*, Adelaide: University of Adelaide Press.

Strehlow, T.G.H. (1971), *Songs of Central Australia*, Sydney: Angus & Robertson.

Todd, Charles (1877), 'Observations of the phenomena of Jupiter's satellites at the observatory, Adelaide, and notes on the physical appearance of the planet', *Monthly Notices of the Royal Astronomical Society*, 37.

Trudinger, David (2010), 'Demythologising Flynn, with love: Contesting missionaries in Central Australia in the twentieth century', in F. Peters-Little, A. Curthoys, and J. Docker (eds), *Passionate Histories: Myth, Memory and Indigenous Australia*, Canberra: ANU Press.

Turner, Margaret Kemarre (2010), *Iwenhe Tyerrtye – What It Means to be an Aboriginal Person*, Alice Springs: IAD Press.

Williams, Michael (1997), 'Ecology, imperialism and deforestation', in T. Griffiths and L. Robin (eds), *Ecology and Empire: Environmental History of Settler Societies*, Edinburgh: Keele University Press.

Notes

1 The 'Red Ways' project ran intermittently in Alice Springs between 2007 and 2011. Initiated by the Uniting Church, it became an integral part of the Alice Springs Revitalisation project supported by the Northern Territory Government and the Alice Springs Town Council. An urban design renewal strategy developed by Design Urban, Clouston, Sue Dugdale and Associates and Material Thinking was delivered in 2011.

2 In somewhat Heideggerian terms, Rosen states that the 'opening' is 'neither the present, the past, nor the future [but] the founding of the presence as the atemporal condition that makes possible the articulation of past, present, and future'.

3 Media attention to the violence in the Aboriginal town camps is a source of local frustration. For a historical account of the camps and the context of the difficulties they presently face, see the still useful thesis by Coghlan (1991).

4 Michael Williams (1997: 169–184, 172) quotes Isaac Weld, commenting on the American forest clearances: 'They have an unconquerable aversion to trees'. Identical observations, albeit put less succinctly, are common in the Australian literature.
5 Until recently, this remark and the discussion it stimulated could be viewed at www.connectingalice.com.au, the public information resource established by the Northern Territory Government to communicate the project's findings. At the time of writing, however, we understand that the Alice Springs Town Council has ordered that the site be removed from the Web. Mrs Stewart's remark raises the question of what happens when sacred trees die naturally. According to Strehlow (1971: 573–777), the spirit essence of the site, which the tree incarnates, remains at that site and migrates to new trees growing at that site.
6 See note 5.
7 In this context, the word evokes something like a creative region: bigger than the father's homeland: 'Dreams and stories and trees and songs and animals and ceremonies, all holds in that one big patch, that *apmereyanhe*, just in that one big country-ground it holds the whole pile. And *utyerre* holds all those people together to do all those things, to make all those things, to get all those things, and to make it happen, and to keep it happening, so it just goes on and on and on' (18).
8 However, note that Yawuru people interpret the pearl shell as 'the essence of water' (275).
9 The original brief had invited us to create a 'Federation Square in Alice Springs', by which was meant a meeting place design modeled on the precedent set by 'Nearamnew' at Federation Square. It is a matter of regret that these aspirations were ignored by the government agencies charged with 'delivering' the project. All stories were eventually eliminated, with predictable effects on the creative communities who had given their knowledge and time so generously.
10 Although 'cellular', the influence of the *altepetl* was pervasive throughout the 'cells' and indeed circulated between them (Lockhart 1999: 102).

Chapter 2

Creative and Destructive Communities of Lake Condah/Tae Rak, Western Victoria

Louise Johnson
Deakin University

> Lake Condah is the heart of Gunditjmara country […] we have always been with the lake and it has always looked after us […] if the lake is good then we are good […] we have been different since the lake was drained by authorities but with water soon to return, we will achieve an important healing for the country and for ourselves.
> Ken Saunders, Gunditjmara Elder, quoted by Bell and Johnston (n.d.)

Introduction

The Indigenous peoples of Australia have long occupied the entire continent, moving across it, but also connecting to particular country. Initially estimated to number around 750,000 (Aboriginal Heritage Office 2013), in 2011 the Aboriginal and Torres Strait Islander population numbered only 548,000, with most living in the Northern Territory. The southeastern state of Victoria had the lowest proportion of Indigenous peoples in 2011, at only 6.9 per cent of the nation's Indigenous population and 0.7 per cent of the population of Victoria. Nearly half of these Indigenous peoples living in Victoria lived in the capital city of Melbourne; the remaining 52 per cent, or 19,683 people, lived beyond the city, in the regions (Australian Bureau of Statistics 2011). It is in regional Victoria that the few successful claims on land by Aboriginal residents – to secure less than 1 per cent of the state (www.home.vicnet.au) – have occurred. These claims register the resilience of these communities and the interconnection of their histories with more recent recognition and restitution systems. One of these important victories occurred in western Victoria, around the old reserve and mission at Lake Condah. Lake Condah, or Tae Rak, is part of Budj Bim country, occupied by the Gunditjmara. Its history exemplifies the story of one cultural landscape meeting, but also interconnecting with, another community that was both destructive and creative. Thus, the story of this lake is not only one of creativity – in making enduring landscapes and communities – but also one of connectivity – between Indigenous people and the resources of their country, as well as between Indigenous and non-Indigenous people and their different world views.

In contrast to many other Indigenous groups, the Gunditjmara oversaw an elaborate system of water management, semi-permanent dwellings and eel farming, which left distinctive imprints and stories on an already unique volcanic landscape. The subsequent history of colonization saw the decimation of this Indigenous population through disease

and violence, the destruction of food sources, land seizure and their spatial confinement on government reserves and church missions. As pastoralists occupied the lands, swamps and lakes were drained and the technologies of commercial land use were imposed. From the 1880s until the 1950s, drains were cut through the deep sediments of Lake Condah to extend grazing, destroying a vital part of the Indigenous cultural landscape and registering on this land the impacts of a destructive colonizing community.

Despite a declining population and spatial confinement, the Gunditjmara presence in this country did not disappear. Rather, it was asserted during the Eumerella Wars of the 1840s on the mission and in adjacent dwellings, as well as through ongoing demands for dignity, autonomy and recognition. This can thus be understood as an actively negotiated contact zone. However, new factors continued to be added to the Gunditjmara cultural landscape, as explorers, government officials, pastoralists and farmers occupied their lands. Later, scientists, historians and archaeologists imposed their readings upon the land, which on occasion intertwined with those of the Gunditjmara. The result was that this territory would come to be celebrated for its geological and historical uniqueness, aesthetic beauty and built forms, as well as for its commercial potential and heritage value. Given priority during colonization, these creative but destructive communities and meanings initially overrode, but did not obliterate, those of the Gunditjmara, who have continued to assert their presence, rights to occupancy and meanings in this landscape. Here then is a contact zone across which was negotiated a complex array of Indigenous and non-Indigenous cultural landscapes (Pratt 2008).

Within a broader context of 1960s Indigenous challenges to exclusion from lands, citizenship, rights and wealth (Clark 2008; McGregor 2009; Morris 2013), the Gunditjmara launched successful claims for their ongoing presence to be formally recognized within new legal frameworks: first by a challenge to the Alcoa aluminium plant at Portland via an amendment to the Victorian Aboriginal Land Act (1987) and then by a Native Title determination in 2007 (*Gunditjmara People v State of Victoria* 2007), along with a number of co-management agreements, an Indigenous Land Use Agreement and recognition under the Aboriginal Heritage Act 2006 (Vic) of the Mt Eccles eel traps. The Gunditjmara are now conceiving their future through the further mobilization of the area's cultural heritage by making a claim for World Heritage recognition. In preparing a case that meets the demanding criteria for 'Universal Value', the role of their creative community that has occupied and imprinted their meanings onto this landscape is critical. In this sense, it remains the lands of the Gunditjmara, a creative community registered in and through the people and their cultural landscape. However, the terms of this recognition also take in the nature of the contact zone interactions and interconnections, as the landscapes of colonial conflict – both actual and legal – become part of the claims.

The following account will consider a series of historical transects across this landscape, particularly those that have received recognition under the Australian national heritage regime. In the 2004 National Heritage Listing of the Mt Eccles/Lake Condah area, the Budj Bim creation story, the eel management complex of water races and stone villages,

the volcanic resistance landscape and the legal procedures by which the landscape was formally recognized in 1987 were acknowledged as moments of 'outstanding heritage value' (Commonwealth of Australia Gazette 2004; Jones 2011). These moments will be detailed where possible through the words of contemporaries and can be conceptualized as key intersection points across the contact zone.

Budj Bim Dreaming

For Indigenous Australians, each country has a boundary and sacred origins in ancestral beings who create all animate and inanimate things. These Dreamings are written in the land and are known through traditions, story and cultural practices:

> Spiritual associations to country arise from the activities of creation beings at particular places. Through story and totems, the land, the people and other species are connected together in a complex web of meanings, responsibilities and reciprocities […] This Dreaming is ever-present. It is not a past time or a past event that has concluded.
> (Bell and Johnston n.d.)

However, these Dreamings can be damaged as well as restored. For the Gunditjmara, the creation story for their country has not disappeared or receded into the past; it is registered in the land and remains ever-present. As an outsider, I cannot know its full extent, but published summaries provide some insight into the story that animates the Budj Bim landscape and its people:

> At the dawn of time, it was the ancestral beings – part human, part beast – who brought what was previously barren land to life. At the end of their Dreaming journeys, the ancestral beings left aspects of themselves behind transformed into part of the landscape. To the Gunditjmara people, Budj Bim's domed hill represents the forehead of one such being, with the lava spat out as the head burst through the earth forming his teeth. […] Only the law man of a clan can stand on top of Budj Bim. From there he can trace a straight line of peaks from Serra Range at Gariwerd (the Grampians ranges) to Cape Bridgewater on the coast. These sites mark the journey of the creator beings. To the south off the coast, the forbidding cliffs of Deen Mar (Lady Julia Percy Island) guard the final resting place of the spirits of Gunditjmara people when they die. To the north is Tappoc (Mt Napier) and in the far distance Muttt Te Tehoke (Mt Abrupt).
> (Gunditjmara people with Wettenhall 2010: 7)

For those coming to this landscape in western Victoria with different traditions and languages, the landscape can be read as having registering a series of volcanic eruptions from 30,000 years before the present, until the last one around 6000 years ago. These eruptions

spilled lava across the underlying limestone, disrupted the flows of the area's rivers and creeks (Grimes 2004) and created Mt Eccles and the scoria lava flows known as the stony rises. On reaching Darlot Creek, one lava flow formed a blocky ridge, damning the valley to form the Condah and Whittlebury swamps (Gunditjmara people with Wettenhall 2010: 8).

Dreaming stories are often privileged when the long history of a landscape is presented to then disappear as the era of written/white history arrives, yet they clearly persist here. It was this persistence and the clarity of the story that was specifically singled out in the 2004 Heritage Listing of the site as 'the line between the eruption of the volcano and Budj Bim is of outstanding heritage value as a demonstration of the process through which ancestral beings reveal themselves in the landscape' (Commonwealth of Australia Gazette 2004). The geological account has direct parallels to and affirms the Gunditjmara creation story. The two can be comfortably interwoven and connected to specify events, dates and landscapes. However, if the area around Lake Condah – or Tae Rak – were brought into being by massive forces emanating from the earth, it was subsequently modified by the humans who then occupied it. More recently, within a regime that acknowledges cultural heritage, this was a creative exercise that left particular and unique impressions on the landscape, to be subsequently recognized as constituting 'outstanding heritage value'.

Engineering Tae Rak and the Budj Bim Landscape

The Dreaming not only created the major landscape features, but also the resources that could then be mobilized to sustain human life. As Gunditjmara Elder Eileen Alberts notes:

> In the Dreaming, the ancestral creators gave the Gunditjmara people the resources to live a settled lifestyle. They diverted the waterways, and gave us the stones and rocks to help us build the aquaculture systems. They gave us the wetlands where the reeds grew so that we could make the eel baskets, and they gave us the food-enriched landscape for us to survive.
>
> (quoted in Gunditjmara people with Wettenhall 2010: 7)

Damein Bell and Chris Johnston (n.d.) further note:

> Through a weir lower down on Darlot Creek, Gunditjmara managed the water flows through a system of wetlands from Condah Swamp, Whittlebury Swamp and Lake Condah; together these wetlands cover 500 hectares (5 square kilometres). Within Lake Condah and in other wetland areas towards the coast, Gunditjmara created extensive aquaculture systems to harvest eels and fish. In Lake Condah itself, these stone and earth structures – weirs, races, canals, walls – enabled active management of water flows and effective trapping using woven nets. Use of deeper pools suggests that eels and fish were held over extended periods, enabling extended use of this resource.

The resulting landscape is remarkable in many ways, for it registers the elaborate and sophisticated engineering works that were associated with canalizing water at different levels for the harvesting of migrating eels, as well as the stone-based semi-permanent dwellings that were established alongside them. Archaeologists and anthropologists have long studied these works, confirming their human origins and their areal extent and longevity, with dates ranging from 500 to 7000 years before the present day (Coutts et al. 1978; Lourandos 1976, 1977; McNiven 2009). For her doctoral research, Heather Builth (2002) reconstructed the historic water levels of Lake Condah and dated hollowed out trees in this area, including one where the evidence of eel smoking indicated that this bounty supported gatherings of up to 10,000 people, who would have been drawn from a vast area. Based on this, it can be argued that this resource allowed social connections to be made well beyond this region. Builth also found an artificial system of ponds and canals covering more than 75 kilometres. This was a gigantic aquaculture system that both sustained the local community and enabled connections with many others. With its facilities to procure, preserve and store eels, Builth claimed that the pre-contact Aboriginal people who utilized the Mt Eccles stony rises 'had the means to be sedentary' (Builth 2002: 310–312). She recorded over 150 stone dwellings with patterns so uniform that she concluded they could only have been stacked there by humans (Builth 2002: 255; 2004; Builth et al. 2008).

Across the lands adjacent to what was later called Lake Condah then is an elaborate set of engineering works and the foundations of dwellings, grouped together in unique constellations (Gunditjmara people with Wettenhall 2010). Hundreds more of these structures have been recorded across Gunditjmara country by archaeologists since the 1970s. Interpretation of them has varied widely. Some archaeologists see these sites as clusters of 'houses', occupied simultaneously to form 'special camps' or semi-permanent settlements inhabited by hundreds of people (Builth 2002; Coutts et al. 1978: 38; Lourandos 1976; Williams 1987). Others have suggested that they might be the remains of relatively short-term camp sites (Wesson 1981: 76), windbreaks, hunting blinds or day camping places (Clarke 1994: 10). For others more sceptical, these stone circles are the outcome of natural processes of lava flow and tree growth (Clarke 1991; Lane 2008a). Some local landowners believe that the structures are of European construction and have dismantled them both to clear their fields for other uses and to utilize the stone for fencing and sale (Lane 2008b: 2).

While such debate rages among academics, for the Gunditjmara, there is no doubt as to what the various landscape features indicate. Their stories call this landscape into being in a particular way. In 2008, I was taken by Elder Eileen Alberts to the Allambie property just south of Lake Condah. Here, Eileen walked me in a vast circle, along pathways that edged canals and traversed bridges, which in turn were dotted by groups of round stone circles. Adjacent to each other, in clusters of two, three and more, some even had common walls, making a terrace in a suburb, as Eileen cheekily explained. For her and other Gunditjmara, there is no question that what we were seeing was an ancient and long-occupied site of permanent habitation, where hundreds if not thousands of their forebears had lived and made skilful use of the aquaculture system that was all around us. The imprint of this creative

Lourandos, Harry (1977), 'Aboriginal spatial organisation and population: South western Victoria reconsidered', *Archaeology and Physical Anthropology I: Oceania*, 12(3), 202–225.

McGregor, Russell (2009), 'Another nation: Aboriginal activism in the late 1960s and early 1970s', *Australian Historical Studies*, 40(3), 343–360.

McNiven, Ian (2009), 'Archaeological excavations at Muldoons Fishtrap complex, Lake Condah', *Cultural Heritage Report Series* 50, Report to Winda Mara Aboriginal Corporation and Gundij Mirring Traditional Owners Aboriginal Corporation, Clayton: Monash University.

Mignolo, W. (2007), 'Delinking: The rhetoric of modernity, the logic of coloniality and the grammar of de-coloniality', *Cultural Studies*, 21(2/3), 449–514.

Mignolo, W. (2009), 'Epistemic disobedience, independent thought and decolonial freedom', *Theory, Culture and Society*, 26(7/8), 159–181.

Morris, B. (2013), *Protest, and Rights and Riots: Postcolonial Struggles in Australia in the 1980s*, Canberra: Aboriginal Studies Press.

Pascoe, Bruce (2007), *Convincing Ground: Learning to Fall in Love with Your Country*, Canberra: Aboriginal Studies Press.

Porter, Libby (2013), 'Co-existence in cities: The challenge of indigenous urban planning in the 21st century', in R. Walker, T. Jojola, T. Kingi and D. Natcher (eds), *Reclaiming Indigenous Planning*, Montreal: McGill-Queens University Press.

Pratt, Mary-Louise (2008), *Imperial Eyes: Travel Writing and Transculturation*, New York: Routledge.

Reynolds, Henry (2003), *The Law of the Land*, Camberwell, Victoria: Penguin.

Wesson, J.P. (1981), 'Excavation of stone structures in the Condah area', Unpublished Masters preliminary thesis, La Trobe University, Melbourne.

Williams, Elizabeth (1987), 'Complex hunter-gatherers: A view from Australia', *Antiquity*, 61(232), 310–321.

Wiltshire, J.G. (1975), *A People's History of Portland and District. Section One. The Aborigines*, Portland: E. Davis and Sons, accessed 4 August 2013, available at www.home.vicnet.au

Chapter 3

Creativity and Attenuated Sociality: Creative Communities in Suburban and Peri-Urban Australia

Mark Gibson
Monash University

Saturday night, no subway station
Saturday night just changing TV stations
I'm just a Suburban Boy, just a Suburban Boy
And I know what it's like
To be rejected every night
And I'm sure it must be, easier for boys from the city
<div style="text-align: right;">Dave Warner, 'Suburban Boy', 1978</div>

A Law of Creative Concentration?

Dave Warner's 1970s rock classic, 'Suburban Boy', gives voice to a familiar experience in the Australian suburbs of distance and alienation from the city. In Warner's case, this experience is made especially poignant by the fact that he came from Perth, famously the most isolated city in the world. The distance in question is not only a distance from the immediate urban centre – a city, which has always suffered, in any case, from doubts about whether it properly qualifies for the term. It is also a distance, more generally, from the global metropolis: an 'elsewhere' of possibility and plenitude that can only be imagined. As Jon Stratton (2008: 618) observes, 'Warner's lyrics reflect a preoccupation with, and ambivalence towards, the suburbs that is not present in the music of the inner-city Alternative Rock bands in the other cities'. Yet Warner also expressed a widely shared predicament for those with creative aspirations in a nation whose dominant pattern of settlement is overwhelmingly suburban.

It is not only creative practitioners themselves who have seen a suburban location as a disadvantage. If Warner imagines that 'it must be easier for boys from the city', this has also been a frequent theme in the now considerable body of scholarly writing on the cultural geography of creativity (Landry and Bianchini 1995; Hall 2000; Scott 2000; Chapain et al. 2010). Much of this work has borrowed from a wider literature in economic geography on the benefits of spatial agglomeration. The idea of the 'cluster' has seemed particularly relevant to understanding the development of creative industries, as the framework within which it has been developed is one that has focused on innovation: a term that can easily be associated with creativity. In Michael Porter's (1990) influential theorization, business success is no longer determined by cost advantages gained through proximity to cheap resources or labour, but by continual development of new approaches in the way that inputs are processed or deployed. The capacity to innovate is enhanced by proximity to others with

whom it is possible to share knowledge and ideas, creating a business imperative for spatial concentration. Those who do not participate in a cluster lose connection with the leading edge of innovation and risk being left behind.

As cultural development has come to be understood under the rubric of creative industries, the model of business clusters has increasingly been mapped onto the cultural domain. If new forms of creative expression are considered for the economic benefits they deliver, then they can be considered as business innovations, opening them to types of analysis applied to other kinds of business activity. The idea that spatial concentration is important for cultural development has been given weight by some excellent studies of cases where it does indeed appear to have been important (for example, Leadbeater and Oakley 2001). It has been further strengthened by theoretical elaboration on the importance of spatial proximity in the transfer of 'tacit knowledge' (Desrochers 2001) and additional arguments such as on the role of lifestyle magnets for the 'creative class' (Florida 2002).

The result has been a convergence of views around what I have elsewhere called a 'law of creative concentration' (Gibson 2011: 527): a law according to which the prospects for creativity increase in proportion to density of population. As applied to the suburbs, this proposition can also draw on widespread representations of the suburbs as culturally monotonous, unoriginal and unexciting. The best-known popular example of this may be Malvina Reynolds' 'Little Boxes', made famous in the 1960s by Pete Seeger. The classic statement in scholarly writing is probably Lewis Mumford's withering description of American suburbia in his monumental study, *The City in History*:

> a multitude of uniform, unidentifiable houses, lined up inflexibly, at uniform distances, on uniform roads, in a treeless communal waste, inhabited by people of the same class, the same income, the same age group, witnessing the same television performances, eating the same tasteless pre-fabricated foods, from the same freezers, conforming in every outward and inward respect to a common mold, manufactured in the central metropolis.
>
> (Mumford 1961: 486)

Australia, which has competed with the United States for the status of the world's 'first suburban nation' (Davison 1995), has developed its own rich tradition of anti-suburbanism: from Robin Boyd's (1960) *The Australian Ugliness* and the 'Godzone' debate in the literary journal *Meanjin* in the 1960s (Ashbolt 1966), to contemporary critics of suburban 'McMansions' and outer-suburban sprawl (see Powell 1993; Ferber et al. 1994; Turnbull 2008; Flew 2012).

However, there are good reasons for questioning the idea that the suburbs are a dead zone for creativity. In Australia, a considerable volume of cultural production has either come from the suburbs or has developed from a base of suburban themes and references. From Warner's 'suburban rock' to Kylie Minogue, from *Neighbours* to *Kath and Kim*, the suburbs have proven a fertile terrain of creative possibilities. There are particular reasons in Australia for engaging with this terrain: given the suburban nature of the country's pattern

of settlement, it is a matter of national interest. If the suburbs are incapable of creativity, then it would almost follow that so too is Australia. Other reasons have wider relevance. Understanding creative practices in the suburbs helps us to refine our understanding, generally, of the cultural geography of creativity. It requires us specifically to question the law of creative concentration, alerting us to alternative spatial logics where it does not apply.

I want to suggest in this chapter that creativity in socially attenuated spaces needs to be understood differently from that which takes form in socially concentrated spaces such as clusters and inner-urban zones. While I will present the case with reference to Australian suburbia – or more specifically *outer* suburbia – the argument also has relevance to the regions. From the perspective of the regions, the suburbs may sometimes appear as simply part of the urban metropolis and therefore what the regions are defined *against*. Social attenuation is also clearly relative. From the perspective, say, of western Queensland or the Pilbara, it may be difficult to think of the outer fringes of Sydney or Melbourne as socially attenuated. However, the relevant distinctions, I will argue, are to be made not just in terms of geographic distance or absolute population densities. More important is the way in which distance regulates social encounters, particularly in defining 'insider' and 'outsider' status in relation to significant inner-urban sites, where metropolitan taste and identity are formed. By this criterion, the structural location of the outer suburbs may be closer to the regions than to the inner-urban cores of the cities to which they belong.

Creative Suburbia

In developing this argument, I am drawing on research conducted for 'Creative Suburbia', an interview-based study of creative practitioners in the outer suburbs of Melbourne and Brisbane. The project, completed in 2011, was conceived as a critical response to the inner-urban bias of much of the recent literature on creative places and spaces, particularly that which has been inspired by Richard Florida's (2002, 2005) identification of creativity with buzzing downtown zones with high 'gay' and 'bohemian' indices. It set out to add some flesh to indicative statistical evidence (Gibson and Brennan-Horley 2006) that there are in fact significant numbers of creative practitioners in the suburbs. The project team conducted 133 interviews with outer-suburban workers in occupations falling within the Creative Industries National Mapping Project's six-category definition of creative industries: film, television and entertainment software; writing, publishing and print media; advertising, graphic design and marketing; architecture, visual arts and design; and music composition (Higgs et al. 2007).

In adopting this definition, 'Creative Suburbia' took a broad view of 'creativity'. This approach has attracted some criticism for running together too many different kinds of practices. For Susan Galloway and Stewart Dunlop (2007: 28–90), for example, the concept of the creative industries is 'rather like a Russian doll; once the layers are discarded at the heart it appears an amorphous entity with no specific cultural content at all'. It is certainly the

case that there is considerable definitional confusion around the arts, cultural and creative industries. It is also important to recognize that there are significant differences between, say, music and writing as well as between practices that might be defined as 'art-making' and more commercial activities such as publishing, advertising or graphic design. 'Creative Suburbia' took the view that it is nevertheless productive to group these areas in considering their place within the wider economy. For many critics of the creative industries paradigm, definitional confusion around the term betrays a basic theoretical weakness. However, as Stuart Cunningham (2011) has argued, it can also be seen more positively as a 'ferment' associated with attempts to grasp and understand important phenomena that are still in the process of emerging.

The Creative Industries National Mapping Project has not been merely a neutral descriptive exercise, proceeding according to established and well-understood categories. It has emerged as part of an attempt to develop an evidence base to support policy advocacy for a diverse range of small organizations involved in cultural production but unable to rely entirely on government support. As Cunningham (2011: 49) puts it, 'this is a sector running on tight margins and facing high rates of failure, in need of flexible and in many cases experimental forms of state facilitation, and which rarely figures on governments' cultural policy radar'. If the priority was only to maximize analytical precision, one would focus on specific areas of cultural activity – just live music, for example, or just visual arts and design. There would be a loss in this, however, for the more general argument about the collective cultural and economic contribution of small-scale cultural innovation. 'Creative Suburbia' was framed by the latter project and deliberately adopted a broad definition of creativity. It sought to identify general structural factors affecting the development of creative enterprises in the suburbs across a range of fields.

There are also questions of definition around 'suburbs' and 'suburban'. In Australia, the word 'suburb' is sometimes used to refer simply to any local area within a metropolis. In this sense, even areas very close to the centre of the city – for example, Carlton or Fitzroy in Melbourne or New Farm or the West End in Brisbane – could be described as 'suburbs'. In 'Creative Suburbia', however, the meaning used was a more standard international definition of 'the outlying parts of a city'. In fact, the project restricted itself to sites that fitted this definition in quite a strict sense: Frankston, Dandenong and Caroline Springs in Melbourne and Redcliffe, Springfield and Forest Lake in Brisbane – all between 20 and 30 kilometres from the city centre. In many countries – particularly in Europe – anything at such a distance would be defined as beyond the city altogether. However, in Australia, even more than in North America, the capital cities cover sprawling geographic territories with relatively weak and ill-defined boundaries between their outer edges and the surrounding regions.

The term 'peri-urban' is sometimes used to capture these ambiguous zones. It has gained particular currency in relation to developing countries of the Global South, where a rapid influx of rural populations into cities and the development of built-up pockets in the country have confused the distinction between 'urban' and 'rural' (Simon et al. 2006). However, it is also applicable elsewhere. As Buxton et al. (2006) suggest, it is productive to consider the

fringes of Australian cities as peri-urban zones in which there is a dynamic and constantly changing relation between the metropolis and its rural and regional surrounds. As they point out, suburban development begins as peri-urban development. 'Peri-urban development is thus closely connected with suburban development and cannot be understood without an understanding of the relationships between these landscapes and nearby metropolitan areas' (Buxton et al. 2006: 2). It should perhaps be added that the outer fringes of metropolitan areas equally cannot be understood without understanding their relationship to the regions.

The findings of 'Creative Suburbia' have been reported elsewhere (Felton et al. 2010; Flew 2011; Gibson 2012; Collis et al. 2013) and there is not space to repeat them in detail here. The major overall conclusion was that the outer suburbs can and do provide positive environments for creative work. An obvious dimension of this is simply cost. As inner-urban rents and property prices have spiralled over the past twenty years, the city has become increasingly unaffordable for creative workers, who often survive on relatively low incomes, particularly in the precarious early stages of developing a career. The city and suburbs are not absolutely opposed, nor do they represent entirely different kinds of people. Many of the interviewees had moved between them. A common and unsurprising pattern was one in which people had spent some time in the city as students or young singles before moving to the suburbs in later adulthood.

It would be a mistake, however, to see creative practitioners as 'exiles' in the suburbs, forced out from the city as a place to which they longed to return. When asked about their ideal place to live, a majority of the interviewees did not indicate a desire to move closer to the city. Indeed, a significant proportion was attracted by the idea of moving further out, to a rural or regional location. Many stated positive reasons, apart from cost, for living in the suburbs – including an ability to combine work and family; closeness to beaches, bays or other sites of natural amenity; peace and quiet; and a certain freedom to pursue their own creative direction without feeling they had to follow the latest trends in inner-urban fashion or style.

A common theme among those who had moved from the city to the suburbs was a surprise in discovering an interest there that they had not at first expected. One of the more dramatic cases of urban-suburban displacement was a film-maker who had moved from Elizabeth Bay in Sydney to Goodna in the outer suburbs of Brisbane, a move that was made for a combination of family and financial reasons. As he described it, Elizabeth Bay was almost the paradigm of a creative cluster. He had mixed with the likes of Jane Campion, Baz Luhrmann, Russell Crowe, Murray Bale and Helen Garner:

> I had a little office in a building called Minton House where John Polson, who is now a film director in America, started Tropfest. He started it in a small room opposite my own small room. Down the corridor were editing suites, around the corner was another film producer. There was a music company […] and now they are doing huge things, you know. Editing rooms, all half baked and low tech, you know, and put together, but energetically striving towards something.
>
> (Film-maker, Springfield)

This interviewee confessed to missing all this 'incredibly' on moving to suburban Brisbane: it was 'like going to, you know, Sleepy Hollow, you know, it was like *asleep*'. But over time, he also learnt to find a certain quirky appeal to the suburbs:

> I think there's an opening in this area, some beautiful little nooks and crannies and funny houses and funny lifestyles and stories […] I mean, I like stories, you know. I like characters and stories and I see people around and I think, 'God, look at that little life', you know. He's the plumber and she's the ambulance bearer […] And I see little houses people live in and funny little back streets and ramshackle houses and funny little blocks of flats and grumpy ashamed people, you know? And you think, there's something going on here.
>
> (Film-maker, Springfield)

This kind of discovery often extends to surprise at how many other creative practitioners there are in the suburbs. As a textile designer put it after moving from the city to Redcliffe in outer Brisbane:

> Yeah, more and more I'm amazed at who does live in suburbia. And how unnoticed they go like. Sometimes I think, if I can miss you, if I never knew that you lived here […] like […] how many *other* people live here that I don't know?
>
> (Designer/textile worker, Redcliffe)

My focus here, however, is a little more theoretical. I want to address a question that emerges once it is established, at least, that there *are* creative practitioners in the suburbs: To put it baldly, how is it possible that they exist? How are we to understand the nature of suburban creativity when so many of our explanatory models tell us that it must always be disadvantaged against inner-urban forms? It is not enough to see suburban creative practices as simply a residue or leftover – a kind of accidental extra to those that have been theorized in relation to the city or other sites of concentration. A more positive account is needed of how they take form.

'To Go into Solitude…'

A good starting point here is to consider a historical case in which the assumed relation between creativity and social concentration was not only challenged, but completely reversed: the case, that is, of Romanticism. It was without question for Goethe and Schiller, for Wordsworth, Keats, Coleridge and Shelley, for Emerson and Thoreau, that creative inspiration requires a certain removal from society, that it is precisely in *leaving* the city that artistic stimulation is to be found. Emerson's 1836 essay *Nature* is exemplary:

To go into solitude, a man needs to retire as much from his chamber as from society […] Crossing a bare common, in snow puddles, at twilight, under a clouded sky, without having in my thoughts any occurrence of special good fortune, I have enjoyed a perfect exhilaration. I am glad to the brink of fear. In the woods too […] is perpetual youth. Within these plantations of God, a decorum and sanctity reign, a perennial festival is dressed, and the guest sees not how he should tire of them in a thousand years. In the woods, we return to reason and faith.

(Emerson 1849: 5–8)

This orientation outward, away from urban concentrations, should not be mistaken for a rejection of social contact as such. Emerson's essay clearly has a social address. It might be *about* Nature, but it is intended for human readers who can recognize and respond to his ideas. The point is rather that the sociality in question is *attenuated*: it is one in which social agents are dispersed at such a distance that contact can only be sustained through mediated communication – in this case, writing.

Many of the qualities we associate with Romanticism can be related to this social condition. Remoteness and distance give creative expression a heightened emotional intensity. The thinness of the conduit, a mere line of marks of ink on paper, calls forth a compensating focus and passion in the act of communication. Just as the poetry of love letters would appear excessive or overwrought if spoken directly, the smouldering power of Emerson's prose is difficult to imagine in any other medium than writing. Social attenuation also amplifies the role of the imagination. That which is not immediately present, which is only partly known, invites the mind to complete it. On one side, the writer must imagine the receiver; on the other, the receiver must imagine the writer. Both construct a picture of the other on the basis of the incomplete fragments available to them.

There are more than a few leads suggesting a transposition of this analysis to the suburbs. A significant proportion of suburban creative practitioners could be described, in some sense, as 'romantics'. As mentioned above, many of the interviewees for 'Creative Suburbia' cited closeness to nature as a factor in their choice of location. This was particularly marked in suburbs near to natural attractions such as the Mornington Peninsula in the case of Frankston on the outer edge of Melbourne, or Moreton Bay in the case of Redcliffe in Brisbane. In some cases, the suburbs were conceived in classically romantic terms as retreats from the imagined noise, crowds and social pressures of the city. For an architect from Frankston, you are an 'ant' in the city:

you lose your uniqueness, you lose your individuality, you lose your creativity as it were. And your creativity, whatever your creativity is, tends to have to conform to a pattern. And the pattern is dictated by the mould around you, you know? Rather than creating your own mould, you have to conform to the mould that's established by the environment around you. And that's the sad thing about big cities.

(Architect, Frankston)

The suburb emerges here in strikingly Emersonian terms as a flight towards nature. The access to trees and mountains is inspiring: 'It's exhilarating, tremendously [...] it's like being surrounded by the stars [...] it's inspirational' (Architect, Frankston).

However, the comparison with Romanticism is of limited value if we look only for references to nature or stylistic features we might associate with Romanticism in its classical form. Some of the creative output of the suburbs is about as far from Emerson's snow puddles or Wordsworth's daffodils as it is possible to imagine. To focus only on nature-inspired architecture or creative writing would be to ignore the thrash metal guitarists, body artists, software designers, three-dimensional modellers for the automotive industry and graphic designers for the engineering, manufacturing and construction markets – all of which were well-represented types in the research for 'Creative Suburbia'. As one graphic designer put it when asked if he found any creative stimulus in the area: 'I stare at a 22-inch monitor for 6–8 hours per day. Apart from my kids' drawings on the wall, I don't have much else!' (Graphic Designer, Frankston).

As Robert Bruegmann (2005: 23) has pointed out, as far back as ancient times, the suburbs have been a contradictory zone. Outside the walls of Rome, in the area then known as *suburbium*, were two very different kinds of activity. Close to the sea or the cool hills to the east near Tivoli and Frascati were the elegant villas of wealthy Roman families, escaping the noise and stench of the city; alongside these were an eclectic range of industrial and service activities and the poorly built dwellings of those who could not afford the security of living within the walls. Similar contradictions can be observed today in suburbs like Frankston, in the co-existence of million dollar mansions to the south overlooking the bay and low-cost government housing to the north – with a jumbled assortment in between of car yards, civic spaces, graffitied public transport facilities and shopping malls. Unlike the countryside proper, it has always been ambiguous whether the suburbs are an escape from the city or, on the contrary, a zone where many of its excesses are revealed.

Thrash Metal Romanticism

I have suggested elsewhere (Gibson 2011, 2012) that comparison between suburban creative practices and Romanticism may be productive if we shift the focus to the similarities in the structure of the social relations within which they have taken form. The argument draws from the sociology of Norbert Elias, who developed an understanding of romanticism – here in the lower case – not as an aesthetic movement or specific set of ideas, but as a gradually unfolding series of counter-tendencies to processes of social-political centralization in the west since the Late Middle Ages (see particularly Elias 1983). The key historical development, for Elias, was the achievement by the state of a virtual monopoly over violence and taxation. At a political level, this required suppression by the sovereign of the warrior nobility, depriving them of the right to an independent resort to arms or the direct extraction of feudal dues. The process also involved a profound

cultural transformation, as those seeking to influence events learnt to achieve their ends by working indirectly through the apparatus of the state.

The initial forming ground for this transformation was, by Elias' account, the court, where the aristocracy learnt the arts of what we would now recognize as modern politics – of alliances and factions, of the strategic concealment of motives and of the subtle manipulation of social and political relations to advance personal ambition or other causes. Success at court required, above all, a control over the affects; that is, an ability to subordinate one's immediate impulses to social demands. This control was displayed not only in what was done or said, but also in a detailed stylization of manners, speech, dress and other aspects of social presentation.

Romanticism is understood, for Elias, in sociological terms, as a reaction to this development. It emerges first within elements of the nobility:

> [W]hen the assimilation of the nobility to the court was an accomplished fact, when court nobles looked down on the landed nobility with unconcealed contempt as uncivilized rustics, country life nevertheless remained an object of nostalgia […] Country life became a symbol of lost innocence, of spontaneous simplicity and naturalness. It became an opposite image to urban court life with its greater constraints, its more complex hierarchical pressures and its heavier demands on individual self-control.
>
> (Elias 1983: 215)

However, as processes of social-political coordination and centralization unfold, other classes find themselves in a similar structural location and other romantic tendencies emerge: 'The overall direction of [the] shift towards increasingly interdependent, larger and more complex human associations produces recurrent movements and situations of this kind' (217).

In this more abstract perspective, romanticism is not rooted inherently in a particular social class or historical period; it is a pattern that emerges recurrently in response to long-term processes of social-political integration and control – the establishment first of modern sovereign states and then of 'larger and more comprehensive centres of government and administration, the growth of cities, increasing monetarization, commercialization and industrialization' (217). Each wave of response to these processes has its own particular qualities. Courtly-romantic tendencies have 'certain peculiarities' that distinguish them from later bourgeois-romantic tendencies. Yet for Elias, 'there is no lack of common structural features that show them all to be manifestations of one and the same long-term change of the total figuration of people' (217).

The basic determinant in each case is a distance or alienation from centres of social-political regulation and control. This is associated with an outward orientation, away from sites of immediate social presence. In its paradigmatic eighteenth and nineteenth century versions, this was an orientation, as in Emerson, towards Nature. However, Elias more abstract sociological perspective allows recognition of other ways in which it can be expressed. The

thrash metal guitarist from Frankston might also be identified as 'romantic'. The one we interviewed for 'Creative Suburbia' clearly occupied a similar place within the social field. Rejecting the inner-Melbourne scene of music venues and local cognoscenti ('bands from Brunswick and trendy art school wankers' – Musician, Frankston), he oriented himself instead to a sparsely populated international horizon of those with similar music tastes.

Romanticism in this sense is a shifting node of cultural possibilities within ongoing processes of transformation. It is constantly re-defined in response to new geographies of centralization, dissolution and recentralization. The concentrations or 'scenes' against which it is defined are never permanent, being subject to shifts in demography, technology and economy, as well as more mercurial dimensions of fashion or taste.

This perspective brings attention to other romantic characteristics in suburban creative expression. One of the most obvious is the importance of themes of spontaneity and lack of inhibition. Many of the interviewees for 'Creative Suburbia' cited creative 'freedom' as one of the things they valued most about their location. For example, a photographer who had migrated from Europe and settled in Frankston waxed lyrical about the physical environment: 'we have a lot of nature and from nature we can create everything […] We don't need to imitate' (Photographer, Frankston). Another significant characteristic is sophistication in the use of media. It is no doubt true that there are few prose stylists in the suburbs of the quality of Emerson. They have been few at any time. However, much of the passion that was directed to 'letters' in the nineteenth century is now being directed to digital media and the Internet. Suburban home offices, bedrooms and kitchens are full of experimental blogs, mashups, electronic music compositions, games development and video-editing projects. Much of this is, of course, at the amateur end of the spectrum; however, as in the nineteenth-century culture of middle-class letter writing, it provides a base of creative development for significant contributions to emerge.

Towards Plural Models of the Cultural Geography of Creativity

The argument I have tried to make here is not as developed as most of those that have been made about creative cities and clusters. The theoretical base for understanding the relation between creativity and attenuated sociality is still relatively thin compared to that which can be called upon in analysing sites of creative concentration. Nevertheless, some conclusions can be drawn.

The most important is simply that we need to recognize significant differences between creative practices in the outer suburbs and regions and those that emerge from inner-urban sites of social concentration. The latter are too often taken to provide models of creative practice in general – models against which the suburbs and regions will always be found wanting. It is certainly true that suburban and regional creatives often suffer problems not experienced by their inner-urban counterparts – from isolation and lack of professional networking opportunities, to practical difficulties of transport or access to supplies and

other resources. However, remoteness and distance should not be seen *only* as problems; they should also be recognized as important conditions for at least certain kinds of creative practice. The point is not only that some forms of cultural expression *can* emerge in dispersed or attenuated social spaces; it is that there are forms that actually *require* them.

It should be noted that this is not an argument that geography does not matter. The case for recognizing the creative potential of outer-suburban, peri-urban and regional areas has been damaged by association with an early misreading of the cultural implications of the Internet as resulting in the 'death of distance' (Cairncross 1997; Negroponte 1995). A significant motivation for the geographic emphasis of much recent work on cultural and creative industries has been to counter overdrawn ideas that digital media have put all places on an equal plain. The strongest way to make this case has been to point to evidence of continuing logics of centralization and concentration in cultural industries. As an extensive literature has now established, the increasing availability and immediacy of communication has not lessened the significance of strategic geographic nodes of cultural brokerage and exchange. In this context, any claim for the potential of dispersed or attenuated forms of cultural production has tended to come under suspicion as ignoring the continuing material realities of space and place.

My argument here is that it is time we moved on from an insistence on the importance of geography as such – a general case that should by now be taken simply as our starting point – to a more open recognition of different *kinds* of geography. The dispersed or attenuated spaces of outer suburbs, peri-urban zones and the regions should be thought of not as some virtual terrain that escapes geography, but as specific geographic contexts for creative production. Certainly, media have a heightened significance in these contexts; mediated communication will always assume greater importance where immediate social contact is restricted by distance or social situation. As I have suggested above, much of the distinctiveness of creative production in socially attenuated spaces is in the intensity of investment in media. However, media also belong within a geographic matrix. They provide the means by which the suburban voice of a Dave Warner is articulated to other places and spaces. Our models of the cultural geography of creativity need to be expanded to recognize this kind of terrain.

Acknowledgements

I would like to acknowledge the Australian Research Council for funding the project (DP0877133) and my co-investigators Terry Flew, Christy Collis, Phil Graham, Emma Felton and Anna Daniel.

References

Ashbolt, Allan (1966, December), 'Godzone – 3, myth and reality', *Meanjin*, 25(4), 373–388.
Boyd, Robin (1960), *The Australian Ugliness*, Melbourne: F. W. Cheshire.

Chapter 4

Learning from Inland: Redefining Regional Creativity

Margaret Woodward and Craig Bremner
Charles Sturt University

Introduction

This chapter is concerned with creativity in inland Australia and pays close attention to creative and innovative activity generated in regional and non-metropolitan settings. We argue that while the discourse about creative industries has been focused on global metropolitan cities, creativity (present but less visible) in regional and agriculturally dependent communities can be re-framed. To do this, we look at the scope and scale of the inland from the footprint of Charles Sturt University in regional New South Wales. Then, we refine our focus using the lens of the portmanteau word 'agri-tivity', which we have coined to describe the interface between creativity and innovation, markets, technologically advanced forms of production and high-value services in regional settings.

Historically, some of the strongest evocations of creativity and ingenuity in the national imagination have originated from inland Australia and its communities. Charles Sturt University's footprint is an inland one; the majority of its campuses are located in inland regional communities in the state of New South Wales, covering an area of approximately 800,000 square kilometres. This inland regional setting corresponds with and holds traces of the most celebrated (and contested) sites and characters of Australia's creative and cultural heritage. The Wiradjuri people, whose land the Charles Sturt campuses are built on, have occupied the land for many tens of thousands of years. Since European colonization, this inland region has also been the home of and inspiration for many of the country's most celebrated artists, poets, writers and film-makers.

Australia's inland regions fall into the quintessentially Australian category of imagined space known as 'the bush', a concept that has iconic status in Australian identity and is central to understanding the origins of contemporary regional communities. The bush, in physical landscape terms, describes a forested area of shrubs and trees. Colloquially, the term 'the bush' has come to refer to any region outside the major metropolitan cities. Attitudes towards 'the bush' are often couched in pejorative terms and reflect deeply entrenched assumptions that these areas are marginal and unsophisticated (Gibson 2010: 3). Perceptions of social and economic disparities between metropolitan centres and rural, regional and remote areas feature regularly in political debates on services, infrastructure and social inclusion (Cocklin and Dibden 2005; Argent et al. 2013). We argue that negative assumptions about the bush underpinned the lack, until relatively recently, of close scrutiny of Australian regional creative activity. This chapter provides a counterpoint to this absence and is intended as a contribution to the growing body of literature on regional creative industries and creative

regions in Australia (Gibson et al. 2010; Gibson and Klocker 2005; Gibson and Kong 2005; Lea et al. 2009; Luckman 2012).

Creative Regions

This chapter seeks to focus the discussion through the concept of 'creative regions' to better represent inland Australia as having multiple, diverse sites of creative ingenuity that extend back through generations prior to and post colonization. To open out the discussion of creative regions, a micro-view of the Snowy Mountains, a region of south-eastern New South Wales, will serve to locate this discussion geographically and historically and reveal the inherent creativity of this region. The Snowy Mountains are the highest mountain range in Australia, with Aboriginal occupation dating back over 20,000 years. Since the mid-1800s, the landscape has been modified to include livestock grazing, stock routes, land protected by national parks, ski-fields and tourism. This region has been the setting for ballads, including the famous ballad by Banjo Patterson, *The Man from Snowy River* (Patterson 1895), as well as films and paintings that loom large in the national imaginary through stereotypes of heroic stockmen, horses and shearing tallies of epic and mythic proportions (Dominy 1997). The drive to Tumbarumba, situated on the slopes of the Snowy Mountains with a population of around 1500 people, is a pilgrimage through a cultural landscape of ingenuity and traditions of 'making do'. En route, corrugated iron, windmills, water tanks, silos, shearing sheds and cattle yards punctuate the drive at regular intervals. Orchards co-exist with power schemes, vineyards, country town halls and churches, where the land is laced by power lines, fences and communication cabling. In many places, this settler landscape overlays and obscures the living cultural landscape of the traditional owners, the Wiradjuri people, who are the largest Aboriginal language group in New South Wales, and whose land was claimed for agriculture, forestry and power generation.

Also located in Tumbarumba is The Pioneer Women's Hut, which Donald Horne in *The Intelligent Tourist* regards as one of the world's best small community museums for its collection and celebration of everyday objects, gathered and made by local people. The project started in the 1970s when local women decided to collect objects 'so they could provide material evidence for quite a different legend of pioneering in Australia' (Horne 1992: 348). In this museum, objects such as kitchen utensils, furniture, packaged household products, clothing, patterns, collections of needlework, quilts and tablecloths can be handled and examined. Common among the collection are objects that have been repurposed and recycled, with hybrids emerging as farm life met domestic life. A cake mixer is an amalgam of mechanical parts of a milk churn, a beater (or is it a fly swat?) is constructed from bed springs, 'Wagga' quilts are pieced together from scraps of clothing during the Depression, furniture is made from kerosene tins. The household objects displayed function to protect, decorate, clothe, clean, kill and celebrate life in an alien and harsh environment to non-Indigenous 'pioneer families' settling in Australia in the nineteenth and twentieth centuries.

Depending on the time of year, the climate sharpens the lens through which the objects inside are viewed. A visit on days of extreme heat or cold brings the necessity of such inventions starkly into focus and adds a poignantly visceral perspective to the collection.

Herbert A. Simon in the *Sciences of the Artificial* writes that '[e]veryone designs who devises courses of action aimed at changing existing situations into preferred ones' (Simon 1969: 112). The collection of The Pioneer Women's Hut holds objects – some hand-crafted one-offs, others mass-produced – which are intelligibly designed responses to improving conditions. As such, it forms an important archive of design and social history. This modest community museum preserves a key chapter of Australia's early legacy of design and showcases exemplars of ingenuity, determination and innovation that reverse the metro-centric expectation that nationally significant design archives are only located in metropolitan museums and galleries. Importantly, museums such as The Pioneer Women's Hut provide a traceable lineage for design and creativity, becoming a reference point for a renewed interest in the vernacular and the homemade, nationally and internationally.

A recent touring exhibition, *Built for the Bush: Green Architecture of Rural Australia*, reappraises nineteenth-century rural building practices for their environmental suitability and use of traditional building materials, which are now reappearing in contemporary architectural design. The social lineage of vernacular design and craftsmanship rests solidly within the lives of rural communities, whose stories and practices circulate through what Appadurai (1988) calls the 'social life of things' and the meanings and values that accumulate through their everyday use. The creators of the majority of the 'things' in the Tumbarumba Pioneer Women's Hut would not identify as designers or creative workers; yet viewed as a whole, this is undeniably a body of 'creative' work that challenges us to broaden the aperture of current definitions of creativity and creative industries. These objects occupy the nexus of agricultural and creative activity and are the forerunners of a concept we describe as agri-tivity, which recognizes a range of existing creative activities that originate in agricultural communities but are unacknowledged in contemporary metropolitan definitions of creative industries. That inventive and creative communities have always existed is not at issue here; rather, the notion of agri-tivity provides us with a lens to recognize this practice as part of an adaptive social and historical continuum, founded on social inclusion and motivated by invention, design and change as distinct from 'art-making'.

Examining the contemporary interface between design, technology, innovation and agriculture reveals that sites of everyday life in inland Australia continue to be a source of ongoing invention and adaptation. The design impulse evident in objects from the past, such as the adaptation of a milk churn to become a cake mixer in the Tumbarumba collection, has parallels within the contemporary dairy industry. Challenges facing researchers in the dairy industry relate to labour and lifestyle on Australian dairy farms, focusing on releasing dairy farmers from the twice-daily regime of milking all year round. Projects such as the FutureDairy programme are investigating the application and impact of robotic dairies, which have already been commercially used in Tasmania and other parts of the world.[2] Meanwhile, the virtual agriculture genre of farming computer games has experienced a

attitudes to change, openness to creative and innovative thinking, and societal shifts as populations drift between coastal cities and rural 'islands'.

Regional Creativity

Returning the focus of this chapter to the regional footprint of Charles Sturt University, we ask what characterizes the contemporary creative landscape of New South Wales. At a meta-level, the recently released New South Wales State Government's *Creative Industries Action Plan* shows that New South Wales is home to nearly 40 per cent of the creative industries workforce in Australia (State Government of New South Wales 2013: 4). Here, the Australian Government's definition of the creative industries includes the employment categories of music, performing arts, film, television, radio, advertising, games and interactive content, writing, publishing, architecture, design and visual arts. To visualize the geographical spread of this creative activity, the demographic data from the 2011 Australian Bureau of Statistics (ABS) census can be mapped to show the location of the creative workforce in New South Wales (see Figure 2).

Current research under way at Charles Sturt University shows that in New South Wales there are concentrations of creative industries occupations in the regional centres of Albury, Wagga Wagga, Bathurst, Orange, Armidale, Newcastle, Port Macquarie, Broken Hill and the Northern Rivers area, with nearly all of these centres having a Charles Sturt University campus (Woodward et al. 2013). Mapping ABS creative occupations data from the 2006 and 2011 census has allowed us to identify 'hotspots' of creative industries present in regional places; however, this does not adequately capture the substantial creative activity outside traditional industry and employment classifications. In response to the challenges in mapping the creative economy, the ARC Centre of Excellence for Creative Industries and Innovation has developed a 'Creative Trident' methodology to recognize broader creative activities beyond those listed by traditional industry and employment classifications (Higgs and Cunningham 2008). However, we will argue that this method is not inclusive enough to capture all creative activity particular to agricultural communities, nor does it represent the artists, musicians, writers, performers and makers whose main income is not sourced from their creative practice, yet who also participate in and contribute productively to the cultural life of cities and regions.

While this mapping exercise confirms that creative activity is not primarily confined to Australia's coastal fringe and main capital cities, such research will inevitably remain limited by the current definitions of creative industries in the literature. As expected, the map of New South Wales shows the creative industries to be clustered towards the east coast, with the highest concentration corresponding to the highest population concentrations: the Sydney area. This reflects Richard Florida's theories on the pre-conditions needed to attract a talented 'creative class' to 'creative cities'. In the wake of initial enthusiasm for and critique of Florida's concept of creative cities, with their attendant creative workers, café culture

and high levels of tolerance, much of the literature on the creative economy has focused on creative cities (Florida 2002; Pratt 2008a, 2008b; Flew 2012; Cunningham 2008; Scott 2006; Howkins 2002). Since Florida, a more critical analysis of the feasibility and relevance of transforming regional centres into creative cities has led to an emerging emphasis on creative regions, especially from the discipline of Geography. This re-focus of attention on regions has encouraged those regions with common issues to link together in international networks (Lewis and Donald 2010; Gibson and Kong 2005; Gibson and Klocker 2005; Waitt and Gibson 2009; Gibson 2002; Comunian et al. 2010). Despite this development, creative cities rhetoric is still reinforced in documents such as the New South Wales State Government's *Creative Industries Action Plan* (2013), which distinguishes between only two geographical areas: Sydney or 'the regions'. However, as the map of creative activity (see Figure 2) shows, the creative industries are not focused on urban centres alone.

The familiar 'Sydney and the bush' characterization underpinning the creative cities agenda is now being challenged by counter-narratives from Australia's many regional centres and towns. As more sophisticated tools of analysis are developed and more research into the rural and regional dimensions of creative activity is carried out, a more nuanced and complex patterning of creative activity is revealed. Significant research tools that render creativity in regional places more visible include the 'Cultural Asset Mapping for Planning and Development in Regional Australia' (CAMRA) project, which aims to map the cultural assets in regional Australia and 'provide an understanding of how a region's capacity for creativity and innovation can ensure its quality of life and its economic viability'.[3] The Regional Australia Institute has also recently released an interactive mapping tool, 'InSight',[4] which draws together social, economic and census data to rank Australia's 560 local government areas (LGAs) and 55 regional development areas (RDAs) according to a number of measures, including innovation, business sophistication and technological readiness. This mapping tool reveals some surprising results, with the university town of Armidale LGA on the New England tablelands in NSW ranking highly (9th) for innovation and the Northern Rivers RDA ranking 4th for business sophistication. Despite the obviously politicized report from Melbourne University's Grattan Institute (Daley and Lancy 2011) claiming that investment, in market terms, in regional universities is non-productive, the overwhelmingly positive relationship between the presence of universities in regional areas and research, innovation, cultural and entrepreneurial activity has been well documented in Australia, the United States and Europe (Powell 2007; Crase et al. 2011; Comunian and Faggian 2011; Baltzopoulos and Broström 2013). While it is unwise to use ranking tools such as these to set up competition between regions or to distinguish between winner and loser regions and thus reinforce stereotypes, the capacity of these tools to analyse regional potential in greater levels of detail counters the otherwise prevalent tendency to treat the regions as homogeneous entities.

Australian regional creativity has also been the subject of recent scholarly publications, including a special edition of *Australian Geographer*,[5] edited by Chris Gibson from the University of Wollongong. Gibson argues that regional areas have registered the most noticeable impacts

of the rise of the cultural economy due to ubiquitous digital environments of creative activity rendering the physical location of the creative workforce increasingly less relevant:

> Moreover, creativity and innovation are not unique to large cities. Though their critical mass clearly influences the number of firms and size of output from creative sectors in cities, creativity is everywhere possible (Gibson and Connell, 2004), and transformations triggered by the rise of the cultural economy have been as, if not more, profound, in rural and regional areas where the cultural industries previously had little presence at all.
>
> (Gibson and Kong 2005: 549)

While some of the criteria identified by Florida as necessary to foster creative classes apply in smaller non-metropolitan centres, such characteristics do not always hold true when applied in regional settings (Pratt and Jeffcutt 2011; Gibson 2010; Bures 2012). Florida's criteria for attracting an exogenous creative class rest on assumptions that overlook and dismiss the endogenous creative activity that is present but less visible in rural and regional locations. Caution against the indiscriminate application of creative industries models is being supported by evidence from creative industries studies. In his article 'Creativity and the Problem of Free Labor', Andrew Ross (2013) summarizes much of the evidence for an increasingly common descriptor of the working class that populate the creative industries as 'the precarious generation'. Without any of the traditional structures supporting the sale of their labour, these mostly young, independent 'entrepreneurs' (as classified by both the market and the generation themselves) are trading their productive creative labour in a market that is massively fragmented. As such, they invariably supply a very small 'component' for mostly service 'products'. In addition, the massive competition for this creative work results in a downward pressure on the price they can charge for their labour and products.

The 'precarious generation' are nearly all 'products' of the pressure on the tertiary education sector to grow its business by satisfying demand. The market force demand for education and training in the creative industries has seen programmes, and therefore graduates, boom. How this educational field took on its current apparently attractive form is very important to consider in order to gain an understanding of its condition. In his essay 'When Form Has Become Attitude – And Beyond', Thiery de Duve (1994) reviews the evolution of art education in the twentieth century and provides a useful background to the origins of the current preoccupation with creativity and innovation as drivers of neo-liberal progress. In the absence of talent and skill as the origins of practice, creativity and innovation have been universally applied to all cultural and economic activity as the replacement for the shrinking manufacturing sector (O'Connor 2013). With the acceleration of digital technology since de Duve wrote his essay, it is not just the creative class but literally everyone who is now being categorized as both a consumer and potential producer. This occurs in a world in which the relationship between talent and making is being transformed into digitally reproduced serial variability. The regional agenda of creativity and innovation has been shaped by the same vectors, is being driven by the same universal measures (which ignore the origins

of both creativity and innovation) and is bracing itself for the roll out of the information superhighway, the National Broadband Network (NBN).

Initiatives by Australia's Commonwealth Government, such as the NBN, are anticipated to have a significant impact on the growth of creative industries. This is especially true in rural and remote regions, where high-speed Internet has the capacity to transform how creative content and services are created, distributed and marketed and is expected to produce a levelling of the playing field for creative industries across Australia, and especially in rural and regional areas (Ministry for the Arts 2011). How this field is to achieve its level is yet to be revealed; however, the heralded capacity to transmit local particularity could easily be swamped by a very unequal and seductive flood of global generality.

Examining creative activity at the micro level in New South Wales, as evidenced in the collection of The Pioneer Women's Hut, reveals much about the lived experience of those engaged in creative activities and enterprises in regional areas. We have interviewed creative practitioners from various practices and cross-disciplines to gather first-hand accounts of those with creative enterprises and businesses. The notion that 'creativity is everywhere possible' is echoed in an interview with Damian Candusso, an internationally recognized sound designer working in the film industry on large-scale Hollywood projects such as Baz Luhrman's *Australia* and *The Great Gatsby*. He spoke of the benefits of working regionally, and the geographically dispersed locations of the team members, which diminishes the distinctions between Sydney and the bush:

> If we took a snapshot today on a film and where we are all working, I'm here in Wagga, the Foley guys are in Quorn near Port Augusta, South Australia somewhere, there's another guy on the Central Coast and the rest are in Sydney, but we are still quite spread out really, it's all reliant on technology [and] making sure we can get our files to Sydney quick enough and without errors. […] I almost feel more central in one way […] A job at the end of the year, I'm the only Australian on that, the director and editor are in Los Angeles and I'm doing all of the sound from Australia.
>
> (Damian Candusso)

Creativity Without Borders

As we made clear at the outset of this chapter, the creative contribution from rural and regional Australia is the platform of the national imaginary, shaping the mythology of landscape, and by so doing reassuring Australia's predominantly urban population that the vast inland retains its natural wonder. Over time, the creative plains have been relegated to the fringe by the flows populating the coastal edge; however, there is still much to learn from regional Australia. This is exemplified by the transformative urban study 'Learning from Las Vegas', originally subtitled 'The Forgotten Symbolism of Architectural Form' (Venturi et al. 1972). The agendas for the creative industries by all levels of Australian Government relegate

the regions to a sub-clause of their multiple action plans, not because the regions are not important but because they no longer exist to symbolize the creative class in their creative city. In much the same way as it was possible to learn from Las Vegas, further research should show that it is also possible to learn from Australia's inland.

Beyond agri-tivity, what could regional Australia tell us about future creative practices? Already, virtual farming that combines games technology and farming and agriculture for urban dwellers is massively popular. Further, the Australian Research Council project *Eat, Cook, Grow: Ubiquitous Technology for Sustainable Food Culture in the City*[6] spans the fields of agriculture, urban and user-centred design, while the Australian designer-initiated web-based project, *The Locavore Edition*,[7] uses social media and print to connect producers, manufactures, retailers and consumers in a network focused on eating locally, combining regional food and tourism. The premise of this latter project is to combine the growing international interest in being a 'locavore', one who eats locally, with what Donald Horne called 'intelligent' tourism, bringing together those who grow and consume produce, and attracting virtual and actual visitors to the regions. Future research should capitalize on such signals of interest in the local, the regional and their communities and the increasingly borderless and nomadic nature of creative activity. In Australia, the prospect of an inland-focused lens holds great potential for regional communities to transform both the outer and inner of the nation's creative schedule.

References

Appadurai, Arjun (ed.) (1988), *The Social Life of Things: Commodities in Cultural Perspective*, Cambridge, UK: Cambridge University Press.

Argent, N., Tonts, M., Jones, R. and Holmes, J. (2013), 'A creativity-led rural renaissance? Amenity-led migration, the creative turn and the uneven development of rural Australia', *Applied Geography*, 44, 88–98.

Baltzopoulos, A. and Broström, A. (2013), 'Attractors of entrepreneurial activity: Universities, regions and alumni entrepreneurs', *Regional Studies*, 47(6), 934–949.

Bures, F. (2012), 'The fall of the creative class', *Thirty-Two Magazine*, accessed 13 March 2013, available at thirtytwomag.com/2012/06/the-fall-of-thecreative-class/

Chang, A. (2012), 'Back to the virtual farm: Gleaning the agriculture-management game', *ISLE: Interdisciplinary Studies in Literature and Environment*, 19(2).

Cocklin, C. and Dibden, J. (eds) (2005), *Sustainability and Change in Rural Australia*, Sydney: UNSW Press.

Comunian, R., Chapain, C. and Clifton, N. (2010), 'Location, location, location: Exploring the complex relationship between creative industries and place', *Creative Industries Journal*, 3(1), 5–10.

Comunian, R. and Faggian, A. (2011), 'Higher education and the creative city', in D.E. Andersson, Å. Andersson and C. Mellander (eds), *Handbook of Creative Cities*, Aldershot: Edwards Elgar Publishing.

Crase, L., O'Keefe, S. and Dollery, B. (2011), 'Nuances of regional growth and its public policy implications: Some comments on the flaws in the Grattan Institute's investing in regions: Making a difference report', *Economic Papers*, 30(4), 481–489.

Cunningham, S. (2008), 'What is the creative economy?', accessed 24 May 2009, available at http://www.creative.org.au/webboard/results.chtml?filename_num=99329

Daley, J. and Lancy, A. (2011), *Investing in Regions: Making a Difference*, Melbourne: Grattan Institute.

De Duve, T. (1994), 'When form has become attitude – And beyond', in Stephen Foster and Nicholas deVille (eds), *The Artist and the Academy: Issues in Fine Art Education and the Wider Cultural Context*, Southampton: John Hansard Gallery, pp. 19–31.

Dominy, M.D. (1997), 'The Alpine landscape in Australian mythologies of ecology and nation', in B. Ching and G.W. Creed (eds), *Knowing Your Place: Rural Identity and Cultural Hierarchy*, New York: Routledge, pp. 237–265.

Flew, T. (2012), *The Creative Industries: Culture and Policy*, London: Sage.

Florida, R. (2002), *The Rise of the Creative Class. And How It's Transforming Work, Leisure and Everyday Life*, New York: Basic Books.

Gibson, C. (2002), 'Rural transformation and cultural industries: Popular music on the New South Wales far north coast', *Australian Geographical Studies*, 40(3), 337–356.

Gibson, C. (2010), 'Creative geographies: Tales from the "margins"', *Australian Geographer*, 41(1), 1–10.

Gibson, C. and Klocker, N. (2005), 'The "cultural turn" in Australian Regional Economic Development discourse: Neoliberalising creativity?', *Geographical Research*, 43(1), 93–102.

Gibson, C. and Kong, L. (2005), 'Cultural economy: A critical review', *Progress in Human Geography*, 29(5), 541–561.

Gibson, C., Luckman, S. and Willoughby-Smith, J. (2010), 'Creativity without borders?: Rethinking remoteness and proximity', *Australian Geographer*, 41(1), 25–38.

Higgs, P. and Cunningham, S. (2008), 'Creative industries mapping: Where have we come from and where are we going?', *Creative Industries Journal*, 1(1), 7–30.

Horne, D. (1992), *The Intelligent Tourist*, McMahons Point: Margaret Gee Publishing.

Howkins, J. (2002), *Creative London: The Mayor's Commission on the Creative Industries*, Comments by John Howkins – 12 December 2002, available at http://creativelondon.org.uk/commission/pdf/JohnHowkinstalk.pdf

Lea, T., Luckman, S., Gibson, C., Fitzpatrick, D., Brennan-Horley, C., Willoughby-Smith, J. and Hughes, K. (2009), *Creative Tropical City: Mapping Darwin's Creative Industries*, Darwin: Charles Darwin University.

Lewis, N.M. and Donald, B. (2010), 'A new rubric for "creative city" potential in Canada's smaller cities', *Urban Studies*, 47(1), 29.

Luckman, S. (2012), *Locating Cultural Work: The Politics and Poetics of Rural, Regional and Remote Creativity*, New York: Palgrave Macmillan.

Micoo, N. and Vinodrai, T. (2010), 'From cars to creativity: The changing dynamics of the rural economy in Essex County, Ontario', in *Fostering Entrepreneurship in the Creative Economy Conference*, Queen's University, Kingston, Ontario, 19 November 2010, available at http://www.creativemuskoka.ca/uploads/8/1/4/1/8141704/micoo_and_vinodrai_from_cars_to_creativity_presented_at_moneison_centre_nov_19_2010.pdf

Returning Creativity

Chapter 5

Getting to Know the Story of the Boathouse Dances: Football, Freedom and Rock 'n' Roll

Tamara Whyte, Chris Matthews, Michael Balfour, Lyndon Murphy and Linda Hassall
Griffith University

There was a worldwide revolution and the revolution was called rock 'n' roll.
(Uncle Charlie King, 4 March 2012 interview)

Introduction

In 2011, the Indigenous[1] Research Network (IRN) at Griffith University, Brisbane, Australia brought together a team of playwrights and researchers to tell the story of the Boathouse dances as its first community-driven research project. The Boathouse dances were held in the late 1950s and early 1960s and were a significant meeting place for Aboriginal people of Brisbane and the greater South East Queensland region. The dances were organized by an Aboriginal man, Uncle Charlie King, to fund the first Aboriginal football team in Brisbane and an Aboriginal women's virago team.[2] The Boathouse dances were a time of celebration, reconnecting, establishing new relationships and falling in love. The dances were also a focal point of significant social change in the lives of many Aboriginal people and were driven by Aboriginal people who were experiencing a new agency. To date, this story is untold; it is a part of Australia's hidden histories.

The chapter focuses on the processes and subsequent tensions of researching and retelling the story of the Boathouse dances. To understand these tensions, we firstly need to take the reader on a journey to understand what is meant by hidden histories within the Australian context. This involves a brief history of colonial Australia leading into the social and political backdrop of the 1950s and 1960s. From this backdrop, we explore the cultural and social significance of Boathouse dances, the significance of the location of the Boathouse, the ritual of preparing and traveling to the dances, and the story of Uncle Charlie King who made the event possible. We also explore the evolution of researching and retelling the Boathouse story so that it is an authentic representation for our Elders and also honours the transformative nature of the dances to create a better future for Aboriginal people in the greater Brisbane region.

At this point, it is helpful to understand the notion of regionalism within the context of this story. Regionalism can be defined as the area outside of a city's urbanized centre. Given the colonization process described below, urban and city centres became the realm of white society, while many Aboriginal people were pushed into fringe areas like Cherbourg, Stradbroke Island and Beaudesert. In other words, many Aboriginal people were regionalized and only entered the urban centres for work within service roles such as factory workers and housekeepers. The very concept of regionalism in relation to Aboriginal identity is

problematic. Regionalism can mask the broader and deeper realities of Aboriginal and non-Aboriginal relations in Australia if confined to sites of geo-political tensions. Aboriginal groups across the country encountered and responded to the impacts of colonization and disempowerment imposed upon them. While there were variations in Aboriginal responses to this confrontation, the central tenet was thematic; that is, the ideas or preconceptions about Aboriginal people traversed the country in silent unison with non-Aboriginal people wherever they went. Although these ideas were initially unobtrusive towards Aboriginal well-being, the harsh reality of these preconceptions would manifest and develop into legislative practices that would later dominate the Aboriginal existence. Charles Perkins commented upon this silent, often-forgotten characteristic of regionalism:

> [...] Our culture was smashed by the first white settlers [...] We are now in the process of re-establishing our society. But we are re-establishing it within an already well-established society, making the process much more difficult than if we were creating a society free of the constraints imposed by an alien culture.
>
> (Perkins 1983: 12)

If we limit our understanding of regionalism to the ad hoc entanglement of tensions produced by geo-cultural differences, then there is a danger of erasing the shared social experience of Aboriginal people. The significance of the Boathouse story is the way in which it contributed to redefining the urban space and reinstatement of Aboriginal identity, not only in a locally defined space, but in the broader national context of being Aboriginal in white Australia.

Hidden Histories: The Socio-Political Backdrop

Australia was colonized under the doctrine of Terra Nullius (nobody's land). This doctrine denied the existence of the Aboriginal peoples of Australia, rendering Aboriginal culture, knowledge and ways of life as of no significance to the British colonizer. As an example, when the constitution of Australia was established in 1901, Aboriginal Australians were only considered in the *Flora and Fauna Act*; that is, they were not given any basic rights as a people in Australia and hence were considered subhuman. The classification and enshrining of Aboriginals as subhuman justified the attempted genocide of Aboriginal Australians, the establishment of missions to control their lives through the government's Native Affairs Department and the removal of children from their parents and extended family into dormitories under government control. For non-Aboriginal people in Australia, the colonization process created a society that had very little knowledge or understanding of Aboriginal Australia, leaving a void in the Australian psyche. This void is usually filled with misconceptions and stereotypes that, even today, uphold a cultural divide and continued tensions between non-Aboriginal and the Aboriginal peoples of Australia. There has been a

deliberate silencing within Australia's histories regarding Aboriginal peoples, particularly with respect to their culture, knowledge and experiences with colonization. Aboriginal people can also engage in this silencing where they would rather forget the past and look towards the future.

In the 1950s and 1960s, Queensland was a conservatively governed state in which the Catholic Church still had significant sway on moral and social codes (Walden 2003). Many Aboriginal people were still under the control of the Protection Act and were subject to curfews and restrictions on their movements. During this period, the enforcement of these draconian laws was starting to relax (relative to past enforcements) and many Aboriginal people (mainly men) could manoeuvre around these laws to gain employment and greater independence. A public debate started in the lead up to the 1967 Referendum that resulted in an amendment to the Australian Constitution to include Aboriginal people of Australia in the census, thereby giving them voting rights (Bennett 1985). In Australia, the 1950s and 1960s was the period during which the need for change became manifest.

The Boathouse dances are about a group of people living under laws designed to restrict their movements and freedom, and how they persevered under those repressive circumstances. Less than 60 years after Federation, Uncle Charlie King started the Boathouse dances in Brisbane, Queensland to fund the first Aboriginal rugby league football team and an Aboriginal women's vigaro team. Every Saturday night between 1957 and 1962, Uncle Charlie King and the Boathouse committee would organize dances for local and regional Aboriginal people. The dance nights included live music, records, dancing and dressing up. It was a regular space for meeting, celebrating, socializing and courting. The Boathouse dances reflect the lived experiences of an informal community living under the Protection Act and the implications it had for Aboriginal people. As Uncle Charlie King asserts, 'rock 'n' roll was a revolution' (interview). It was a revolution against the establishment, and the battleground was the dance floor.

Indigenous Research Network: How the Boathouse Project Started

In 2009, the IRN was developed by a small but focused group of Indigenous academics at Griffith University. The philosophy of the IRN was to develop community-driven and -owned research projects, aiming to overturn past research practice in which Aboriginal people were purely the subject of the research rather than willing participants or collaborators in the research process. To achieve this, the IRN aimed to build a solid foundation by bringing together all of the Aboriginal and Torres Strait Islander academics within Griffith University as a community of researchers. With this collective and cross-disciplinary expertise, the network would use their existing connections to develop meaningful research projects with individuals and/or organizations within Aboriginal communities.

Lyndon Murphy, a member of the IRN and Aboriginal academic at Griffith University, introduced the idea of documenting the Boathouse experience after working with Sandra

Georgiou, daughter of Boathouse founder and organizer Uncle Charlie King. Sandra, a prominent figure in Brisbane's Aboriginal community, was passionate about getting the story greater exposure and documenting it for future generations. As Lyndon and Sandra were working on a project for which they met on a regular basis, week by week the conversation and idea developed until Lyndon brought it to the attention of other Aboriginal academics at Griffith University.

The Boathouse project had many facets: a community oral history project, a possible exhibition and also an interest in developing a documentary theatre performance based around the story of Uncle Charlie King and his dealings with the running of the Boathouse. The project gathered momentum and in 2010 a community meeting was called at the State Library. A number of Elders attended the meeting and their stories were recorded. There was a sense of urgency and necessity in undertaking the interviews sooner rather than later. During the life of the project, a number of Elders who had been involved in the Boathouse and the All Blacks football team passed away due to age or ill health. It seemed that the logical next step was to continue collecting the oral histories and develop a project around what was being recorded.

Getting to know the story of the Boathouse has been an ongoing experience. From the outset, there was an understanding of what it meant to live under the Protection Act and hence the significance of an Aboriginal man staging a dance for Aboriginal people under these laws; however, we did not know how significant the Boathouse dances were or that they had been a strong positive influence for many Aboriginal people in Brisbane. The significance and experience of the Boathouse dances for our Elders is multi-faceted and includes the importance of place, the preparation before the dance, the gathering itself, how the dance was structured and the importance of rock 'n' roll culture. The Boathouse dances offered a space for gathering and cultural renewal.

The oral histories led to the development of a community documentary script, written by Tamara Whyte and Tamika Currie. The narratives contained in the script are based on the shared histories of Elders from Brisbane and their recollections of the people, events, music and social gathering of the 1960s from an Aboriginal perspective. In so doing, the practices bind regional and urban contexts in a fluid and discursively formed mnemonic space. The creative development process involved walking an ethical tightrope between being truthful to the verbatim material, representing individual as well as community perspectives, and constructing a compelling theatrical story that captured the essence of the times. Unlike other theatrical representations of Aboriginal dances, for example Wesley Enoch's (2000) *The Sunshine Club*, the play emerged from community voices and the strong desire for community representation and the sharing of these stories. This added a level of complexity and placed pressure on the writers to not only value and respect collective memories, but also to negotiate different voices within the community of Elders. The team around the Boathouse believed that as a story, and as a historical experience, the Boathouse has implications and lessons for all. The struggle has been, and still is, to find a way to take as many people as possible on that journey, and to make that journey represent the experiences

of the dance attendees while also sufficiently informing the audience, be they local, domestic or international.

Understanding the Story

The Boathouse dances were a focal point of change, where many circumstances and ideas converged to create a unique event. This section explores various elements of the Boathouse dances to draw out the significance of the changing times and how Aboriginal people became active agents to facilitate this change. The main aspects of the Boathouse dances that are explored are the significance of where the Boathouse was situated, the ritual behind preparing and traveling to the Boathouse and the gathering itself.

Significance of Place

The Boathouse dances were held at the O'Connor Boathouse, which was situated on the northern side of the Brisbane River near the centre of Brisbane. As the name suggests, the Boathouse was an actual house that stored boats for the local rowing club. The Boathouse had two levels: the bottom level stored the boats and equipment, while the top level was a large hall surrounded by a veranda (see Figure 3). The Brisbane River and roads, aptly named Boundary Street, marked out the boundaries for the imposed curfew on Aboriginal people. During the curfew, Aboriginal people were not allowed on the north side of the river without specific permission. Hence, by the 1950s, the north side of the river was generally considered among Aboriginal people as the domain of white society.

One of the Elders, Aunty Faye Gundy, recalled walking across the Victoria Bridge towards the north side of the river and being stopped by a suspected Native Affairs 'spy':

> he actually came to me with his little scooter, in front of me, tried to stop me from going across the bridge. I said get out of my road or I knock you off. So he got out of the road and he wouldn't stop me. I knew that he was the spy cause that's when I went back to Native Affairs on Thursday (they said) […] 'You were seen going across that bridge'.
> (Aunty Faye Gundy, interview)

The experiences of Aunty Faye Gundy demonstrate that at this time the Native Affairs Department was still trying to enforce the ideas behind the curfew, but that a change of agency now meant that Aunty Faye Gundy was brave enough to assert her rights and continue to cross the bridge. As the Boathouse occupied the side of the river from which Aboriginal people were still excluded, to be able to access the O'Connor Boathouse and hold dances there was a significant achievement for Aboriginal people at that time. Organizing the dances within the boundaries of the city precinct saw Aboriginal people placing

themselves within the domain of white society: their social dance was on par with any of the others held around town. In addition, the river and the ability to access it were definite highlights in some attendees' memories. At different times during the dance, couples would move to the veranda for the cool air and a view that overlooked the south side of the river.

The Preparation

> For most Aborigines it was still a life of controlled subjugation, dominated by extreme poverty, lack of basic services, poor housing, ill health and relentless surveillance, control and intervention by state and church authorities. Infant mortality remained high, life expectancy low, and only a few managed to beat the odds and obtain a decent education.
>
> <div align="right">(Fryer Library, University of Queensland 2013)</div>

The Boathouse dances provided the men and women who attended the chance to dress up and dance. For some, it was their only chance to socialize away from their domestic duties and get together with family, countrymen and other Aboriginal people. In contrast to the prevailing attitudes and experiences of the time, the Boathouse dances were gatherings where people felt free to enjoy themselves and express their individual personalities. Not all attendees had the same access to the fashionable clothing of the time. As our interviews with the Elders revealed, there was a difference between the women employed as domestics under the Act and women who were employed at the Mater Hospital, with the latter having access to a wider variety of dresses, materials and accessories. Aunty Elva Dickfoss (interview) recalls:

> We made our own dresses, we couldn't buy them, you know, with working and things like that. And especially by this time I was the one that, I was the one that wasn't working at the time. So I had to watch my pennies.

Aunty Honour Cleary (interview) explains life for her under the Act:

> See, when we were let out to go out, we would ask if we could go to the dance. See we were paid five pounds a week and three pounds went to the department and we only got two pounds. We had to buy our clothes if we wanted to go out, our toiletries and everything with that money.

Dressing up and attending the dances for many interviewees was a point of pride and fond memories. Attendees fondly recall the beauty of the women in their dresses and the men dressed in snappy suits. One of the male attendees, Maxie Currie, is distinctly remembered for his lime green suit and hat, an outfit that left a visual impact; while another, Earl Drake, the Master of Ceremonies, was noted for always carrying a handkerchief: '[He was] very

particular, and he was dressed in a suit, a white shirt and all that hanky. The lady put her hand on the hanky, not his sweaty hand' (Uncle Charlie King, interview). The Boathouse saw a mix in ages of Aboriginal society. Many of the attendees were in their early to late teens, with some still under twelve when they attended with their parents. Some of the women interviewed fondly recalled the glamour of the evening:

> All I know it was a beautiful thing to see. There's one Murri women especially, she was up there dancing, and she was the centre of attention. When she got on the floor people just stopped and looked at her. She was, you know a really neat dancer, real deadly.
> (Aunty Lyn Johannsen, interview)

To get to the dances, people would walk or catch the bus, train or boat to get to the venue. There was a strict curfew and the evenings always ended promptly to ensure everyone got home:

> People used to rally to the dances. It's the same when the Boathouse arrived. I could name you a few people they would come to the dance of a Saturday night and drive all the way back up to Beaudesert. A lot of people from Ipswich would after the dance walk up to Roma Street and catch the last train home to Ipswich.
> (Uncle Stanley Smith, interview)

The Gathering

In hindsight, the Boathouse dances can be seen as contemporary gatherings of Aboriginal people within the region. With many of the social structures of Aboriginal people disrupted by the British colonization and subsequent government intervention, the emergence of this social gathering served to unite and strengthen families and communities in South East Queensland; that is, the Straddie mob, the Cherbourg mob and the Beaudesert mob (the areas in which large numbers of Aboriginal people lived and which they identified as their home).

The evenings themselves were multi-generational, with the Elders of the time attending the dances, and children brought by their parents watching the dancing. The music was a combination of a three-piece band that played older time music for the older generation to dance to and a record player connected to a sound system to play the new rock 'n' roll music. In between the sets of the band, the record player would play rock 'n' roll. At first, songs that had a slow tempo would be played, with the tempo increasing throughout the night to build up the excitement of the dance until it was time to leave. The tempo would then be slowed down again, to prepare everyone to catch the last tram, bus or train home. There were some strict social codes in place for the evening. For example, no woman should be left seated during a dance and there were to be no broken glasses or drinking. The dances also provided the ideal opportunity to fraternize with the opposite sex:

encouraged relatedness and identity (Anderson and Wilkinson 2007: 156). Derek Paget's work in the 1960s used tape recordings of interviews that captured the vernacular life of 'real' people and 'real' stories. Paget refers to the need for this type of verbatim work as 'painstaking, protracted and scrupulous use of historical evidence' (Paget 1987: 48). In Australia, landmark projects include the work of the Murray River Performing Group, Aftershocks (about the Newcastle earthquake) (Brown 1993), the Maralinga project (about the impact of nuclear tests in Australia on veterans and Aboriginal populations) (Brown 2006) and many other community theatre initiatives.

While there is not space in this chapter to discuss the history of documentary and verbatim theatre, it is clear that there are substantial connections between the objectives of oral history workers and theatre practitioners. There can also be tensions. The most common is the ways in which a community maintains control over the representation of stories in performed work. In well-planned projects, there is a process of community consultation and dialogue. Project teams institute a range of protocols; for example, establishing a steering committee, developing release forms that indicate community ownership and including processes that enable a feedback loop for community members. These kinds of negotiations take time, patience and care, but are essential in creating work that has integrity. For the writers and editors of documentary-based work, developing a compelling dramatic narrative while balancing the need to be inclusive of the spectrum of stories and perspectives is fraught with ethical and aesthetic dilemmas. The Boathouse project is currently in year five of its development and achieving this balance is both frustrating and essential if community ownership of the project is to remain intact. At the same time, there is community pressure to move on with the project, as already some of the interviewees have passed away.

For the writers and editors of the oral history transcripts, there are multiple competing tensions that inform the creative process. Tamara Whyte has been involved in both the interview process and now the writing and editing. The next section draws on Tamara's voice and details the issues and tensions involved in writing a script that captures the Boathouse story as well as maintaining and enabling the multi-voices and experiences to come through in the script. Tamara worked with a co-writer, Tamika Currie.

The Writer's Perspective – Tamara Whyte

It was evident from the oral history interviews that the experience of the Boathouse dances was distinctly different for the men who attended as compared to for the women. Although this may be partly attributable to the ritual of dress and preparation, it seems that the way the Boathouse was used for socialization was a defining difference. As writers, we discovered this as we worked our way through the oral histories to prepare an initial short form draft for a public reading for the participants. I was eager to include the stories of the men, for they brought the dimensions of sport, socializing in bars and fear or hesitancy to dance into the narrative. Additionally, it seemed that a number of the men moved with somewhat more

personal freedom throughout the city and South East Queensland. In part, this may have been due to the broader social constraints around what was expected of women, and particularly so from an Aboriginal viewpoint. However, a number of the men interviewed moved more freely 'under' or 'around' the Act due to having greater choice in employment compared to women (for example, they could work in abattoirs, droving, market gardens). This gave them more financial freedom, which seemed to lead to increased freedom of movement, association and independence. In contrast, many of the women were still employed as domestics, either under the Act or through the churches, or in unpaid employment as housewives and mothers. Boxing and football also featured heavily in the men's stories. Although many of the women played vigaro, the boxing and opportunity it afforded men in terms of socialization and a potential source of income and travel again fed into how their Boathouse experience was shaped.

The Reading: Are the Writers Getting It Right in the Eyes of the Community?

The writing process began by creating a few short scenes (in the initial draft for public reading). I (Tamara) looked at the men and their recollections of boxing, drinking, the iconic fig tree in front of the Boathouse and how these experiences fed into the overall Boathouse experience. Tamika focused on the women's stories – the preparation for the dances, the courting and the fun of the dances – and the notion of one man's (Uncle Charlie King) connection to the Boathouse.

There was a mixed reaction when the script was presented to the attendees and community at the reading in 2011. We invited all the Elders and the families to the reading, which was presented as a celebration of the oral histories. We also ensured that it was an opportunity for community feedback and consultation. There was a great deal of reminiscing and questioning of the script. For example, in one scene, the story of a fight that had occurred underneath the fig tree was re-told. Some people had no recollection of the events (fighting and drinking) and to a degree the reading challenged the validity of their recollections. Others preferred to see references to drinking removed, as they felt it was a negative representation and a commonplace stereotype.

The initial showing highlighted the tensions that exist when working in this setting. As writers, we feel an obligation to represent the communities' experiences and ensure that they are at ease with the manner in which we do that. However, at the same time, we are looking for the interesting, untold, engaging or illuminating stories within the larger narrative. The honesty with which the men related their experiences had provided us as playwrights with exactly those story qualities. Like many other scenes in the play, the fight scene set under the branches of a fig tree, helped to re-contextualize and redefine Aboriginal men. We kept the humour of the situation and the genuine camaraderie of the fighters, which was very apparent in the oral history interviews. The desire to present a multi-faceted representation of Aboriginal life and contribution in the 1950s and 1960s marks one of the strengths of this story.

As playwrights and members of the project team, we had a fair idea of how we wanted the process of scripting the Boathouse to flow. For us, the community play reading was just an initial step in a longer process; however, for some community members, this was not the case. There had been a swell of interest once the oral history interviews began and community members had hoped for more progress. It became obvious that we had to continue to work at bringing the community along with the process. Some Elders at the reading asked aloud 'Where was the dancing?' or commented: 'Perhaps you could have some music'. 'It's a good start but you need more'. All of these were valid observations and allowed us to some degree to relate the process of bringing this story to life.

Heading Towards a Full Play

In September 2012, the project team engaged the services of two dramaturgs to help to sculpt the meta-narrative of the Boathouse. Being so close to the oral histories, celebrating the discovery of interesting anecdotes and having slowly constructed the socio-political context over the months of research meant that I (Tamara) no longer had the space to see the strongest story arc for the work. Co-writing also meant that there were two minds and voices and therefore a multitude of experiences and preferences for different aspects of the Boathouse story. This is a strength, but both writers identified a tension early in the process in how to balance these qualities and harness our passion for a community-driven story that showcased a unique experience to create a successful first draft. The dramaturgical support was essential and in some ways acted as the silent umpire in a writers' tussle.

It was also imperative for us to hand over the subject matter to people who came from an outsiders' perspective and who therefore brought another opinion on the strengths of the story, which characters were needed to tell the story and which of the stories needed to be told. It was during this period that I saw the play shift away from a pure verbatim approach to one that incorporated interpretation and aesthetic writing that captured the essence and feeling of the times.

On top of this, creating a dynamic working relationship within the Aboriginal community presented different challenges for each of us. Tamika Currie had local connections and even family members who had attended the Boathouse. Therefore, she had an implicit understanding that she was accountable for the work being produced, and that there was an expectation on her as a daughter, niece and teacher, in addition to that as one of the writers. I am a little further removed from that close circle of responsibility; but, having developed strong ties with some of the key proponents of the Boathouse story, I nonetheless felt a desire and obligation to see those experiences truthfully represented on the page. In this way, Tamika and I represented two sides of the same coin, bearing different community responsibilities.

I have struggled continuously through the drafting process with the dilemma of being intimately aware of some of the most engaging and surprising incidents within the many

stories that make up the narrative of the Boathouse. Yet, I am also acutely aware that the friendships and rapport that we have built to gain access to these stories often serve as a barrier to writing. I struggle with the desire to bring these stories to the page and then imaginatively to the stage, while being aware that these stories have caused pain and hurt to people who are still with us today. At the same time, the raw and the painful are engaging, as each strikes a chord within us all.

Questions of Ownership

As the project was initially brought to Lyndon Murphy's attention, it found itself a home through the IRN at Griffith University. Different members of the team working on the project have raised questions regarding community ownership of the story and subsequent public performances. As we move through the process of unravelling and immersing ourselves in the story of the Boathouse dances, it has become apparent that one way to tell the story is through Uncle Charlie King's actions and visions. Yet the actual dances are the memories and creation of a broad and diverse group of Aboriginal people. As we move forward towards scripting the work, we are continually wondering whose work this is, and how we can appropriately recognize their varying contributions.

At this stage, as writers, we feel that remuneration for the writing process and the experience to work on a community-based production is fair payment. We have received professional development through participating in the process and working with a range of colleagues, and for a community-based project perhaps this is enough. Holcombe (2010: 23) writes about the process from research to knowledge formation:

> [knowledge] gains a different value as it enters a less negotiated space. The 'expertise' of the researcher as knowledge transcriber is transformative: knowledge becomes arranged into factual data, losing it contingent and partial nature. It gains a different potency that tends to favour the transcriber. This process is especially apparent within the accepted academic process of mobilising knowledge through publication.

These observations have ongoing points of conflict within the development of a script to a stage production and beyond. Considering the roles involved – for instance, writer, dramaturg, director, producer and publisher – how can the project ensure that the original intention of the IRN is carried through into the future? If we are looking at different ways that Aboriginal academics and researchers interact with their own communities, can we confidently say we have the capacity to work in a different way? The university system of research can seem like a glacial monument, slow to change and yet ultimately achieving its intended outcomes; like a glacier, there will be damage in its path. Can academia truly work with Aboriginal communities on an equal footing, or better yet on a footing that offers Aboriginal people and communities a definitive say?

Working with these factors in mind and trying to sit down and write the script was a difficult process. The script development workshop allowed us the chance to look at the macro structure of the story of the Boathouse, including the organization of the dances, the football, the relationships and the night itself. The difficulty came when trying to select elements of the story and create a narrative that represented the greater whole. As writers, we felt that each of the oral history interviewees needed to see their story reflected on the stage, whether it be through the retelling of a story, a line of dialogue or an element of a character. Thus, it was essential that we weaved a narrative that told an engaging story while also retelling everyone's experience of the Boathouse.

As the project has evolved, it is possible to draw correlations between what we are doing and notions of corroboree for Aboriginal peoples. (A corroboree is an event at which Aborigines interact with the Dreamtime through dance, music and costume.) Social memory and the lessons and knowledge to be learnt from the collective experience have been passed down through generations, stories are added, some are no longer shared and new occurrences are integrated into the cycle. Oral tradition has played a key role in Aboriginal history in documenting and passing on stories. The compilation of the Boathouse story continues that oral tradition and takes it a step further by writing it down for future performances. In this way, it is transformed from social memory within the Aboriginal community to a public sharing for the broader community. In script form, we are attempting to incorporate many stories and multiple memories of history into an overall representation of one night at the Boathouse. Like a corroboree through story, dance and music, we are establishing the history, exploring the knowledge, representing the spectacular and sharing the teaching.

Conclusion

The Boathouse story represents a compelling celebration of community resistance and resilience. Caught up in the changing social contexts of the 1950s and 1960s, the Elders at the heart of the story made something extraordinary happen. As with other acts of civil rights resistance, the Boathouse Elders refused history by negotiating new terms. The Boathouse story represents a significant regional and national turning point, celebrating the determination and refusal to submit to the imposition of old codes and regulations. Documenting the story and the memories of Elders has been a privilege. Representing the story through performance is a long-term work in progress involving ethical issues, the need for continuing community consultation, aesthetic deliberations and a race against time to ensure that the Elders and the wider community see the story shared, celebrated and recognized.

References

Anderson, Michael and Wilkinson, Linden (2007), 'A resurgence of verbatim theatre: Authenticity, empathy and transformation, *Australasian Drama Studies*, 50, 153–169.

Bennett, S. (1985), 'The 1967 referendum' [online], *Australian Aboriginal Studies*, 2, 26–31, accessed 20 May 2015, available at http://search.informit.com.au/documentSummary;dn=291198630838025;res=IELIND

Brown, Paul and the Workers Cultural Action Committee (1993), *Aftershocks*, Sydney: Currency Press.

Brown, P.F. and the Maralinga Research Group (2006), *Half a Life*, Stage Play based on testimonies of Australia's nuclear veterans seasons, a collaboration with the Australian Nuclear Veterans Association and British Nuclear Test Veterans Association, Performances at Leeds, Central Coast and Sydney.

Enoch, W., Rodgers, J. and Enright, N. (2000), *The Sunshine Club: A Very Black Musical* (Draft 9 as at 30 April 2000), accessed 20 May 2015, available at http://trove.nla.gov.au/work/8421936?q=The+Sunshine+Club+Enoch&c=book&versonId=9715924

Fryer Library, University of Queensland (2013), accessed 14 April 2013, available at https://www.library.uq.edu.au/fryer/1967_referendum/postwar2.htm

Holcombe, Sarah (2010), 'The arrogance of ethnography: Managing anthropological research knowledge', *Australian Aboriginal Studies*, 2, 22–32.

Paget, Derek (1987), '"Verbatim Theatre": Oral history and documentary techniques', *New Theatre Quarterly*, 3, 317–336. doi:10.1017/S0266464X00002463

Perkins, C. (1983), *The Myth of Multi-Culturalism*, Address to the National Conference of the Federation of Ethnic Communities' Councils of Australia Inc., Hobart, 10 December 1983.

Walden, G. (2003), 'It's only rock 'n' roll but I like it: A history of the early days of rock 'n' roll in Brisbane, as told by some of the people who were there', PhD thesis, Queensland University of Technology, Brisbane.

Notes

1 The term 'Aboriginal' will be used to refer to the many cultures of the Aboriginal and Torres Strait Islander peoples of Australia.

2 Vigaro is a women's team sport that was predominantly popular in Australia and has been described as a cross between cricket and baseball.

Chapter 6

'The Artists Are Taking Over This Town': Lifestyle Migration and Regional Creative Capital

Susan Luckman
University of South Australia

While some less desirable locations suffer a crisis of critical mass, other regional places are in demand from incomers in search of affordable housing, enhanced quality of life or some of the other affordances of rural locales. As such, regional places beyond large cities able to attract such amenity migration are experiencing transformational growth in their post-productivist (including tourism and creative) economies. In Australia, these places include those like the town of Healesville in the hills of the Yarra Valley just outside Melbourne, where the sign in Figures 4a–b: 'the artists are taking over this town' was photographed outside the Artist's Lounge, a retail shopfront on the main street selling both artists' supplies as well as original arts and crafts works.[1] Demonstrably then, among those attracted to the downshifting lifestyle are creative workers, who bring with them a wealth of experience and talent, as well as the capacity to open new spaces through which to fashion inclusive regional communities. The growth of digital communication technologies means they also tend to be less tied to a particular location for employment purposes (Gurran and Blakely 2007: 123). Drawing upon both empirical field research and ABS census data, this chapter examines relatively privileged regional sites – namely, those 'amenity-belt' regional areas close to capital cities that are increasingly able to attract in-migrants – to examine how the flow of people also brings with it not only new cultural practices, but also creative literacies and skills. It argues that while much of the emphasis in Australia and elsewhere has been upon the 'loss' of young people from rural and regional communities, this has been at the expense of greater consideration of and attention to the creative arts and cultural production capacities of older residents. The (re)turn of creative arts practitioners to regional areas marks an essential return of creative capacity to these regions, which, frequently, would not otherwise be attainable in the region due to a lack of training facilities and/or creative critical mass. Thus, in this way, mobility can be seen as a form of personal and community resilience for those desirable, often peri-urban, regions in demand from incomers. To demonstrate this, this chapter focuses on data from two amenity-belt regions located within approximately an hour of major cities: the Yarra Valley, immediately outside of Melbourne in the state of Victoria, and the Barossa Valley, in the state of South Australia and now, thanks to the opening of a new dual carriageway, around an hour's drive from the city of Adelaide. Both regions are known internationally for their long post-settlement history of wine production, and hence for the kind of commercial and cultural infrastructure to which this particular kind of economic activity gives rise, including, notably, wine tourism.

Creative Industries and Rural Cultural Economies

The creative industries have been at the forefront of place-based renewal strategies since the 1980s, which saw the massive shifting offshore to cheaper labour economies of a huge percentage of the manufacturing industries of the Global North. 'Cultural work' or the 'creative industries' are most commonly defined as those segments of the economy concerned with the generation of intellectual property and the production of 'aesthetic' or 'symbolic' goods or services (Banks 2007; Hartley 2004, 2005; Hesmondhalgh 2002). A number of definitions of the creative industries are in circulation, but one model with particular global strength and which also has currency in Australia was initially offered by the British Department for Culture, Media and Sport, whose list of relevant fields initially included advertising, architecture, the art and antiques market, crafts, design, designer fashion, film and video, interactive leisure software, music, the performing arts, publishing, software and computer games, television and radio (Department for Culture, Media and Sport 2001). Underpinning all of the interest in creative industries over the last couple of decades is a growing recognition of the place of creativity as a key driver of economic growth in the information age, with its associated appetite for content, and increasingly too for the bespoke or handmade in the face of precisely the kind of 'faceless' production enabled by the globalized shifts in manufacturing (Luckman 2013). Policy agendas for economic development and population management have thus been reinvigorated by creative cluster thinking (Matarasso and Landry 1999; Leadbeater 2000; Florida 2003). This has been most popularly manifested in urban policy via the work of economist Richard Florida, whose 2003 best seller *The Rise of the Creative Class* initiated a wave of interest globally among city officials and urban planners in attracting and keeping the knowledge workers seen as essential to economic growth in the new economy. However, creative place-making ideas – both academic and policy-oriented – have tended to focus on cities and urban spaces. All too often, the young, the digital and the urban have been the privileged sites of creative industries discourse and policy.

Some notable exceptions to this more general absence of work on rural and regional cultural economies are emerging in cultural geography, particularly in the United Kingdom (Bell and Jayne 2010; Chapain and Comunian 2010; Drake 2003; Jayne 2005; Luckman 2012) and to a growing extent in Australia (Connell and Gibson 2009; Gibson 2002, 2003, 2009; Gibson and Klocker 2004; Gibson and Robinson 2004; Luckman 2012). However, even among this body of work, creative industries at a regional level (beyond any one city or town) have received relatively little attention (Thomas et al. 2013: 78). In the United Kingdom, Bell and Jayne (2010) connect the broader push towards a post-agricultural economy in rural and regional parts of Britain to the development of rural creative industries policy there, and note that much of the discussion of rural cultural industries has been couched in terms of arts *as* rural regeneration strategy. They particularly critique these 'arts policy' moves for their assumption that urban creative industries development templates can be applied seamlessly in rural locations (Bell and Jayne 2010: 210; see also Chapain and Comunian 2010). They also challenge stereotypes of non-urban creative industries as most are about 'traditional' rural activities such as crafts, art and antiques, which they argue are based on problematic

visions of a rural idyll, rather than on the reality of decentred contemporary practice (Bell and Jayne 2010), especially as enabled by communications technologies. This said, in the United Kingdom as in Australia, more traditional arts and crafts are a particularly visible part of the regional creative economy, particularly in amenity-belt locations, partially precisely because of these romantic assumptions; city day-trippers as consumers often come in search of this kind of handmade local economy. In a globalized marketplace of the international flow of goods, the quest for the 'authentic' and the 'original' drives a growing middle-class consumer demand for unique products, and non-urban creative enterprise is able to 'exploit local traditions, reputations or narratives as a form of product branding' (Drake 2003: 520; see also Crouch 2006).

While this retail visibility may reinforce a stereotyped vision of the regional creative economy in some tourist-oriented locales, there remain a variety of creative producers operating in less visible ways. Often operating from a home office or studio, for many their production presence in the locale is not necessarily visible on its main roads or shopfronts. Thus, just as in cities (Luckman et al. 2009), rural, regional and remote locations are complex and diverse and hence resistant to 'one-size-fits-all' solutions to developing creative economies, especially given that most of these policy responses were fine-tuned over the past few decades in urban locations. Indeed, at least six key economic relationships can be identified for regional creative workers:

1. Marketing and selling to locals goods/services with a distinct local/regional character
2. Marketing and selling to visiting outsiders goods/services with a distinct local/regional character
3. Marketing and selling widely goods/services with a distinct local/regional character
4. Marketing and selling to locals goods/services that just happen to be made/located in a rural, regional or remote location
5. Marketing and selling to visitors goods/services that just happen to be made/located in the regional location
6. Marketing and selling widely goods/services that just happen to be made/located in the regional location

Each relationship defines the nature of the business: how it advertises and positions itself in the market, what kinds of products are made and, significantly for regional cultural identity and politics, how 'local character' is manifest as a key aspect of the consumer practices underpinning the first, second and third types of relationship.

Creative Workers and the 'Post-Productivist' Countryside

> Men and women still want to live in specific places. This could mark the beginning of an alternative market culture.
>
> (Zukin 1991: 275)

The economic re-structuring of the 1970s that saw the decline of industrial cities and jobs in urban centres as cheaper labour was found offshore has had a parallel economic shift in the countryside in the industrialized world. As Bell and Jayne (2010: 210) write, this has seen the rise of diversified rural economies aimed at least in part at 'attempting to offset declines in traditional rural production'. They continue: 'Policies of farm diversification, for example, have turned to various economic activities for rural communities, including creative work. Alongside revitalized and rebranded rural food production and other landscape consumption cultures, and growth in the tourism and leisure sectors […]' (Bell and Jayne 2010: 210; see also Urry 2002). As such, and as Abrams et al. (2012: 274) have noted, far from moving away from production absolutely, this rural post-productivist economy is bound up in new modes of production that 'represent significant investments of financial resources and effort'. Such a 'post-productivist countryside' (Halfacree 1997; Wilson 2001) being championed increasingly across the industrialized world acknowledges a shift in local economic foundations from agricultural production to an emphasis on the countryside as a site for 'consumption, tourism and recreation' (Bell and Jayne 2010).[2] Often without any irony, especially in terms of contemporary food tourism and niche markets, these industries reify an 'aspirational ruralism' (Woods 2011), a romanticized image of what 'farming could or should be' (Holloway 2000: 314, quoted in Abrams et al. 2012: 274); an acceptable simulacra of rural industries where farming and processing odours are contained, farm labour is idealized, death is absent and food production is small scale, bespoke, niche, and gourmet, not industrial.

Not all regional locales are able to compete equally in this contemporary production marketplace. 'Amenity-belt' peri-urban and iconic regional locations within a few hours' driving distance of major capitals, those who have long attracted weekend sojourners, are those best placed to capitalize from the post-productivist economy and from population renewal fuelled by incomers. Such 'amenity migration' – 'the movement of largely affluent urban or suburban populations to rural areas for specific lifestyle amenities, such as natural scenery, proximity to outdoor recreation, cultural richness, or a sense of rurality' (Abrams et al. 2012: 270)– of those in search of what in Australia is frequently popularly referred to as a 'sea-change' or 'tree-change' lifestyle,[3] tends to also favour those parts of the countryside deemed attractive to the potential visitor on account of them fitting with conventional ideas of desirable 'landscape' (Urry 2002: 88). Therefore, these changes have not impacted all rural towns and regions equally, with the effect that new divides are emerging between regional communities experiencing growth, and those places outside the zones of desirability (Rogers and Jones 2006: 9). The effect is that some regional communities are already well on their way to establishing strong post-productivist economies with a visible cultural economic presence, while others, like cities before them, are still looking to creativity-led regeneration or other renewal strategies.

Despite the glossy brochures, rural idyll magazines and high production value advertisements, such shifts in rural identity and economies are clearly not seamless – far from it – and internal divides are appearing. All this patently gives rise to a range of concomitant

challenges to local identity, affordability (with gentrification being a logical outcome of rural regeneration, just as it is in urban and suburban locales) and environmental sustainability (Costello 2007; Luckman 2012). A 'countryside in crisis' discourse is present at the amenity-belt regional level and this is marked by an emphasis on things such as rapid growth; concerns about the fragility of regional identity, especially for those involved in traditional rural industries; social dysfunction and resilience; unsustainable population growth; long commutes; ageing communities; infrastructure pressure; and a loss of local identity. Summarizing literature from a number of English-speaking nations of the Global North that are facing similar challenges (Australia, the United States and the United Kingdom in particular), Abrams et al. (2012) identify other problems that arise for rural communities as a result of such in-flows of new residents, including pressure on physical facilities, which in communities whose economy is strongly dependent upon tourism are often designed to only accommodate larger populations for part of the year during peak visitor season; new rural residents seeking to '"lock the gate" behind them to prevent further development after their own migration'; and more general issues that identify a particular middle-class or overly romantic vision of 'rurality' being brought into the community by incomers (Abrams et al. 2012: 277; Costello 2007; Luckman 2012; Urry 2002).

Creative Workers, Stage of Life and Lifestyle 'Amenity Migration'

Despite the challenges, people continue to arrive, or return; and while not dismissing the importance of these challenges, this mobility can be a valuable source of creative capital. Among those attracted to the downshifting lifestyle are, unsurprisingly, creative workers, attracted increasingly by the possibilities afforded by digital technology to undertake decentralized practice. As I have written in greater depth elsewhere (Luckman 2012), rural and regional cultural work presents a number of opportunities as well as challenges, not all of which are unique to their non-urban location. The realities of small business as a non-urban cultural worker include the need to engage in 'bread and butter' work to supplement income. This includes having diversified offerings; for example, low-cost options such as everyday household items or lower-cost prints alongside large-scale sculptural pieces or original paintings. Importantly too for this discussion, 'bread and butter' top-up employment frequently involved engaging in teaching work, both informally out of a home studio or retail shopfront, or more formally as a visiting artist or teacher in a local school. Non-urban creative workers also frequently refer to difficulties in advancing or further developing their practice, given the limited opportunities available for training and immersion in cutting-edge practice in smaller communities. This notably parallels concerns in many rural and regional communities around the loss of young people, who frequently leave to pursue educational and development possibilities elsewhere. Such training gaps are also often accompanied by concerns over a lack of critical culture; when everyone knows everyone else, chances are the local newspaper is not going to condemn your latest exhibition.

It is difficult to fight against global trends that have long seen creative young people flowing out of country towns, to pursue opportunities in larger centres. The desire when young to go off and 'find oneself' or attend the kind of training facility not possible without critical mass is a strong pull factor not limited to rural and regional communities. As indicated by one of my Barossa interviewees, it is valuable to query whether this is always a bad, or stoppable, thing:

> You know, it's interesting, local governments […] have a real focus on 'how do we retain our young people?' You don't necessarily want to retain them. You want them to come back, or you want to attract others, but they need to go out and see a bit. We've got friends that have grown up and lived in the one place all their lives, and I just think, 'oh, go and see a bit more of the world'. Each to their own, but yeah, I would want to encourage my kids to go out and see a bit and experience a bit.
> (30–40-year-old female community and cultural development coordinator, Barossa Valley)

Importantly too, in the Newcastle-Gateshead region of the United Kingdom (Chapain and Comunian 2009) and in sea-/tree-change locations in Australia (Costello 2007) including the Barossa, this traffic is not always one way. In a world in which not all regions are able to compete equally for incomers and economic growth, some regions are able to experience a new 'brain gain', drawing in people from other regions as well as cities. That young people leave regional communities for a variety of reasons is not something this chapter has any desire to challenge; rather, it considers another trend that receives less publicity: the (re)turn of creative workers (back) to regional locales as different stages of life with different priorities emerge in their lives.

In September 2010, the results of a British study were released that found that those aged between 35 and 44 were most likely to feel lonely, depressed and that work was getting in the way of personal relationships (Allan 2010). Loaded up with some other findings, and ever keen for broad-brush generational stories, the day's newspapers both in the United Kingdom and elsewhere where the story was picked up (for example, in Australia) loudly proclaimed that the late 30s were the new 'mid-life' crisis years (Allan 2010). While such findings, not to mention the study itself and most especially what the mass press made of it, clearly need to be taken with the proverbial grain of salt, they did tap into a feeling of burnout or of there being 'something more' among some younger creative workers. Particularly vulnerable to this are those who may have 'front-loaded' their career in the hopes of getting ahead early, only to find it difficult to slow down and maintain status and/or income as other life interests (for example, partners and children) come along. In such an environment, it is unsurprising that the so-called Gen Xers (those born from roughly the early 1960s to the early 1980s), who hit this paradigm shift with its exponential technical learning curve head on, and the current twenty-somethings who frequently, especially in technology-driven industries, remain the 'workhorses' of the creative economy (Florida 2003: 155) may identify with a discourse of burnout and crisis.

Certainly this was a finding of Hesmondhalgh and Baker's recent research into the British television, music recording and magazine publishing industries, where they observed that 'many workers leave the cultural industries at a relatively early age, burnt out by the need to keep up to date with changing ideas of what is fashionable, relevant and innovative, a process that requires not only hard work at work, but also a blurring of work and leisure' (Hesmondhalgh and Baker 2011: 220–221). Even if they are not 'burnt out' as such, many creative workers find that the working patterns required to maintain expensive accommodation and an urban lifestyle, often in inner-city housing not large enough to raise a family, are no longer sustainable or desirable when they decide to have children. In my research, this was the key point in many rural, regional and remote creative workers' lives when the decision was made to move. For example:

> My family was absolutely the motive for going to the Barossa. I was living in inner-city Sydney in Surrey Hills, in a little street called Batman Lane which is really appropriate considering I was doing comic books. And my wife had just given birth to our oldest son. I was 26, she was 35. We had decided to have a family at that point because of her age. I would have probably waited a couple more years, but because there was this age gap and the old biological clock was ticking we decided that that was the time to do it. So my career probably wasn't as established as I would have liked. At that point my comic book career was very strong in Australia and I was just starting to dip my toe into the waters of the American scene. But I didn't have that sort of level of financial security from my career that I could afford to keep working in Sydney, given that my wife had just had a child, we had agreed that she was not going to be a part-time mum, that she was going to, at least for the first 3 or 4 years, become a full-time mother. We expected to have two children, so we assumed that there'd probably be a five-year gap where we'd have to live pretty much on my income. So I had a business partner who was working down in the Barossa and I wasn't actually heading for here, I was heading for just anywhere outside of Sydney, because Sydney is one of the most expensive cities in the world.
> (40–50-year-old male independent film producer, director and writer, Barossa Valley)

This also partially explains recent Australian research into internal migration drawing upon ABS data, which found that 79 per cent of those making a sea/tree change were under 50 (Weekes 2010). It is also the story that emerges in the most recent Australian census data for amenity-belt regional communities with strong and emerging post-productivist economies. For example, if we return to where this chapter opened in the Yarra Valley, looking at the 2011 Australian census data, we can see in Figure 5 a clear trend whereby in the 20–29 age bracket inner-city Melbourne does indeed have far more resident arts professionals[4] than the nearby amenity-belt Local Government Associations of the Yarra Ranges, Hepburn and Macedon (east/north-east, north-west and north of Melbourne, respectively). However, once the age profile shifts to 30–39 years, the inner-city figures start

a strong and consistent downward trend as young people settle down into home ownership and families outside the inner city. Concurrently, there is a growth in the figures for the amenity-belt locations, which is most pronounced for the Yarra Ranges where the numbers of local arts professionals overtake inner-Melbourne figures in the 40–49-year range. Similar, although less equivocal, figures are evident in Figure 6 for the equivalent South Australian locales. Here, the Adelaide Hills (which start less than 20 minutes' drive from the centre of Adelaide) offers a trajectory that most directly parallels that of Victoria's Yarra Ranges. The steady and clear growth of regional arts professionals as one ages can again be considered in terms of the freedom to pursue the work one loves that can come with greater financial security. What is clear here is that the picture, at least in this economic sector in such amenity-belt locations, is indicative of a potential growth of capacity around creative capital that grows as the community ages. Further, the trend emerging here towards regionally located cultural work peaking among older residents challenges deeply the urbanized stereotypes of the creative worker as young hipster.

Therefore, and importantly for fortunate regional communities and policy-making, the story is not all one of 'loss'. In desirable amenity migration locations, one clear trend was for young people from rural, regional and remote communities to head to the cities for education, training or simply to experience the lifestyle for a while – to be able to say they had gone away and 'done' the 'city thing' – and then to return as skilled workers, often with families. Such 'boomerang' people and their young families return with heightened social, economic and cultural capital, which they can then feed into their regional communities.

Additionally, as the baby boomer generation starts to contemplate their post-full-time work lives, it is important to acknowledge that, while they may not be the focus of Richard Florida-style appeals to the creative class that emphasize youth, older cultural workers too are a vital part of the regional creative economy, especially in the sole-trader and micro-enterprise sector. In my own research, I found a clear trend in rural and regional areas in particular for cultural workers to be engaged in a form of downshifting as part of a semi-retirement lifestyle (Luckman 2012). For some, this involved a different role within an industry that they had long worked in; for others, it involved the chance to focus specifically on their creative practice without the pressure to have a 'day job' as well. Economically less encumbered than they were when they had dependent children, and often with capital freed up due to downshifting from a larger suburban home to a smaller, more rural lifestyle, 'e-tirement' (Pink 2001: 234) participation in the cultural economy is a valuable strategy of activity and top-up income for many. Semi-retirement furnishes these older creative workers with a chance to pursue professionally an interest long held but never realizable alongside life pressures such as mortgages, children or other careers. Creative work, often funded by a sea-/tree-change lifestyle shift to the country, is in many ways a logical and highly desirable form of semi-retirement predicated upon 'work' that is a form of 'post-Fordist labour/leisure' (Dawkins 2011: 264).

With many young families and (semi)retirees (re)turning to regional communities to raise children or wind down, respectively, the amenity migration of creative workers

represents a subsequent return of expertise back into amenity-belt regional communities. Smaller, regional locations are generally simply unable to offer the same opportunities and economies of scale as urban locales. Nor can they compete with the desire of young people to explore the world, go out on their own and learn for themselves what they may or may not be missing. In this situation, as the population of the Global North ages, and as people live longer with prodigious hopes for active and engaged lifestyles, this ageing community should not be viewed as wholly a burden on local infrastructure. Instead, it is timely that a greater focus be directed towards them as key contributors to the local infrastructure that bring in outside expertise of value to (isolated) young people, among others. Creative workers are an important education and training resource in regional communities, especially in the absence of any nearby formal facilities. Therefore, (semi)retirees are to be embraced as important and rich creative contributors in regional communities. Further, rather than an emphasis on 'children leaving', a significant opportunity exists in rural and regional research and policy-making for a greater emphasis on 'families returning', bringing with them the kinds of expertise and capacity to create lifestyle amenities in search of which people may otherwise gravitate towards urban locations. Young families also mean a significant return of population and demand for goods and services in regional communities, including education and retail. With the in-migration of young families also tending to outweigh the loss of young people from rural communities (Cleary et al. 2013; see also Gurran and Blakely 2007: 115), this gives rise to a virtuous circle of supply and demand, and the potential need for secondary migration to service the amenity migrants. Having more resources *in situ* (provided in part by returning residents) also helps to engage younger and other residents more and longer, with potential subsequent increases in the creative capacity of the area's community, leading to enhanced retention, re-attraction/return and growth. To maximize this potential, regional communities need to follow the example set in the literature on creative cities to ensure that new and/or returning residents are made to feel welcome by the community and are able to quickly become part of local employment, development and volunteer networks so that their expertise can be recognized, rewarded and fed promptly back into the community in diverse ways.

The lifestyle migration of creative workers represents a subsequent return of expertise – a 'brain gain' – back into some regional communities well-placed to capitalize upon post-agricultural production economic transformation, the growth of cultural and leisure-based businesses and lifestyle migration. In this light, creative workers should be viewed as an important regional education and training resource, especially in the absence of any nearby formal facilities, and thus this chapter calls for (re)turning young families and (semi)retirees to be embraced as important and rich contributors to the growth of creative literacies of regional areas. The flow-on effects are not only economic but also social, and include the likelihood of providing an environment more connected to global flows and thus, ironically, more attractive precisely to the young people that regional communities fear losing to larger urban centres (Gibson 2008). Thus, rather than being seen as a source of 'loss', mobility is

more appropriately located as a form of personal and community resilience and capacity building for regional communities able to attract amenity migration.

Acknowledgements

A sincere thank you to all of the interviewees who gave their valuable time and generously shared their life experiences with me. Thank you also to the ABS staff who worked with me to generate the custom data set employed in this discussion.

References

Abrams, J., Gosnell, H., Gill, N. and Klepeis, P. (2012), 'Re-creating the rural, reconstructing nature: An international literature review of the environmental implications of amenity migration', *Conservation and Society*, 10(3), 270–284.

Allan, C. (2010), 'My midlife crisis has focused me on what to do between now and death', *The Guardian*, 5 October.

Banks, M. (2007), *The Politics of Cultural Work*, Basingstoke and New York: Palgrave Macmillan.

Bell, D. and Jayne, M. (2010), 'The creative countryside: Policy and practice in the UK rural cultural economy', *Journal of Rural Studies*, 26, 209–218.

Chapman, Caroline and Comunian, Roberta (2010), 'Enabling and inhibiting the creative economy: The role of the local and regional dimension in England', *Regional Studies*, 44(6), 717–734.

Cleary J., Hogan, A., Carson, D., Houghton, K., Tanton, R., Donnelly, D. and Carson, D. (2013), 'Securing the wealth and well-being of rural communities', *Institute of Australian Geographers Conference*, Perth, WA, 1–4 July 2013.

Connell, John and Gibson, Chris (2003), *Sound Tracks: Popular Music, Identity and Place*, New York: Routledge.

Connell, John and Gibson, Chris (2009), 'Ambient Australia: Music, meditation and tourist places', in O. Johansson and T. Bell (eds), *Sound, Society and the Geography of Popular Music*, Farnham: Ashgate, pp. 67–88.

Crouch, David (2006), 'Tourism, consumption and rurality', in Terry Marsden, Patrick Mooney and Paul Cloke (eds), *Handbook of Rural Studies*, London: Thousand Oaks and New Delhi: Sage, pp. 355–364.

Dawkins, Nicole (2011), 'Do-it-yourself: The precarious work and postfeminist politics of handmaking (in) Detroit', *Utopian Studies*, 22(2), 261–284.

Department for Culture, Media and Sport (2013), *Classifying and Measuring the Creative Industries: Consultation of Proposed Changes*, London: DCMS, available at www.gov.uk/dcms

Drake, Graham (2003), '"This place gives me space": Place and creativity in the creative industries', *Geoforum*, 34, 511–524.

Florida, R. (2009), *Who's Your City?: How the Creative Economy Is Making Where to Live the Most Important Decision of Your Life*, New York: Basic Books.

Gibson, Chris (2002), 'Rural transformation and cultural industries: Popular music on the New South Wales far north coast', *Australian Geographical Studies*, 40(3), 337–356.
Gibson, Chris (2003), 'Digital divides in New South Wales: A research note on socio-spatial inequality using 2001 census data on computer and internet technology', *Australian Geographer*, 34(2), 239–257.
Gibson, Chris (2009). 'Place and music: Performing "The Region" on the New South Wales far north coast', *Transforming Cultures eJournal*, 4(1), 60–81.
Gibson, Chris and Connell, John (2004), 'Cultural industry production in remote places: Indigenous popular music in Australia', in Dominic Power and Allan J. Scott (eds), *Cultural Industries and the Production of Culture*, New York: Routledge, pp. 243–258.
Gibson, Chris and Connell, John (eds) (2011), *Festival Places: Revitalising Rural Australia*, Bristol: Channel View.
Gibson, Chris and Klocker, Natascha (2004), 'Academic publishing as "creative" industry, and recent discourses of "creative economies": Some critical reflections', *Area*, 36(4), 423–434.
Gibson, Chris and Robinson, Daniel (2004), 'Creative networks in regional Australia', *Media International Australia*, 112, 83–100.
Gurran, N. and Blakely, E. (2007), 'Suffer a sea change?: Contrasting perspectives towards urban policy and migration in coastal Australia', *Australian Geographer*, 38(1), 113–131.
Halfacree, K. (1997), 'Contrasting roles for the post-productivist countryside. A postmodern perspective on counterurbanisation', in P. Cloke and J. Little (eds), *Contested Countryside Cultures: Otherness, Marginalisation and Rurality*, London: Routledge, pp. 70–93.
Hartley, J. (2004), 'The new economy, creativity and consumption', *International Journal of Cultural Studies*, 7(1), 5–7.
Hartley, J. (ed.) (2005), *Creative Industries*, Malden and Oxford: Blackwell.
Hesmondhalgh, D. (2002), *Cultural Industries*, London, Thousand Oaks and New Delhi: Sage.
Hesmondhalgh, D. and Baker, S. (2011), *Creative Labour: Media Work in Three Cultural Industries*, London and New York: Routledge.
Jayne, Mark (2005), 'Creative industries: The regional dimension?', *Environment and Planning C: Government and Policy*, 23, 537–556.
Leadbeater, C. (2000), *Living on Thin Air: The New Economy*, London: Penguin.
Luckman, Susan (2012), *Locating Cultural Work: The Politics and Poetics of Rural, Regional and Remote Creativity*, Basingstoke and New York: Palgrave Macmillan.
Luckman, Susan (2013), 'The aura of the analogue in a digital age: Women's crafts, creative markets and home-based labour after Etsy', *Cultural Studies Review*, 19(1), 249–270.
Luckman, S., Gibson, C. and Lea, T. (2009), 'Mosquitoes in the mix: Just how transferable is creative city thinking?', *Singapore Journal of Tropical Geography*, 30(1), 47–63.
Matarasso, F. and Landry, C. (1999), *Balancing Act: Twenty-One Strategic Dilemmas in Cultural Policy*, Strasbourg: Council of Europe.
Pink, D.H. (2001), *Free Agent Nation: The Future of Working for Yourself*, New York and Boston: Business Plus.
Rogers, M. and Jones, D. (2006), 'Renewing country towns', in M. Rogers and D. Jones (eds), *The Changing Nature of Australia's Country Towns*, Ballarat: Victorian Universities Regional Research Network Press.

Thomas, Nicola, Harvey, David and Hawkins, Harriet (2013), 'Crafting the region: Creative industries and practices of regional space', *Regional Studies*, 47(1), 75–88.
Urry, J. (2002), *The Tourist Gaze: Theory, Culture and Society*, 2nd edn, London: Thousand Oaks, and New Delhi and Singapore: Sage.
Weekes, P. (2010), 'In pursuit of a richer lifestyle', *The Age*, 25 August.
Wilson, G.A. (2001), 'From productivism to post-productivism ... and back again? Exploring the (un)changed natural and mental landscapes of European agriculture', *Transactions of the Institute of British Geographers*, 26, 77–102.
Woods, M. (2011), 'The local politics of the global countryside: Boosterism, aspirational ruralism and the contested reconstitution of Queenstown, New Zealand', *GeoJournal*, 76(4), 365–381.
The Work Foundation (2007), *Staying Ahead: The Economic Performance of the UK's Creative Industries*, London: Department for Culture, Media and Sport.
Zukin, S. (1991), *Landscapes of Power: From Detroit to Disney World*, Berkeley, LA and London: University of California Press.

Notes

1 http://artistslounge.rfbf.com.au/
2 The post-productivist countryside is very much the focus of the current 'Be consumed' advertising campaign for the Barossa Valley tourist region, which has at its centre point an advertisement produced by Adelaide's kwp! Agency, which recently won the grand prix award at the Cannes Corporate Media and TV Awards. The ad can be viewed at http://www.youtube.com/watch?v=MoMp-V_CRdc
3 The term 'sea change' was popularized by demographer Bernard Salt following the 2001 publication of his book *The Big Shift*, Hardie Grant Books, Melbourne.
4 The Australian Bureau of Statistics divides the 'Sub-Major group 21 Arts and Media Professionals' (which is itself a subset of the larger grouping 'Major Group 2 Professionals') further down into the subset 'Minor Group 211 arts professionals'. It notes that in Australia and New Zealand: 'Most occupations in this minor group have a level of skill commensurate with a bachelor degree or higher qualification. At least five years of relevant experience may substitute for the formal qualification. In some instances relevant experience and/or on-the-job training may be required in addition to the formal qualification. Some occupations in this minor group require high levels of creative talent or personal commitment and interest as well as, or in place of, formal qualifications or experience (ANZSCO Skill Level 1)'. The Minor Group 'arts professionals' is further broken down into the constitutive subgroups: Actors, Dancers and Other Entertainers, Music Professionals, Photographers and Visual Arts and Crafts Professionals. Source: http://www.abs.gov.au/ausstats/abs@.nsf/0/0D055BF9F69D3B90CA2571E20083543A?opendocument

Colour plates

Figure 1: Conceptual map of agri-tivity.

Figure 2: Creative occupations in New South Wales by Local Government Area using 2011 Australian Bureau of Statistics Census Data.

Figure 3: The Boathouse.

Colour plates

Figure 4a&b: 'The Artist's Lounge', Healesville, Victoria, Australia.

Location of Arts Professionals in Victoria by Age
(inner city and amenity belt comparison)

	15 - 19	20 - 29	30 - 39	40 - 49	50 - 59	60 and over
Melbourne (city)	16	134	104	63	38	27
Yarra Ranges	8	37	56	61	66	29
Hepburn	0	3	13	15	14	8
Macedon Ranges	6	12	11	16	21	21

Location of Arts Professionals in Victoria by Age
(inner city and amenity belt comparison)

	15 - 19	20 - 29	30 - 39	40 - 49	50 - 59	60 and over
Melbourne (city)	16	134	104	63	38	27
Yarra Ranges	8	37	56	61	66	29
Hepburn	0	3	13	15	14	8
Macedon Ranges	6	12	11	16	21	21

Figure 5a&b: Trends in location of resident art professionals, Victoria (Source: Australian Bureau of Statistics 2011).

Colour plates

Location of Arts Professionals in South Australia by Age
(inner city and amenity belt comparison)

	15 - 19	20 - 29	30 - 39	40 - 49	50 - 59	60 and over
Adelaide (city)	4	32	15	4	9	3
Adelaide Hills	6	13	23	21	24	18
Barossa	0	5	5	11	0	3

Location of Arts Professionals in South Australia by Age
(inner city and amenity belt comparison)

	15 - 19	20 - 29	30 - 39	40 - 49	50 - 59	60 and over
Adelaide (city)	4	32	15	4	9	3
Adelaide Hills	6	13	23	21	24	18
Barossa	0	5	5	11	0	3

Figure 6a&b: Trends in location of resident art professionals, South Australia (Source: Australian Bureau of Statistics 2011).

Figure 7: Jennifer Wright (Summers)'s *Mutant Diversity* used recycled items, papier-mâché and expanding foam to create colourful faux gardens in disused water fountains.

Figure 8a&b: Sandra Jarrett's *The Poetry Within* (2008) is a steel water tank, with its emptiness exposed through decorative plasma-cut floral design.

Figure 9: Charlton's *Forlawn* (2008) – model developed in planning stage; on display at the Toowoomba Regional Art Gallery.

Figure 10: Charlton's *Forlawn* (2008) – completed artwork in the botanical gardens during the 2008 Carnival of Flowers.

Figure 11: A 2007 publicity shot of Mary-Kate Khoo at the empty water feature that her sculpture would fill.

Figure 12a&b: Mary-Kate Khoo's *Bed Of Roses* (2007) and detail.

Colour plates

Figure 13: Mayor Peter Taylor opening the 2008 exhibition in Gallery M.

Figure 14: Deborah Beaumont's plan for 'Four Worlds', constructing fish patterns from discarded aluminium plates used in newspaper printing.

Figure 15: Beaumont's completed work installed in a fountain for the 2008 Carnival of Flowers.

Figure 16: Sister Angela Mary's scanned baggage tags.

Chapter 7

Art in Response to Crisis: Drought, Flood and the Regional Community

Andrew Mason
The University of Southern Queensland

and response. Both of these projects were administered by Arts Council Toowoomba as public expression and to aid community resilience.

Drought

In 2006, the city of Toowoomba was suffering from the most severe drought since European settlement. Australia may be known as a land of droughts and flooding rains, but for areas like Toowoomba that have a reputation for a reliable annual rainfall, the crisis of drought was exacerbated by its unfamiliarity. Perched on the edge of the Great Dividing Range, rain tends to break over the elevated region and run down into the three large storage dams that provide Toowoomba's water supply. The water is then pumped uphill to treatment plants and reticulating facilities on the higher peaks around the edge of the city. Indeed, one of Toowoomba's most recognized man-made structures is an elegant, space-aged water tower. This water tower is an enormous, stylized, mushroom-shaped facility that stands at one of the city's premier public parks, Picnic Point, and welcomes traffic entering the city from the east as drivers negotiate one of the steepest range highways in Australia.

Drought does not suddenly appear, it is an incremental malady, creeping and growing, creating stress and tension as the available water becomes increasingly scarce. The negative effects of drought on the health and well-being of rural communities are well-known: suicide rates increase, farmers leave properties that have been under their family's stewardship for generations and marriages and relationships break down. While Toowoomba is a modern city with a reticulated water supply and a wide range of professions (not limited to farming), drought affects people in much the same way. People discuss the widening cracks in the earth, the plants dying in their gardens, the effect on native wildlife and the structural damage to homes caused by shifting soil under foundations. Toowoomba's strive for modernity was such that in the 1980s, the City Council discouraged the installation and use of rainwater tanks, which were seen as something of the past and as a threat to public health and visual amenity. With the drought biting harder, the City Council in the twenty-first century developed programmes to encourage the installation of rainwater tanks by providing generous subsidies for their purchase and greatly reducing the approval application process. Water tank manufacturing businesses sprang up and quickly became a growth industry, competing with each other for the frenzied demand for subsidized tank installations. In 2014, Toowoomba Regional Council required all new homes to have a rainwater tank installed at the time of building.

During the drought, the City Council imposed necessarily strict water restrictions that meant no reticulated water was to be used outside the house, and residents could be fined for even having a hose attached to a town water supply. Gardens were transformed, lawns turned brown and many gardeners ripped up their turf and replaced it with pebbles, mulch or woodchips, while exotic flowering annuals were replaced with hardy and drought tolerant native species, cacti or rocks and concrete. These water restrictions also affected

Toowoomba City Council's own parks and public garden areas. Fountains and ornamental ponds were drained and filled with pebbles or woodchips and many of the floral garden beds were left unplanted and covered in thick mulch.

The use of grey water was something that the Council had previously discouraged due to fears of contamination and disease; however, under severe drought, grey water diverters were stocked in many shops and the use of grey water became commonplace. Showers were limited to less than three minutes, with the Council providing free shower timers. Old, inefficient shower roses could be exchanged for a free, new water-efficient showerhead from the Council office. Many residents also took to showering above a bucket, to collect water to be re-used in the garden.

Toowoomba's water was running out and this threatened the viability of the city itself. Not only were the dams reduced to unprecedented levels of only a few per cent of storage capacity, but the lack of water in the dams was causing additional problems. While the dams dried out, cracked and became overgrown, they also developed outbreaks of toxic blue-green algae. The problem became so serious that one of the three dams, Cooby Dam, had to be taken off-line; no longer able to supply what little water it had due to its high concentrations of algae. The only solution for this problem was adequate water to flush the dams clean, and an adequate amount of water was unavailable.

With the city's water supply critically low and running on reserves of ground water, solutions such as the so-called 'Water Futures' proposal were debated. The Water Futures policy initially had support and funding from local, state and federal governments. Water Futures was a suite of strategies, with the most notable and controversial among them being water recycling, whereby purified waste water was to be supplemented back into the reticulated water system to extend the water collected from other sources. The proposal was to build a reverse-osmosis treatment plant that would treat the waste water to very high levels of purity. This purified water would then be stored in Cooby Dam, thus curing the algae problem by dilution and allowing the water from that dam to be used, only if needed, by blending it as a small percentage of the water that would then be treated and fed through the reticulated water supply to houses and businesses.

The public debate over Toowoomba's proposed use of recycled water was prominent and attracted national and international media coverage. Many other areas of regional Australia were also in drought and were facing similar decisions; Toowoomba was to be a precedent on this issue. With some disquiet in the community over the distasteful imagery associated with drinking recycled water, the Federal Minister for the Environment and Water, Malcolm Turnbull, amended his earlier decision to fund the project and made funding dependent on a majority of residents supporting recycled drinking water in a poll. The debate became vitriolic at times and greatly divided the community. Anti-water-recycling campaigners formed groups and coalitions and, with funding from a prominent local developer, attacked the Council's plans at public meetings and in the media. While the Council countered with detailed factual and scientific information about the plan and why it had been chosen as the best solution, the 'No' Campaign, as they came to be known, ran an emotive campaign

asking 'Is it safe?' and saying that a 'no' vote would put all the options, including water recycling, back on the table. When the poll was finally taken on 29 July 2006, 62 per cent of those polled voted against the addition of recycled water to the city's drinking water supply. Speaking to the local newspaper in a retrospective piece five years later, Dianne Thorley, who was Mayor during the debate, said that the bitterness had permanently scarred the community and 'turned families against each other' (Anon 2011).

After the tensions of the water debate in 2006 and with ongoing drought, the community was still raw. By 2007, with severe water shortages threatening the viability of the city itself, the Carnival of Flowers appeared as an extravagance that the public could ill afford. There was talk of cancelling the festival; after all, why would tourists want to come to see a drought-ravaged city with brown lawns and dead or empty garden beds? The drought had struck at the heart of Toowoomba's identity. Drought was destroying the Garden City, threatening its iconic event and tearing the community apart by inflaming fear-induced tensions among residents. Cancellation of the Carnival of Flowers would be another blow to the already stressed community and would also have an economic impact, as the festival attracts up to 125,000 visitors annually to view the gardens, a significant number for a regional centre with only around 100,000 people within its urban boundaries.

In a mark of community determination, it was decided that the Carnival of Flowers would proceed, with a reduction in the number of public gardens and a transformation of the focus in the gardening competition towards sustainability and 'Water Wise Gardens'.

Arts Councils and Their Role in Community

It was into this environment that the fledgling Arts Council Toowoomba devised a project that would grow from the community and address the stresses of drought in a manner that would facilitate healing and identity building. The concept, called Avant Garden, was a simple one – to allow local people to create public art that would fill the barren public garden beds left vacant due to lack of water.

Avant Garden was an initiative devised to create ephemeral public art in response to drought. From the start, the concept was that a public call should be made to invite any interested members of the local community to propose their designs for public gardens and spaces during the Carnival of Flowers. Not only did this engage the broader community and emerging artists, it also served to promote membership of Arts Council Toowoomba (it was a requirement that all artists selected become members of Arts Council Toowoomba so they would be covered for public liability insurance). The result was a public profiling of local emerging artists during an event that is one of the largest tourism drawcards in the Toowoomba region. The artworks themselves served to replace the floral and water features in a way that showed community resilience to the ongoing crisis of drought.

Arts councils worldwide are (usually) independent bodies tasked with promoting the arts in their local communities. In Australia, arts councils followed the British model and are local volunteer organizations under a state-managed body, united under Regional Arts

Australia. The Queensland Arts Council was established in 1961 and facilitated theatre and arts programmes throughout the state. Now rebranded as Artslink Queensland, regional development of arts remains central to the vision of the organization. Local arts councils, which number over 50 in Queensland alone, all have their own focus and idiosyncrasies, reflecting their local membership.

Arts Council Toowoomba is a volunteer organization whose mission statement is to showcase Toowoomba and its region as a vital and creative centre for the arts. Arts Council Toowoomba formed a management committee in 2005 and began working on the process of incorporation and affiliation with the state body, the then Queensland Arts Council (now Artslink Queensland). In March 2006, Arts Council Toowoomba was registered and approved; these measures also facilitated public liability insurance, which had become a prohibitive burden on small community organizations in the preceding years. The creation of this new arts organization coincided with the stress of drought and the tensions of the Water Futures debate. Determined to represent the community, Arts Council Toowoomba took up these issues as the most significant at the time.

The Arts as Response to Challenge

It is not uncommon for arts practice to fill a human need within a response to life challenges; it is of little surprise that some of the most significant art in history provides meaningful reflection around human themes of mortality, romance, war and hardship. From operas to religious imagery, the importance of art as response to uncertainty of the future is manifest. Traditional art criticism centres around the engagement with such art on an individualistic level of life, both in terms of the artist and the audience. Anthropologists and the social sciences take a wider approach, examining craft and artefacts as indicative of the cultural life of a community. Art tells stories and invites reflection. Stories move through stages of transformation, often driven by conflict or crisis (Bordwell and Thompson 1991; Todorov 1977, cited in Fiske 1988). The use of art in talking about conflict or crisis is, of course, as old as art itself; however, here we discuss the broader implication of public art as a community-building device in response to crisis or challenge:

> Born out of drought conditions, but rapidly acquiring its own momentum, the project demonstrated the vital role artists play within the community and environment: at a time of crisis these works offered comfort, humour, and inspiration to the public. In keeping with the issues which face us on a global scale, they also called for action and reflection – Councillor Peter Taylor, Mayor Toowoomba Regional Council 2008–2012.
>
> (Bloxham et al. 2009)

The role of the arts in community development is of a generally widely recognized importance, as Radbourne (2003: 211) notes 'The literature in the field suggests that a community without arts practice risks its future […] There is also evidence that arts practice

has revived economic and social activity (and performance measures) in regional cities and towns'. Cultural economy and financial economy are intrinsically linked (Fiske 1991a, 1991b). Financial economy is merely a measure of people's interactions with others, and a vibrant community facilitates the financial economy of a region. The social aspects of community arts and their broader roles are widely discussed. The arts not only provide opportunities for social well-being through community building, cohesion, growth and expression of identity (and identities), but also have potential for tourism, income production and helping to subsidize ailing economies.

Literature on the benefit of art may be broken into three main areas: health, including art therapy and other associated healthcare outcomes (Todd 2010; Jacobus et al. 2011); economic impact, such as art's contribution to the financial economy of a city or region; and social benefits, including community building, meaning generation, social inclusivity, regional identity and the development or extension of a cultural economy. All of these may well be outcomes of the arts, and may be combined in a broader appraisal of art for the community.

Art That Grows from the Community

Going further than merely providing public art, which is often imposed on a community by civic authorities or corporate benefactors, the Avant Garden project engaged the regional community through opportunities for participation in the creation of their own public art in thematic response to the challenges of water shortages and the worst drought in living memory. In this way, the art grew organically out of the community and was not simply brought in or enacted from an external contractor. A previous City Council had elected to pay a design team to construct public art for the 2003 revitalization of the main street of the central business district. Reports and letters in the local paper suggest that the resulting black marble monoliths were initially met with some derision and bewilderment by the broader community, with many questioning the expense of 'rate-payers money'. Indeed the Toowoomba Obelisks, as they became known, were the subject of an April Fool's Day joke by the newspaper, which suggested that they were wonky foundations for a city monorail.

In suburban, rural and regional locations, the normative understanding of the arts is challenged by creative practice in which the 'boundaries between "amateur" and "professional" creativity may be porous' (Gibson et al. 2010: 89). This is clearly demonstrated in Avant Garden, which employed professional artists alongside emerging and new practitioners. With a clear desire to engage the public in creating their own public art, Arts Council Toowoomba approached the Toowoomba City Council with a proposition to place community-generated ephemeral (temporary) art in public garden spaces left vacant for want of water. At the same time, one of the criticisms of the so-called 'community art' is that a dualism may be created between 'art' and 'community art' whereby 'community art' escapes the standards and critiques applied to professional art and art more broadly. The

Avant Garden project, through its employment of professional artists in a mentoring role, and through having a system of application and workshops that not only selected and refined art based on practical criteria such as feasibility and public safety, but also upon artistic conception and principles, ensured that this distinction between the professional and the amateur was more 'porous', with both effectively working together. The garden metaphor, which includes difference and symbiosis, is apt to describe the project.

After all approvals were given, Arts Council Toowoomba, working with Toowoomba City Council Parks and Recreation employees, identified garden beds around the city where ephemeral art could relieve flowers during the spring tourist season of the Carnival. In keeping with the themes of sustainability and renewal, recycled materials were encouraged for the construction of the artworks. Not only did Toowoomba City Council employees provide skills and advice, including public safety assessments, the City Council also provided earthmoving equipment, trucks and some materials from their landscaping depot for the sculptures. The salvage and recycling store at the Toowoomba Waste Management Centre was also available as a source of building resources for the artworks. This facility often has new and second-hand materials from the building industry as well as a range of discarded objects that could form part of the installations. Funding was received from arts grants and sponsorship provided by local businesses. The project met with such enthusiasm in its first year that it ran for three consecutive years. While the theme of drought is no longer pressing, public art of some form has become a continuing feature of the Carnival of Flowers.

Growth of cultural development within regional areas is dependent on the growth of market participation and audience identification with the arts; this requires leadership (Scollen 2008; Radbourne 2003). To lead the Avant Garden programme, a dedicated team of experienced arts professionals was assembled, including members with experience in administration, event management and marketing, as well as a few experienced public art practitioners, who would mentor the majority of the selected participants. These participants were to be chosen from applications, open to all members of the local community. In this way, community capacity building was to be encouraged, alongside a broader participation in the arts. The applicants submitted written proposals and designs and were also able to present their concepts to the selection panel. During the selection and development process, artists proposed and refined their ideas, conveying them through a series of designs and sketches and commonly with the use of models. An example can be seen here with Sally Charlton's 2008 design, 'Forlawn', the concept being letters standing approximately five-foot high, constructed with synthetic turf to appear as a commentary on the dead lawns in most home gardens.

Telling the Public: Ostentatious Art, Promotion and Art Trail Maps

The inaugural Avant Garden saw the project team and artists working together with Toowoomba City Council to ensure the artworks were erected in time for the 2007 Carnival

of Flowers. Avant Garden was publicized widely through a variety of media. A publicity photograph published at the time shows Mary-Kate Khoo holding the second-hand shower heads that would form the theme of her artwork, standing on location at a drained fountain where her finished work would be displayed during the festival.

Often constructed largely from recycled materials, the artworks ranged from ostentatious to subtle and could be found in a variety of public locations. Taking the theme of recycling literally, local artist Sally Nicholls filled a roundabout in a busy central street with bicycles salvaged from the waste centre, vibrantly painted and welded together into a perpetual circle of brightly coloured whimsy. George Szerencsi, an international sculptor living locally, constructed a work utilizing a common, everyday item: a plastic bucket. Identical bright red plastic buckets interconnected to form a sphere 2.2 metres in diameter. The work, entitled 'Until further notice' reflects on the banning of hosepipes and the use of buckets for watering and water-saving during the drought. 'The use of buckets evokes a sense of emptiness, a feeling of longing familiar to all of us living [here] where rain is conspicuous by its absence' (Bloxham et al. 2009).

An 'Art Trail' flyer with a map locating the Avant Garden works was made available to assist the public, and each work had a didactic placard explaining the project and the artist's intent.

Public Response: A Survey of Visitors to the Gardens

During the first weekend of the 2007 Carnival of Flowers, volunteers were stationed at the three main park sites to ask members of the public viewing the Avant Garden exhibits whether they would complete a questionnaire. The results indicated that of the 19 per cent of respondents who had not attended the Carnival of Flowers previously, 68 per cent said that the Avant Garden artworks had been an incentive for them to attend that year.

While over 25 per cent had heard about Avant Garden through newspapers and word-of-mouth, over 40 per cent noted that they had stumbled across one of the works in a park. Approximately half of the respondents already had an Art Trail flyer, with 90 per cent of those without a flyer requesting one from the survey volunteer.

87 per cent of the respondents enjoyed the exhibits, with a further 8 per cent saying they enjoyed some of the exhibits, and only the remaining 5 per cent saying they did not enjoy the artworks. Popular reactions to Avant Garden were 'Quirky idea', 'I like art', 'Good use of space', 'Gardens without water' and 'new addition to carnival'. Over 70 per cent said they enjoyed the creativity of the pieces, and humour was also a popular response.

Of the artworks in 2007, 'A Bed of Roses' by Mary-Kate Khoo proved a popular choice by visitors to the gardens surveyed. This work was created using shower roses collected by Toowoomba City Council in a water-saving programme in which residents could surrender their old shower heads to have them replaced with modern water-efficient models. Khoo's fanciful design fulfilled Avant Garden's brief of sustainable gardens and response to drought by taking these shower roses and combining them with an old brass bed. In completing

this project, the artist had to work with others and extend her skills to include braising and shaping of metals. The finished work took prominence in Toowoomba's public botanic gardens, where it was placed in a circular fountain that had been drained due to water restrictions.

Avant Garden was only one of Arts Council Toowoomba's many projects and was only intended to be temporary. The project's success in 2007 saw it replicated in 2008 and 2009, and other nearby towns requested to exhibit the artworks in their region. Some of the artworks were transported, where it was feasible to do so, and placed on display in the parks and gardens of other rural centres. As most of the artworks were constructed to be ephemeral works, and not built for longevity, they survive now only as photographs and memories.

Additional Exhibitions

The 2008 Avant Garden was launched by the Mayor at 'Gallery M' – a Toowoomba Regional Art Gallery and Arts Council Toowoomba partnership. Located prominently in the Toowoomba Regional Art Gallery, preliminary models and planning sketches for the Avant Garden artworks were exhibited to coincide with the public works on display during the Carnival of Flowers.

Sustainability of the Organization

In terms of capacity development, the project raised the profile of many artists, and it is worth noting that some of the artists selected to participate in Avant Garden have subsequently taken management roles within Arts Council Toowoomba, initiating other projects and facilitating further community engagement. Jennifer Wright (Summers) participated in the first year of Avant Garden and by the second year had a position on the committee. She has subsequently become the long-standing president of Arts Council Toowoomba. Volunteer community groups, by their nature, require a good deal of dedication and active membership if they are to survive and flourish. The initial committee of Arts Council Toowoomba had a core of five members who expended a great deal of time and energy on developing and managing projects, fundraising and public awareness. It is natural for volunteers working hard in unpaid situations to eventually need to reduce the amount of volunteering they do, retire or risk burnout. Therefore, community organizations need to attract new members, at least some of whom are willing and able to volunteer time and skills for the sustainability of the organization. Projects such as Avant Garden do exactly this.

Not only did the programme increase Arts Council Toowoomba's contact with the broader community and attract increased sponsorship and support from the business community, it also brought into the organization new members who were passionate and had initiatives of their own to offer. By bringing new people into the organization through projects, the

new members become engaged and can learn from what has gone before. They may develop new skills that they did not previously have, such as budget management, grant writing or promotion. They may see what has worked previously and what has failed and why. They may also see the many opportunities to do new and innovative projects within the flexibility of the organization. This process of introduction of new members who take an active role as older members step back from their commitments is profoundly important to the long-term viability of such organizations.

Avant Garden demonstrated to the community of Toowoomba that art could be used in response to community crisis, and that ephemeral public art could add an extra dimension to the Carnival of Flowers. Both of these concepts have become normalized in the local community. Public art has continued to play a part in the Carnival of Flowers, with a recent example being portraiture of local people displayed in gardens during the festival.

From the Droughts to Flooding Rains

After more than a decade of drought it was a brutal irony that the city of Toowoomba suffered the most severe flooding in living memory when, in January 2011, the city received more than 160 millimetres of rain in a 36-hour period. Local historians have commented that the early white history of the region does indicate that the settlement, built along a creek and subterranean waterway, has suffered some examples of extensive flooding in the distant past. This was little consolation to the community, who were unsuspecting and ill-prepared for the flash flooding and devastation of what was termed an 'inland tsunami' (Anon 2013).

The deluge and flooding destroyed buildings, bridges and infrastructure and many lives were lost. Arts Council Toowoomba, now under a new committee, again offered public art as a response to a water crisis. Following the precedent set with Avant Garden, the new project – called 'Splashing Back' – drew support from Toowoomba Regional Council, local businesses and the wider community. The Splashing Back project placed permanent art mosaics on buildings that had been inundated by flood waters during the 2011 tragedy. The mosaics were designed to 'not only mark the levels of the water, but also tell the stories of the people affected by this disaster' (Arts Council Toowoomba 2013). Like the pioneering Avant Garden before it, the principles of the Splashing Back project are deeply rooted in ideals of community, storytelling and resilience:

> These mosaics will be accessible to the public and enhance the visual appeal of the inner city. An art trail brochure outlining the stories, businesses and artists involved and details of where to find artworks will be made available widely. Splashing Back will become a unique 'must see' activity for residents of Toowoomba and visitors. As well as being a celebration of creativity and imagination it will be a symbol and focus for recovery and resilience. The works will be important talking points for the community.
> (Arts Council Toowoomba 2013)

From the success of these projects, the role of art as aid to regional resilience is demonstrated. Much as sculptures mark significant points in our history, these community-generated artworks respond and provide focal points and engagement for the wider public.

Imp(ACT)

The role of Arts Council Toowoomba as a focus for community-engaged arts practice has demonstrated impact. Prior to the Avant Garden project, public art was not a part of the Carnival of Flowers, whereas in 2013 public art featured throughout the festival and the Toowoomba City Council engaged artists such as Elysha Gould to create large portraits celebrating local people: 'Every portrait tells a story – so take the trail across the region from the CBD to Highfields, to Pittsworth and discover some of the people in our region' (http://tcof.com.au/).

Another 2013 arts programme, 'Animating Spaces', projected images onto central business district walls, painted graffiti-art murals in CBD alley ways and used found materials sourced in cleaning up debris to construct park bench seating next to the creek where the materials were found. With a booming number of ARIs and local galleries, the regional centre of Toowoomba now has a very prominent and widely supported arts community.

In terms of response to crisis, it is important to note that storytelling need not be either didactic or expressed in written words as it often is in formalized accounts and museum displays. Public art serves to provide an open text through which the reader/viewer's attention is grasped and they are invited to form personal reflections upon the disaster. This form of open storytelling is plural, participatory and engaging. Public art may be something that people either view or pass by, but its presence serves as a reminder, a marker of what has occurred and how the community has survived. This becomes part of community folklore and provides strength and resilience.

Conclusions may be drawn that the prominence of public arts events, even if they are legitimated through being a response to crisis, engage and encourage a wide range of people to participate in arts in their communities, in a range of ways. Participation is not only the production of art, but also its viewing and support by others who circulate meaning in the cultural economy. The contention that arts programmes may be a focus of community response to challenge or crisis is supported by the case study of Avant Garden, by Splashing Back and by the research findings showing a clearly positive reception from both participants and, more importantly, audience.

References

Anon (2011), 'Recycled water poll: Five years on', *The Chronicle*, 13 August, accessed 5 July 2013, available at http://www.thechronicle.com.au/news/toowoomba-recycled-water-poll-five-years-later/1066451/

Anon (2013), 'Toowoomba swamped by deadly "inland Tsunami"', *ABC News*, 1 November, accessed 4 July 2013, available at http://www.abc.net.au/news/2011-01-11/toowoomba-swamped-by-deadly-inland-tsunami/1900720

Arts Council Toowoomba (2013), *Splashing Back*, accessed 28 November 2013, available at http://actmba.com/splashing-back/

Bloxham, B., Kinnear, J. and Reaney, A. (2009), *Avant Garden Catalogue 2009*, Toowoomba: Arts Council Toowoomba.

Bordwell, D. and Thompson, K. (1991), *Film Art: An Introduction*, 3rd edn, New York: Knopf.

Fiske, J. (1988), *Television Culture*, London: Routledge.

Fiske, J. (1991a), *Understanding Popular Culture*, London: Routledge.

Fiske, J. (1991b), *Reading the Popular*, London: Routledge.

Gibson, C., Brennan-Horley, C. and Walmsley, J. (2010), 'Mapping vernacular creativity: The extent and diversity of rural festivals in Australia', in T. Edensor, D. Leslie, S. Millington and N.M. Rantisi (eds), *Spaces of Vernacular Creativity: Rethinking the Cultural Economy*, Abingdon, Oxon: Routledge, pp. 89–105, available at http://ro.uow.edu.au/era/2260

Jacobus, M., Baskett, R. and Bechstein, C. (2011), 'Building castles together', *Gateways: International Journal of Community Research & Engagement*, 4, 65–82, accessed 1 November 2012, available at Academic Search Complete, EBSCO*host*.

MacKellar, D. (1971), *The Poems of Dorothea Mackellar*, Adelaide: Rigby.

McHenry, J. (2009), 'A place for the arts in rural revitalisation and the social wellbeing of Australian rural communities', *Rural Society*, 19(1), 60–70, accessed 1 November 2012, available at Health Business Elite, EBSCO*host*.

Radbourne, J. (2003), 'Regional development through the enterprise of arts leadership', *Journal of Arts Management, Law & Society*, 33(3), 211–227, accessed 31 October 2012, available at Academic Search Complete, EBSCO*host*.

Scollen, R. (2008), 'Regional voices talk theatre: Audience development for the performing arts', *International Journal of Nonprofit & Voluntary Sector Marketing* [serial online], 13(1), 45–56, accessed 31 October 2012, available at Business Source Complete, Ipswich.

Todd, K. (2010), 'Public art: A case study at Nundah Community Health Centre, Queensland', *Australasian Medical Journal*, 2(10), 115–120, accessed 1 November 2012, available at Academic Search Complete, EBSCO*host*.

Chapter 8

'Now We Will Live Forever': Creative Practice and Refugee Settlement in Regional Australia

Wendy Richards
University of Southern Queensland

was expelled from Sudan by the Khartoum government in early 1992. By 1993, an estimated 10,500 minors had arrived at Kakuma refugee camp in northern Kenya, where they formed a disproportionately large proportion of its population (Human Rights Watch Africa 1994: 17–20; Scroggins 2003).

A detailed history of the Red Army and its place in the second Sudanese civil war is yet to be written. Within the Global North, however, this history has become subsumed under the rubric 'Lost Boys', a term applied by aid workers, international media, government agencies and charities to a complex story of displaced and militarized youth. The metaphor invokes childhood experiences found in J.M. Barrie's novel *Peter Pan*, in which young boys without parents band together as protection against a hostile adult world. In the United States, church groups and the federal government employed it to frame the resettlement of around 3500 young south Sudanese from Kakuma across North American cities beginning in 2000 (El Jack 2010; Grabska 2010).

The capsule Lost Boys story at the heart of this Northern narrative is built around orphaned, unaccompanied boys who emerge from 'somewhere' within southern Sudan. The narrative employs a two-part logic of 'displacement' and 'emplacement': displacement within southern Sudan prior to arriving at internationally administered refugee camps, followed by emplacement within a Northern host country via a refugee resettlement programme. It emphasizes extreme youth, emotional tenderness and physical vulnerability and briefly sketches long and dangerous treks on foot and death through animal attack, starvation and disease. The narrative's principal framing motif is children surviving intolerable hardship solely through mutual support. The narrative's second act focuses on resettled Lost Boys' encounters with life within the post-industrialized North and their struggles for education, employment and a secure, productive future. In transforming the Red Army recruit into the Lost Boy of southern Sudan, the figure of the 'child' is discursively separated from that of the 'soldier' and the weaponry, combat skills and affective make-up associated with military action. This separation enables a narrowly conceived representation to sentimentalize the interconnections of childhood, war and movement by occluding the part played by adult family members, clan affiliations, refugee aid organizations and the SPLA, as well as Red Army members' own motivations and interpretations surrounding these events.

Research into refugee camp life has suggested that the Lost Boys rubric has also set up a gendered dynamic of 'lost boys and invisible girls' (Grabska 2010), with material consequences across the South Sudanese refugee diaspora. Young men who return to refugee camps seeking wives are able to compete more effectively in dowry negotiations through their greater capacity to provide the much-needed resources of bridewealth. However, I would argue that a deeper binary of 'lost/found' may be in play here, which, when mapped onto gender within the context of the resettlement policies of the Global North, renders girls and women less in need of third country relocation as 'someone else', with the refugee camp considered to already be catering for their material well-being. Living under the auspices of camp administration and thus already 'found', women and girls are defined as sufficiently safe and thus not in need of further protection and support. Of approximately 4000 young

people resettled under the United States Lost Boys programme, only 89 were female. This disproportion discounts the numbers of young and older women taken into Kakuma in 1992 following their journey south from Ethiopia (El Jack 2010: 21–22) and the fact that many had travelled the same evacuation routes as displaced men and boys (Beswick 2001). The international emphasis on 'lost' young men and boys has generated multiple and unremarked losses for displaced females in terms of services within refugee camps, especially as regards educational opportunities, resettlement to refugee host countries overseas and the sociopolitical narratives that shape states' policies on refugees and humanitarian aid.

The discursive positioning of refugees resettled under North America's Lost Boys programme created an easily identifiable group within policy and an accessible link between their experiences of suffering and exile and ideologies of the nation's benevolent hospitality (McKinnon 2008). As a continuing representational frame for refugee media stories, the narrative helps to construct host countries as promised lands, where failure to succeed can be cast as individual inadequacy rather than systemic inequity (Gale 2004; Haines and Rosenblum 2010; Robins 2003). The narrative also infantilizes refugee subjectivity, rendering those interpellated in this way as irredeemably childlike and incapable of exercising political agency through a fully realized adulthood. The consequence for the individual is positioning as a 'perpetual non-state subject' (McKinnon 2008: 404). Thus, over the past decade, within refugee receiving countries of the Global North, the Lost Boys formulation has helped to engender a refugee category whose occupants are relatable, manageable and worthy of rescue.

Refugee Writing and the Possibilities of Representation

I would like to consider here aspects of the Awulian community's experiences as cultural producers within a regional setting in creatively engaging with this larger refugee history and discourse through writing and speaking as modalities of performance in self-representation. The contradictions and gaps between the history of the SPLA Red Army and the Lost Boys narrative of the Global North create a complex field of representation that many South Sudanese refugees must navigate in forming identity and community in a new home. A 'third space' of liminal in-between-ness opens up (Bhabha 1994; Sbiri 2011), which poses new dilemmas around disclosure, authenticity and connectedness. Within this 'third space' of contradictions and omissions lies the risk of an oppressive misrecognition of lives and events, but also the potential shelter of a seemingly benign rhetoric. Lost Boys themselves can be aware of the label's ambivalence:

> What does it mean usually when we say we are 'lost'? When they say a 'Lost Boy' that doesn't mean that we are mentally lost, no, this is a media term […] But if I know that I am from Sudan, Southern Sudan, and Dinka by tribe then I am not lost.
> (McKinnon 2008: 404)

This liminal space also offers productive and strategic opportunities in the politics of representation. Narratives of identity can be deployed to access critical resources, such as a positive media presence and funding for community development, as well as greater bargaining power in diasporic kinship negotiations (Grabska 2010; McKinnon 2008). Identity narratives can also mobilize 'moral networks of sympathetic international audiences' to support local political and media campaigns (Laudati 2011: 17). Within regional South East Queensland, the Awulian community life writing project exemplifies this pragmatic and affective mobilization. The Red Army brigades and Ethiopian camps appear within and between the lines of individual author's accounts, yet the collection as a whole is explicitly framed within the Lost Boys trope. References to the Lost Boys phenomenon appear in the book's opening material, jacket blurb and related publicity. It was conjured up during the book launch and in the speaking engagements that followed. These invocations established a dual positioning that enabled the authors to engage with personal memories of movement and militarization as Red Army recruits, yet within a discursive frame that brought forth for their readership a known and approachable refugee figure.

As the project progressed, this dual positioning facilitated a range of outcomes that built upon a locally created representational presence that also reached further afield. On the strength of the project's success, the association has been able to compete as a small, regionally based community group for highly sought-after government funding for further development initiatives. In the three years since completing the anthology, the organization has developed a government-funded speakers' bureau through which members give presentations to schools, agencies and community groups on refugees and resettlement. The organization also secured funding to build a website, reinforcing its regional presence as well as connecting the community with members of the diaspora and extending the book's reach with online sales. Its most recent project on refugee youth mentoring produced a publication for use within new communities emerging as a result of ongoing government resettlement of humanitarian entrants within the region. These initiatives have created a strategically important profile as an effective refugee advocate for the association. They have increased the organization's capacity to respond to issues facing South Sudanese communities, as well as to engage in discourses on the place of refugee entrants in regional life.

Scholars of refugee writing have argued that, while the genre has been defined as a literary category, within post-colonial debates it has received 'scant attention' (Nyman 2009: 245; Sbiri 2011). Within the genre, writers must work both with and against the effects of the refugee label, which produces a liminal identity of not-belonging that positions the asylum claimant as an illegitimate, threatening presence (Marfleet 2006, cited in Nyman 2009). This positioning as threat within discourses of national belonging imperils the 'right to narrate' (Bhabha 1994; Huddart 2007), a vital cultural agency that enables participation in representation on the speaker's own terms. However, for refugee writers, exercising this right is also caught within a paradox of representation. The agency of narration can depend on an individual's sense of inclusion, which itself is under threat within hostile representations of refugeeness.

This paradox and its effect on the capacity to speak manifested itself during the project's genesis. A perception within the Awulian community that writing and producing a book were not only beyond their skills but also outside their cultural ambit rendered the project unimaginable for many of its members. The Awulian project instigators had to actively garner support for book-writing within the community itself before they could seek funding, as community involvement and commitment were crucial to the project's success. As Paul Garang describes, for many in the clan's extended networks, writing a book seemed a preposterous notion:

> When I said to Awulians here that we should write a book, they said, 'Book! You're mad. You're trying to build a house in the air'. We have some negative thinking from long periods in the camps. We believe sometimes that we cannot do things.
> (Paul Mabior Garang)

Within Dinka cultural life, the performance of stories, songs and dance is a constitutive and purposive everyday sociocultural practice that builds identity and clan relations and connects the ancestral past with the present (Deng 1984). From childhood, community members learn, compose and perform songs and stories about clan exploits, village and cattle camp life and personal aspirations and regrets, as well as celebrating and reinforcing the clan's abiding bond with their herds of Dinka cattle. Engaging in the performance of authoring would seem on the surface to be a natural extension of the cultural practices of storytelling. Yet within the community, the question of the right to speak also became entangled in racialized notions of 'the author', which diminished access to individual agency and creativity. In entering the process of authorship, the community encountered the difficulty of transcending a belief that they did not have the right to be the authors of a book, even of an anthology of their own life stories. This belief was beyond a new author's fears about engaging the reader or building an emerging audience. For these authors, the containment of agency set up by this belief was related to a strong sense of outsider status in relation to books as cultural objects. When broaching the idea of writing a book among his community, Paul Garang encountered questions about the right to assume that role:

> Many in our community say writing is for white people. We have no concept of how to write a book. To write a book is a great achievement, even for those of us in Australia. People in the community ask me, how did you do it? Only white people write books – but, no, not me, I can't write a book.
> (Paul Mabior Garang)

There are a number of factors that potentially contributed to this response. The first is the immediate concern of literacy, both in their own and other languages and, for this project, in English. For most of the collection's authors, writing in English was problematic. English was their third language after Dinka, their mother tongue, and Arabic, the language of

educational instruction in South Sudan until recent times, as well as Juba Arabic, a *lingua franca* used mainly within Equatoria State in South Sudan. To add to the complexity surrounding expression, while most were multilingual, none were literate in Dinka or Arabic. When it came to writing their life narratives in English, rather than the traditional practice of speaking them in Dinka, most authors were not sufficiently literate in English to find the dimensions of expression for which they aimed. To complicate this further, the memories they drew from were folded within their identities as Dinka speakers. Writing in English while thinking in Dinka was, as Paul Garang says:

> the hardest thing. I think in Dinka about my life. Dinka is my mother tongue, that's how I remember. I ran out of English [yet] I still had more of the story in my mind.
> (Paul Mabior Garang)

For these authors, writing meant undertaking an interstitial performance of the self via a liminoid literacy negotiated between asymmetries of language and literacy competence and the cultural values placed on speaking versus writing. Authorship was experienced as a partial and fluid practice, dependent on complex iterations between personal and collective memory and across multiple limitations in the modalities of expression. Most held insufficient literacy in both English and Dinka to express fully in writing the memories that motivated their narrative intention, and which were to reach both members of their own community and those in wider Australian life. Likewise, these audiences, found both locally as well as globally across the South Sudanese diaspora, were themselves potentially only partially or not at all literate in English. The space enabling a more complete performance of memory lay in the oral retelling of history in the authors' mother tongue; however, this was not a space from which memory realized as literature could readily emerge. These collisions of memory, performance, language and literacy raise questions about the definition of authorship, generally derived in a Northern context from the capacity to write. Yet in engaging with authoring thus defined, these writers could not easily transform into a new representational mode the identity of author or the skills in composition and performance that their cultural practices as storytellers had already given them.

Here I am also concerned with a possible second factor in the authors' entry into authorship: the meaning of competence in English literacy for writers' willingness to risk expressing themselves. McKinney and Giorgis (2009: 112) have argued that life stories link identity and language through 'identity performances'. For people from an oral culture, such as Dinka speakers, performing identity through the modality of writing, where once this performance would have been via verbal narrative and song, can be fraught with risk. We make sense of and articulate our relationship with others through 'narrative structures that are culturally available' (McKinney and Giorgis 2009: 109). If we include in that availability the culturally situated notions of 'author'; that is, what it means to perform this identity, how do writers from an oral culture, such as those we are considering here, envision authorship in order to frame their engagement in an exercise of refugee writing, itself conducted in a language not their own? Literacy can be experienced as an unwelcome break with culture

and family identity that is 'hard to accept' and does not substitute for traditional rites of passage, such as the ritualized transfer of cattle, that displacement disrupts (Awulian Community Development Association 2010: 139). By writing a book, an accepted process of cultural production in the Global North, the authors were placed in the troubling position of endeavouring to preserve in written form their community's history, while simultaneously alienating these stories from those clan members who appeared in its pages but were unable to read what they contained. However, focusing solely on literacy as the pivot point for engaging with stories expressed in book form could also overshadow written testament's deeper significance for a displaced and scattered people. In 2012, while on fieldwork in Jonglei State, I hand-delivered a copy of the book to an author's family member in Bor Town, in the absence of a reliable postal system in South Sudan. While this person could not read the book's contents, its existence and his kinship connection with everyone in the author photograph on the back cover gave a material presence to stories of resettlement that had reached across the diaspora via the mobile phone and rare yet reassuring visual evidence that family members were safe and well.

A third factor may be found in the history of the community's relationship with books as cultural objects. In the decades of the Anglo-Egyptian Condominium administration of Sudan and in the years under Khartoum rule since independence from the British in 1956, education in the south had been systematically under-resourced. South Sudan currently has some of the world's worst education outcomes. In 1976, between the two major periods of conflict, over 90 per cent of South Sudan's population had never attended school (Sommers 2005: 62); currently, half of the country's population is under 18 years of age and school enrolment rates are the second lowest in the world (United Nations Educational, Scientific and Cultural Organization 2011). Although SPLA policy may have been to educate Red Army recruits in preparation for leadership in the new South Sudan, this education was rudimentary and sparsely resourced. In the Ethiopian minors' camps, only a few books were shared among many students, a situation repeated in later camps such as Kakuma. Books were rarely encountered in village life prior to displacement and of little value during long journeys of forced evacuation. At the same time, education was seen as a way out of poverty, conflict and the aftermath of dispossession and as a protection against the possible loss of future national sovereignty. Thus, the cultural and material relationships with books developed in ways that could be described as unpredictable, tangential yet imbued with aspiration. Books were talismanic, representative of the discursive power offered by written expression and instruction, but also inaccessible. The production of books and the processes that circulated them were also seemingly beyond the community's reach, as Paul Garang describes:

> We are rich mentally; we have a lot to say. But how do we do it? What are the steps? I could not see in my mind what we had to do.
>
> (Paul Mabior Garang)

The project also generated overlapping dimensions of individual and communal performance. The book launch, which was attended from within and outside the region, included readings

of excerpts by the authors and songs by an a cappella choir drawn for the event from the local South Sudanese community, many of whom had also spent years with the SPLA's Red Army and identify themselves as Lost Boys. The authors have been invited to speak at literary events, as well as at meetings and gatherings by government agencies and community groups. Many have spoken at regional high schools, using the book as the basis for discussion. They have taken part in local and state festivals with stalls for book sales to the wider community. The project's coordinator, also an author, received formal state government and national community recognition for refugee advocacy, which required speaking on the refugee experience at award ceremonies. During these performances, which have continued in the years since the project's completion, participants were engaging in a politics of compassion. By drawing on memory and history, they hoped to constitute observers as a witnessing public, who would advocate for refugee social inclusion and against negative discourses on asylum seeking.

Testimonies of displacement flow from a number of complexly interconnected motivations. Testimony can be employed to produce a collective social memory, to counter the effects of dispersal and dispossession and to make sense of and soothe the aftermath of trauma (Richards forthcoming). Testimony is also a socio-political strategy in the production of legitimizing knowledge that can help to redress past wrongs, as in the territorial claims of Palestinian refugees (Hanafi 2009). The need to transcend the 'otherness' of refugeeness and lay claim to a deeper and more informed inclusion was an important motive behind the project, as Paul Garang explains:

> In the camps, I was responsible for the younger boys. I was an elder even though I was young. I didn't think about books [...] Then, when I came here, I saw journalists writing our stories [...] so I saw that we needed to do something [...] Then I went to the library for the first time. I saw how you take books out for a while and then you bring them back. I thought, this is how we can share our story, tell everyone about our lives.
>
> (Paul Mabior Garang)

Speaking about displacement is a 'testimony of loss and reconfiguration' (Papastergiadis 2006: 194). Recording the events of the past to create continuity out of fragmentation was equally important for the Awulian community and would help to fix their place in the tumultuous history of an emerging sovereign state. Civil war destroys records and prevents individual accounting, especially in a region with limited literacy and an education system decimated by conflict. Much of the recent South Sudanese biographical writing has been produced outside the region and within the shadow of the Lost Boys discourse. For the Awulian community, with access to the publishing resources of the Global North, fear of the loss of collective memory and an obligation to capture this in the concrete form of a book also lay behind the decision to write:

> Our grandparents told us stories and we learnt how to live, how to keep cattle, how to marry. Our grandparents kept these stories. Our old people are gone now. The book will

never die. It will tell our story over a long period of time. We have lost our culture through war and the camps. We have too many memories and lost too many people, to tell our stories without books.

<div align="right">(Paul Mabior Garang)</div>

'Now We Will Live Forever'

I would like to conclude by returning to the question of cultural practice and individual and collective transformation, to consider whether creative projects can contribute to the connectivity of communities within regional locations. Scholars of biography and life writing have asked whether refugee testimony can have any impact on increasingly hostile representations of those seeking asylum outside their country of origin (Jacklin 2011; Szörényi 2009). Compared with the United States, there have been few Australian book-length (auto)biographies of or by recent humanitarian arrivals, particularly from African source countries. It has been argued that refugee voices enter the popular imagination via asymmetric power relations with advocates, agencies and publishers (Cox 2010: 286), which muffle their representational effect through high levels of mediation. It has also been suggested that minority life writing as a genre will 'continue to languish on the margins of the public sphere' (Whitlock 2007: 76), with limited ability to engage with the very audience to whom it wishes to make a case for recognition and inclusion.

These arguments are valuable in mapping the factors shaping the genre's readership and its capacity to create and control a discursive presence. Life writing by minoritarian groups such as refugees can struggle to gain purchase on the public imagination. High-profile 'authoritative' voices, such as celebrity advocates, speaking on behalf of refugees in book introductions and forewords and on their covers do step between the writer and the audience. Yet focusing on the genre's marginality can also bundle all experiences of writing and publishing by refugees into a unified, singular whole, while at the same time exceptionalizing aspects of its practice. Mediation by editors and publishers occurs in most forms of publishing, and refugees as authors, and in this case as self-publishers, should be able to employ these industry skills without exception, as these skills can contribute to a publication's quality and strength. It may be more fruitful therefore to consider this question from the opposite angle. Mediation's negative effects could be delimited by empowering refugee authors in their engagement with publishing technologies, as well as increasing industry's understanding of what is at stake in bringing refugee stories into print. Arguments that conceptually exceptionalize refugee writing can also place on the genre an unreasonable responsibility for bringing about systemic and discursive change at the larger scale of the public domain. Further, they can set aside or discount the measures of success being applied by those at the centre of the exercise, the writers themselves.

When we look at the example of this anthology, it is possible that, at the smaller scale of the region, there is space for refugee narratives to engage productively and transformatively in local discourses of 'otherness' and the ongoing effort by new communities to belong.

Engaging with the cultural practices of authorship and the processes of book publishing transformed significant aspects of individual and collective identity and engagement between refugee arrivals and the wider community, as well as the region's platform for community development. The project added 'author', a valued appellation in the South Sudanese historical context, to the multiple identities of those who took part. This appellation and their roles in the project have been incorporated within participants' employment resumes and, for some, in negotiations with tertiary education institutions for advanced credit in further study. Bringing a collective history into written form has strengthened the community's sense of its capacity to create a positive local presence that can transcend the adverse connotations of the label 'refugee'. Within the region, it has led to greater skills in the socio-politics of representation, increased community funding and an enhanced capacity for refugee advocacy, which are important for regional development and community relations. In particular, the anthology has contributed to the quality of relationships outlined in research into refugee regional resettlement as an important component of meaningful community inclusion. The project caused a ripple effect of dialogue, activity and connection that continues to expand regionally and within the diaspora. The book has become part of ongoing conversations, within schools, councils, agencies and individual readers, about what it means to be a refugee and how a local community can collectively respond to this.

It is important also that we acknowledge the outcomes of witnessing from the point of view of the witness. As Paul Garang said, for an oral culture community to write and publish a book is a great achievement, particularly against a background of profound dispossession and educational neglect. To typify its significance for the community and the region as 'marginal' because of the project's size and local scale is to risk succumbing to a 'hegemony of resignation' (Meade and Shaw 2007: 414) under which attempts at meaningful testimony may be deemed futile. For the South Sudanese community who engaged in testifying to their history of conflict and displacement, the anthology embodied the hope expressed by Paul Garang on opening the first box of books from the printer: 'now we will live forever'.

Acknowledgements

My thanks go to Robert Mason and Janet McDonald for their thoughtful and insightful feedback on this chapter as it developed. I am especially grateful to Paul Mabior Garang for generously sharing his experiences of the many issues associated with cultural practice, authorship and refugee identity.

References

Abdelkerim, A. and Grace, M. (2011), 'Challenges to employment in newly emerging African communities in Australia: A review of the literature', *Australian Social Work*, 65(1), 104–119.

Awulian Community Development Association (2010), *Walking to Freedom*, Toowoomba: Awulian Community Development Association (AWCODA).

Beswick, S. (2001), '"We are bought like clothes": The war over polygyny and levirate marriage in South Sudan', *Northeast Africa Studies*, 8(2), 35–61.

Bhabha, H. (1994), *The Location of Culture*, London: Routledge.

Bhabha, H. (2003), 'On writing rights', in M. Gibney (ed.), *Globalizing Rights: The Oxford Amnesty Lectures 1999*, Oxford: Oxford University Press.

Broadbent, R., Cacciattolo, M. and Carpenter, C. (2007), 'A tale of two communities: Refugee relocation in Australia', *Australian Journal of Social Issues*, 42(4), 581–601.

Campbell, D. and Julian, R. (2009), *A Conversation on Trust: Community Policing and Refugee Settlement in Regional Australia*, Sandy Bay, Tasmania: University of Tasmania.

Carrington, K. and Marshall, N. (2008), 'Building multicultural social capital in regional Australia', *Rural Society*, 18(2), 117–130.

Cassity, E. and Gow, G. (2005), 'Making up for lost time: The experiences of southern Sudanese young refugees in high schools', *Youth Studies Australia*, 24(3), 51–55.

Clark, S. (2009), 'Anchoring through the arts: Horn of Africa Arts Partnership Program', *Migration Action*, May, 11–15.

Clover, D. (2007), 'Feminist aesthetic practice of community development: The case of myths and mirrors community arts', *Community Development Journal*, 42(4), 512–522.

Colic-Peisker, V. and Tilbury, F. (2007), 'Integration into the Australian Labour Market: The experience of three "visibly different" groups of recently arrived refugees', *International Migration*, 45(1), 59–85.

Cox, E. (2010), 'Dialogue and decentralisation in Australian asylum anthologies', *Life Writing*, 7(3), 285–302.

Cranitch, M. (2010), 'Developing language and literacy skills to support refugee students in the transition from primary to secondary school', *Australian Journal of Language and Literacy*, 33(3), 255–267.

Deng, F.M. (1984), *The Dinka of the Sudan*, Illinois: Waveland Press.

Department of Immigration and Citizenship (2009), *Fact Sheet 97 – Humanitarian Settlement in Regional Australia*, Canberra: Department of Immigration and Citizenship.

Department of Immigration and Multicultural and Indigenous Affairs (2003), *Report of the Review of Settlement Services for Migrants and Humanitarian Entrants*, Canberra: Department of Immigration and Multicultural and Indigenous Affairs.

El Jack, A. (2010), '"Education is my mother and father": The "invisible" women of Sudan', *Refuge*, 27(2), 19–31.

Ensor, M. (2012), 'Child soldiers and youth citizens in South Sudan's armed conflict', *Peace Review*, 24(3), 276–283.

Gale, P. (2004), 'The refugee crisis and fear: Populist politics and media discourse', *Journal of Sociology*, 40(4), 321–340.

Grabska, K. (2010), 'Lost boys, invisible girls: Stories of Sudanese marriages across borders', *Gender, Place and Culture*, 17(4), 479–497.

Haines, D. and Rosenblum, K. (2010), 'Perfectly American: Constructing the refugee experience', *Journal of Ethnic and Migration Studies*, 36(3), 391–406.

Regional Places, Regional Narratives

Oral historian Linda Shopes (2002: 594), in the oral history interviews she gathered in the regional communities in Pennsylvania, has observed that 'place mattered in an individual's consciousness' and 'a shared sense of identity, a sense of community, includes a set of spatial referents'. While engaged in the task of training regional communities scattered throughout the Australian state of Queensland to gather local narratives – particularly following natural disasters – we found that regional locations produced a series of unique regional narratives. Katherine Cashman and Shane Cronin (2008: 408) observe that a crucial step in recovery after disaster is the community's capacity to incorporate the experience of disaster in both personal and community worldviews by developing explanations, particularly through stories. Storytelling projects in regional areas thus need to allow local communities to narrate their own place stories in a manner that encourages the development of a shared community worldview.

In this chapter, we draw on our experiences facilitating community storytelling workshops in regional Queensland in partnership with the Queensland branch of the Oral History Association of Australia (OHAA Qld) to develop a best practice model for promoting creative approaches to recording oral narratives using digital tools, informed by creative writing practice and embedded evaluation (Klaebe 2012, 2013). These experiences offer an insight into how creative approaches to training can facilitate the sharing and preservation of stories in regional communities.

The rise of community deposited and commissioned digital recordings in museums and libraries in recent years reflects an emphasis on publishing 'good stories' in forms that are accessible and creatively use narrative to 'speak' to diverse audiences. In Queensland, the State Library (SLQ) acquires and manages oral history and digital story collections and is increasingly interested in creative writing and transmedia storytelling initiatives that support Queensland communities – particularly marginalized and regional communities – to better connect to their unique histories. Transmedia storytelling – a process by which narrative is dispersed across multiple online, broadcast and print-based platforms to create a unified entertainment experience (Jenkins 2010: 944) – allows users to engage with oral narratives and community histories through multiple pathways. Such developments in digital tools for sharing stories represent both challenges and new possibilities for regional communities. As this case study demonstrates, universities and not-for-profit organizations

important, because precious resources, such as audio recording equipment, local histories, archival documents, 'how to' guides and local knowledge could be accessed and shared.

We felt that the workshop series also offered a unique opportunity to embed our own research, which investigated the links between oral and fictive narratives (Van Luyn 2010, 2012a, 2013) and community engagement through new media storytelling (Klaebe and Foth 2007). We intuitively felt that a focus on creative writing would allow a deeper engagement with the narrative qualities of the oral histories; Kip Jones (2006: 70) supports this assertion, stating that 'using arts-based methods to disseminate research will engage new audiences'. When adapting the first series of workshops to support Cardwell following Cyclone Yasi, we came to see evidence of the value of a creative writing approach. Cashman and Cronin (2008: 410) observe that communities recovering from volcanic disasters recover best when they can understand the disaster, both scientifically and through using metaphorical language and telling stories that take into account the emotional impact of disaster. The emphasis on the emotions and subjective experience in fiction thus allowed a new focus in the workshops on metaphor, imagery and emotion.

Creative writing and oral history are two distinct fields. While Anne Hirsch and Claire Dixon (2008: 190) have argued in the abstract that creative writers can 'operate like magnifying glasses' to understand the narrative structure underpinning life stories, little practical attention has been given to the links between creative writing and oral history. However, as Van Luyn (2012b) argued in her PhD thesis investigating the intersection between fiction writers and oral historians in Australia, both fields are concerned with analysing and framing narratives and documenting the subjectivity of experience. This research in creative writing formed part of the scaffold for the new series of oral history workshops.

Katherine Nelson (2003: 128) identifies the link between life stories and fictional narrative, stating 'Both [fiction and biography] are based on individual life stories and thus depend on real or fictional versions of autobiographical memory'. Memory, the basis of oral stories, shares a similarity with fictive works: its narrative form. Fiction, like memory, uses narrative as a means to organize knowledge. Nelson (2003: 125) argues that *narrative* is the medium of shared memories, collective memories and fictional creations. Paul Rosenblatt (2003: 225) goes so far as to state that 'we hear our interview respondents relating narratives about their lives that seem to be like what we read in novels'. The narrative quality of novels and memories creates the sense that one is similar to the other. Therefore, the notion of drawing on creative writing theory to underpin oral history workshops has traction.

Indeed, when understanding memory, many researchers turn to metaphor – a technique of creative writers – to make sense of the process. James Olney (1998: 20) uses the metaphor of 'weaving' for the operation of memory:

> The weaver's shuttle and loom constantly produce new and different patterns and designs and forms and in operation memory is like weaving […] if it is processual then it will bring forth ever different memorial configurations and an ever newly shaped self.

Researchers have turned to fiction as a means of understanding this complex process of remembering.

Donald Polkinghorn (1988: 71) argues that 'although literary theorists approach narrative as literary expression, their insights into narrative form can be applied to human sciences in their investigation of human experience and understanding'. Daniel Albright (1994: 19) speculates on whether literary constructions of selfhood might be of use to psychologists in order to understand the remembered self. Ulric Neisser (1994: 2) explains the notion of the 'remembered self' as the self constructed on the occasion of recollection. In oral history interviews, it is the self the interviewee constructs when telling their life story. Albright (1994: 21) observes that literature is suspicious of the remembered self. He uses a number of examples from fiction and poetry to demonstrate how the remembered self is made problematic. Albright (1994) argues that literature explores how the brain is selective when creating memories, and the way memory changes when it is recalled over and over again. He uses T.S. Eliot's 1933 line of verse to understand this quality of memory: 'Memory is but a few meagre arbitrarily chosen sets of snapshots'.

This metaphor reflects current understandings about how interviewees create and draw on memories. After all, oral historians have observed that the brain 'cannot record or retain all of our experiences; the overload would make life unmanageable' (Thomson 2011: 297). Most short-term memories are lost within moments or days after the event (297). Only some are retained and consolidated into long-term memories.

Dorrit Cohn (2000: 117) argues that the difference between fiction and biography is that 'a character can be known to the narrator in fiction in a manner no real person can be known to a real speaker'. Literature 'can provide direct access to other people's minds and hearts' (Gregory 1998: 29). Gregory (29) states that:

> literary experience, unlike life, does provide direct access to others' minds, and in so doing yields essential data, which we use in order to sharpen the accuracy and to increase the depth of our inferential knowledge about the interior lives of real-life persons.

Applying Gregory's assertion to the process of remembering, fiction's access to the interior can offer a representation of the complex process of remembering. Fiction can function as another way, alongside traditional methods, of exploring memory in oral history. Fiction becomes a means to explore these ideas symbolically. Creative writing theory thus played a significant role in the re-shaping of the OHAA Qld oral storytelling workshops – albeit with a pragmatic focus – by encouraging participants to understand the complex process of remembering in an oral history interview, and by promoting new thinking into the ways in which oral narratives can be shared. In regional communities, the opportunity to respond creatively to gathering and sharing oral narratives sparked a number of innovative arts-based approaches to sharing oral narratives in the community, such as digital stories, audio and images. In particular, community members in regional towns affected by disaster found this approach helpful in imagining the possibilities for presenting narratives in museum exhibitions.

In the workshops, this theoretical underpinning translated into an emphasis on valuing interviewees' unique reality when designing questions, imaginatively engaging with others' stories through considering their interior life, and encouraging participants to use their local knowledge to write specific and unique questions for interviewees. At the same time, participants were encouraged to reflect on how their knowledge of the history of the place and their own experiences might cloud their questions and responses to interviewees' answers. To ensure this was achieved, we designed the workshops with an opportunity for participants to first interview each other. We gave feedback throughout the interview, pointing out when an interviewer needed to rethink their questions or responses.

Cycle One: The Workshop Series

In the first action research cycle, we designed and facilitated a series of five workshops drawing on our background as creative writers. We were able to adapt these qualities in the next cycle, which supported regional communities to gather narratives post-disaster. The previous workshop series had focused on gathering and preserving oral narratives. We now shifted the focus to exploring oral histories through creative writing and encouraging participants to imagine the many possibilities for sharing and exploring oral narratives, such as creative nonfiction, theatre and fiction. We also encouraged participants to produce rich media packages, including archival quality audio, video, photographs and scanned images and objects, which could form the basis for multiple creative works or exhibitions. With an awareness of the complexity of memory, we supported workshop participants to design questions that promoted first-hand experiential narratives, and to listen for vivid scenes in oral narrative, asking for specific details if these were missing. In the final workshop, participants engaged creatively with practice oral history interviews, exploring memory, representation, theme and image in the oral narrative.

In the first workshop, 'Oral History Basics', we dealt with the pragmatic aspects of oral history, outlining the equipment, time and budget required to bring a project successfully to fruition. Such projects are often more expensive and time consuming than community groups expect. We emphasized the need to break the project into manageable stages, each with tangible outcomes. Based on our understanding of the nature of voluntary organizations, we encouraged volunteers to design projects that could be pursued or set aside as necessary, without causing discouragement by a seeming lack of progress. For example, in the early stages of a project, community groups could conduct preliminary interviews with a small pool of participants, scan relevant documents and images and conduct background research, resulting in a well-researched background study. In the next stage – which could be undertaken by any volunteer with access to the background research – this study could be used to design and conduct interviews recorded at archival quality. In later stages, these interviews could be cut, re-mixed and adapted into digital stories, exhibition pieces and other creative outputs. In this overview workshop, participants were encouraged to consider

their project's aims, and to use these aims to guide their decisions in the remaining series of workshops.

Workshop two was broken into two halves: ethics and copyright, and photography. Participants worked with us to consider and discuss the ethical implications of their project, and to examine model participant information and release forms from the State Library of Queensland and the Queensland University of Technology. Participants were encouraged to ensure that interviewees understood that they owned the copyright of their stories, and to license the interviews under a Creative Commons Attribution-Non-Commercial Share Alike 3.0 Licence, which allows the interviewee to retain copyright and other users to freely copy, modify and share for non-commercial purposes, provided they attribute the story to the interviewee and maintain the same terms. This allows other creative practitioners and researchers to respond to oral histories, even beyond the initial vision of the project.

The afternoon of workshop two was dedicated to photography for oral history projects. New media expert Bryan Crawford showed participants what photography and video equipment was useful for oral history projects; how to choose a location to take video and photos; what to look for in light, location and background; and how to make the best of the location and light available. This allowed participants to include photographs in the rich media package produced from the interviews they conducted.

The third workshop, 'Recording and Editing', extended participants' capability to construct rich media packages. In this workshop, we showed participants how to record audio at archival quality and edit the audio using the open source sound editing software, *Audacity*. We also encouraged participants to scan interviewees' documents and photographs during the interviewing process, rather than taking away precious photographs or other ephemeral material such as letters.

We discovered the value of scanning documents and other precious objects during a preliminary interview with Sister Angela Mary as part of the *Queensland Business Leaders Hall of Fame* project in 2009. Sister Angela Mary had few personal possessions but had kept the baggage tags from her migration from Ireland to Australia as a young nun. These baggage tags became a key component of her digital story (Queensland Business Leaders Hall of Fame 2009).

To gain experience in the workshop, participants engaged in two activities. The first was a practical exercise in recording whereby participants worked in pairs to conduct a three-minute interview. In the second activity, participants edited their interview on *Audacity*. In the afternoon session, we described how to produce transcripts and interview summaries. Then, using the style guide provided and their three-minute interview, participants produced a transcript using the open source software, *Express Scribe*.

In the fourth workshop, titled 'Interviewing', we described some of the complexities of remembering and explored some of the theory around fiction, metaphor and memory. We drew on Campbell's commonly used fictive trope, the hero's journey (Bloom and Hobby 2009), to encourage participants to design interview questions that captured an interviewee's

character arc, documenting how they changed as a result of obstacles encountered. Van Luyn considered her own experiences fictionalizing oral histories as part of her practice-led research to encourage participants to shift questions from the abstract to the specific to elicit narratives grounded in rich and vivid scenes. In the afternoon, participants worked in pairs to interview each other, using strategies discussed in the earlier sessions. We walked around the teaching space, offering suggestions.

In the final workshop, 'What to do with your materials', Van Luyn discussed some of the ways in which participants could present oral history materials, including via academic articles, digital stories, curated exhibitions, blogs, websites, creative nonfiction, theatre and fiction to inform public art, and provided an example of each. In the afternoon session, participants briefly interviewed a partner. Again drawing on the research that links fiction and oral history, we encouraged participants to explore the interview using techniques of fiction; participants could choose to re-represent the interview either as a short story (fiction) or as a factual account that used some of the techniques of fiction, such as scene-setting, dialogue, imagery and theme (a form referred to as creative nonfiction). At the end of the afternoon, participants read their drafts and received feedback from us. This workshop was designed to offer a taste of each of these forms, encouraging participants to imagine the possibilities of being able to share, modify and explore the rich media packages they had been trained to produce.

Reflection

In the initial stages of the workshop planning, we circulated a very brief outline of what each workshop would cover. Owing to the generality of the statement, one participant attended workshop one expecting a discussion on 'the art of storytelling, its usage, history and current forms', while we had a more practical, project-related emphasis. This led to a decision to manage expectations by providing detailed outlines of the workshops on the OHAA Qld website and asking participants at the beginning of each workshop to state their reason for attending and the outcome they expect from the workshops, to ensure all participants have a shared understanding of the content.

Although the workshops were advertised to the public via the OHAA Qld website, flyers in libraries, mailing lists and the SLQ, some participants did not find out about the workshops until halfway through the series, leading to problems with having to revisit content. In particular, Van Luyn found that because the ethics workshop only had four participants, many ethics-related questions were raised in later workshops. This led her to provide her slides on ethics to all subsequent workshop participants. Potential participants may not have realized the value of, or been interested in, an ethics workshop, even though such considerations are fundamental to all oral history projects. That they then sought out this information in other workshops they attended points to their awareness of just how critical and engaging this topic can be.

Feedback

The workshops were generally attended by five to eight participants including professionals working in a military museum and recording oral histories for training purposes, community historians producing traditional research outcomes such as academic articles and Higher Research degree students from universities. Three participants attended all five workshops. Two were professionals at a military museum and the third was a researcher embarking on her PhD project. Due to our academic backgrounds and the participant's dedication and enthusiasm, we were able to provide support to the research student over the five months of the workshop series, which produced a development in her research project. The participant stated:

> I found the workshops were well structured and presented to provide an overview of an extremely complex topic. Having attended the whole series I thought there was a natural progression.

She also stated that she 'found the [workshop content on] planning an interview and ideas on how to modify my strategy have made a huge difference'. The benefit of having the series of five workshops was to capture that complexity – an understanding needed for work in an academic context. However, participants who 'picked and chose' the workshops missed this sense of progression and were left with only part of the picture.

The gap between the aims and needs of professionals, academics and community oral historians was difficult to bridge. Further, although the format meant there was more time to discuss individuals' projects, we found it hard to tailor the workshops to suit such a diverse range of participants. For the series of workshops to be fully effective, participants should be encouraged to attend all five. We produced a teaching pack, consisting of PowerPoint slides, suggested readings, hand-outs and classroom activities, for sharing with members and other facilitators. This teaching pack can also be tailored to develop workshops for specific interest groups. After running these workshops, the feedback and reflection became the basis of the workshops we tailored for regional communities.

Cycle Two: Cardwell and Post-Disaster Narratives

As a result of our detailed advertising, community groups outside Brisbane took an interest in the workshop series. After Cyclone Yasi struck the town of Cardwell, destroying the historical museum and the Cardwell and District Historical Association's (CDHA) recording equipment, the association contacted OHAA Qld requesting workshops similar to those advertised, although CDHA could only afford to host facilitators for two days. As we had already developed the teaching pack, Klaebe, Van Luyn and Crawford were able to deliver a weekend-long 'emergency' workshop – a condensed version of the first three

workshops – teaching Cardwell participants to use OHAA Qld's equipment, and discussing ethical considerations and interviewing theory. We also supervised historical association members while they conducted three interviews with residents at the nursing home struck by the cyclone. This model reflected the focus on training participants to break the project into manageable parts with tangible outcomes; volunteers were able to produce three audio files and many pictures from the interviews during the weekend of our visit.

The historical association later received funding from a Regional Arts Development Fund grant for Klaebe, Van Luyn and Crawford to return to Cardwell and conduct a follow-up weekend of workshops on transcription and digital storytelling in September. Klaebe (2013: 2) argues that 'acknowledging the aims and goals of all stakeholders involved in arts-based narrative-driven projects ensures greatest impact' and that precious grant money is spent fruitfully. Klaebe (2013) describes this process as 'embedded evaluation'. We developed the storytelling workshops further by including an embedded evaluation element in the planning of content delivery.

In the six months after workshop one and before workshop two, we liaised with CDHA to support them in work that needed to be completed and to revisit and clarify their project aims. Volunteers concluded that they would like to put together an exhibition, featuring the oral narratives, images and objects from Cyclone Yasi; produce a book based on their oral history interviews; and safely archive any outputs with the historical association and the SLQ. Volunteers also hoped to encourage school children in Cardwell to work with the interviews and images to produce creative outputs. In line with these intentions, we supported volunteers to conduct five further interviews using the techniques developed in the first workshop, and to put together rich media packs for each of the interviews. The participants edited these packs, alongside the interviews and photographs collected during the last visit, to produce, with our help, digital stories in the second September workshop. In addition, drawing on creative writing techniques, we worked with volunteers to brainstorm reoccurring themes, metaphors and images from the interviews, which formed the basis of their exhibition.

Cycle Three: Creative Writing and Embedded Evaluation in Regional Communities

In May 2011, OHAA Qld applied for and received funding from the Gambling Community Benefit Fund to conduct oral history workshops in regional Queensland. The successful grant application marked a new direction for OHAA Qld, which had previously focused on delivering workshops only to the Brisbane metropolis. After the experiences in Cardwell and based on e-mail requests to their secretary, OHAA Qld felt that many communities in regional Queensland were interested in, and could benefit from, learning more about new media approaches to collecting oral narratives. Drawing on the two previous cycles of planning, action and reflection, we decided to work with regional communities to tailor the workshop series to suit their specific needs. OHAA Qld circulated an expression of interest

to its networks, inviting community groups and local councils to apply for training. Expressions of interest came from local council heritage librarians in Mackay, Townsville and Cunnamulla, and the secretary of the Cultural Heritage Network Toowoomba Region. All but the workshop in Cunnamulla (which was cancelled due to staff changes in the local library) were successfully completed.

In keeping with the embedded evaluation methodology and our previous experience, we worked with regional contacts to develop a plan for the workshops, most of which ran for two days over a weekend. We linked the training to projects the local libraries were undertaking; for example, in Mackay, which is situated 970 kilometres north of Brisbane and has a population of around 119,081 people (Mackay Regional Council 2012), the local library planned to launch the second phase of its 'Mackay through the Decades' project. In the first phase, Mackay community members donated to the library over 200 images of the region from approximately 1950s onwards. Staff members planned to gather oral histories around particular images, capturing the rich and personal history frozen in the snapshots.[1] We formulated a detailed description of the workshops to manage expectations and asked the regional contacts to circulate flyers among their networks, as they had the local knowledge.

Eighteen people attended the workshop in Toowoomba. Toowoomba is located 127 kilometres west of Queensland's capital, Brisbane, and has a population of about 157,669 (Toowoomba Regional Council 2012). The participants were staff from the geographically diverse areas of the Western Downs Libraries, Dalby branch and volunteers from Milmerran Historical Society, Boondooma Museum and Heritage Association, Bowenville History and Heritage Association and Queensland Parks and Wildlife Services, Clifton Progress Association and Museum, Murphy's Creek Neighbourhood Centre, Gympie Woodworks Museum, Toowoomba Grammar School, National Trust, Toowoomba, Glennie School Archives, Blackbutt District Tourism and Heritage Association and Surat Aboriginal Corporation. Participants attended for diverse reasons, such as collecting oral histories from past staff and students who went to Glennie and the Boys' Grammar School; collecting the stories of Indigenous elders, focusing on those dwelling on the fringes; using oral histories in the Woodworks and Blackbutt Museums and depositing them in their archives.

In Townsville, 1366 kilometres North of Toowoomba, attendants included volunteers from the Performing Arts History Society Townsville who were hoping to record oral histories from Townsville artists; a member of Writers in North Queensland planning to rely on oral histories to augment his playwriting; community members wanting to capture stories from men and women who worked on cattle stations in the centre of Australia; and a member from the local Indigenous community who wanted to collect oral histories to complement her work in Indigenous education. We invited the participants to share this information early in the workshop, and tailored the focus in discussion to meet participants' needs during the delivery of content.

Eight participants attended the workshops in Mackay. Some participants hoped to learn more about their family histories, while volunteers from Greenmount Homestead,

five kilometres outside of Mackay, hoped to collect oral histories documenting the rich history of Greenmount and surrounds. Others came simply to learn more about oral history.

In each of these workshops, we trained participants to conduct oral history interviews using narrative techniques informed by creative writing practice and to produce rich media packages that they could modify, adapt and engage with for a variety of different purposes and contexts. We also encouraged participants to share contact details to ensure local sustained support. In Townsville, this resulted in the establishment of an oral history group, who meet once a month to conduct interviews with community members that the group has identified as having rich local knowledge and stories to share. The city council library purchased audio recording equipment to support this activity, which is available for loan to community members, and Heritage Librarian Annette Burns acts as secretary for the group. This group runs autonomously, although we are available via phone or e-mail to answer questions. Local communities are thus equipped to continue to gather oral histories in a sustainable manner.

Reflecting on experiences in Brisbane and regional communities, we observed that the workshop forums offered an opportunity for community members to access local knowledge. The opportunity to interview each other allowed participants to tap into shared memories and experiences of local areas, generating new knowledge. Local libraries played a key role in this process, becoming a repository for local stories and a central site at which like-minded community members could meet and interact.

Conclusion

Our experiences in regional settings demonstrate the complex negotiation between research commitments and service to the community. After engaging in planning, action and reflection cycles, we came to see that our theoretical research into new media and creative writing techniques can be used pragmatically to facilitate impactful outcomes for communities. By re-shaping oral history workshops to encourage participants to gather rich media packages that can be modified and adapted for a variety of purposes and forms, a deeper understanding of the constructed qualities of oral narratives can be introduced. Embedded evaluation, a methodology that encourages stakeholders to negotiate outcomes from the outset of a project, is another practical and effective way to support regional Queensland's professional and amateur oral historians as they engage in creative new media storytelling projects in their local communities.

Oral stories can connect regional communities because they offer a metaphorical means to make sense of past events, including natural disasters. Our facilitation of oral history workshops encourages participants to see memory as a meaningfully constructed narrative and, in doing so, appreciate an interviewee's unique reality. In a new media age, oral histories can be shared and re-used on multiple platforms, increasing connectivity between regional

locations and the wider community. Facilitators may best serve regional communities to produce innovative narrative-based projects through consultation at all stages of the project, equipping community members with the skills to complete the project themselves and a realistic understanding of the commitment required to achieve their goals, and encouraging the formation of local networks at workshop events.

References

Albright, Daniel (1994), 'Literary and psychological models of the self', in Ulric Neisser and Robyn Fivush (eds), *The Remembering Self: Construction and Accuracy in the Self-narrative*, Cambridge: Cambridge University Press, pp. 19–40.

Beer, Andrew, Maude, Alaric and Pritchard, Bill (2003), *Developing Australia's Regions: Theory and Practice*, Sydney: University of New South Wales Press.

Bloom, Harold and Hobby, Blake (2009), *Bloom's Literary Themes: The Hero's Journey*, New York: Chelsea House.

Cashman, Katharine and Cronin, Shane (2008), 'Welcoming a monster with words: Myths, traditions and modern societal response to volcanic disasters', *Journal of Volcanology and Geothermal Research*, 176, 407–418.

Cohn, Dorritt (2000), *The Distinction of Fiction*, Baltimore: The John Hopkins University Press.

Creative Commons Australia (2013), *About*, accessed 26 February 2014, available at http://creativecommons.org.au/

Gregory, M. (1998), 'Fictions, facts, and the fact(s) of (in) fictions', *Modern Language Studies*, 28(3/4), 3–40.

Hearn, G., Tacchi, J., Foth, M. and Lennie, J. (2009), *Action Research and New Media*, Cresskill: Hampton Press.

Hirsch, Anna and Dixon, Claire (2008), 'Katrina narratives: What creative writers can teach us about oral history', *Oral History Review*, 35(2), 187–195. doi:10.1093/ohr/ohn056

Jenkins, H. (2010), Transmedia storytelling and entertainment: An annotated syllabus, *Continuum: Journal of Media & Cultural Studies*, 24(6), 943–958.

Jones, K. (2006), 'A biographic researcher in pursuit of an aesthetic: The use of arts-based (re) presentations in "performative" dissemination of life stories', *Qualitative Sociology Review*, 2(1), 66–85, available at http://eprints.bournemouth.ac.uk/1178/1/Jones_Output_1.pdf

Klaebe, Helen G. (2012), 'Disaster strikes, then what? Using evaluation in narrative driven (oral history & digital storytelling) community-based projects', in Liliana Barela, Joana de Pedro, Juan José Gutiérrez, Miren Llona and Miroslav Vanek (eds), *Proceedings of the 17th International Conference of Oral History: The Challenges of Oral History in the 21st Century: Diversity, Inequality and Identity Construction*, Buenos Aires, Argentina: International Oral History Association (IOHA), pp. 1–8.

Klaebe, Helen G. (2013), 'Facilitating local stories in post-disaster regional communities: Evaluation in narrative-driven oral history projects', *Oral History Journal of South Africa*, 1(1), 125–142.

Klaebe, Helen G. and Foth, Marcus (2007), 'Connecting communities using new media: The sharing stories project', in Larry Stillman and Graeme Johanson (eds), *Constructing and Sharing Memory: Community Informatics, Identity and Empowerment*, Newcastle, United Kingdom: Cambridge Scholars Publishing, pp. 143–153.

Klaebe, Helen G. and Burgess, Jean E. (2008), 'State Library of Queensland Oral History and Digital Storytelling Review', accessed 26 February 2014, available at http://eprints.qut.edu.au/14611/

Klaebe, Helen G., Mulligan, Suzanne, Van Luyn, Ariella and Volkova, Lena (2011), 'Training the public to collect oral histories of our community: The OHAA Queensland Chapter's model', in Sue Anderson (ed.), *Proceedings of the 17th National Biennial Conference of the Oral History Association of Australia 2011: Communities of Memory*, Melbourne, Victoria: Oral History Association of Australia (OHAA) Inc.

Mackay Regional Council (2012), *Mackay Region*, accessed 26 February 2014, available at http://www.mackay.qld.gov.au/business/economicdevelopment/about_the_region/mackay_region

Neisser, Ulric (1994), 'Self-narratives: True and false', in Ulric Neisser and Robyn Fivush (eds), *The Remembering Self: Construction and Accuracy in the Self-narrative*, Cambridge: Cambridge University Press, pp. 1–18.

Nelson, Katherine (2003), 'Self and social functions: Individual autobiographical memory and collective narrative', *Psychology Press*, 11, 125–136.

Olney, James (1998), *Memory and Narrative: The Weave of Life Writing*, Chicago: University of Chicago Press.

Polkinghorn, Donald E. (1988), *Narrative Knowing and the Human Sciences*, New York: State University of New York Press.

Queensland Business Leaders Hall of Fame (2009), *Sister Angela Mary*, available at http://leaders.slq.qld.gov.au/inductees/sister-angela-mary-ao/

Regional Arts Australia (2013), *National Cultural Policy*, available at http://www.regionalarts.com.au/wp-content/uploads/2013/10/RegionalArtsAustraliasubmission.pdf

Rosenblatt, Paul C. (2003), 'Interviewing at the border of fact and fiction', in Jaber F. Gubrium and James A. Holstein (eds), *Postmodern Interviewing*, Thousand Oaks: Sage Publications, pp. 225–241.

Shopes, Linda (2002), 'Oral history and the study of communities: Problems, paradoxes and possibilities', *The Journal of American History*, 89(2), 588–598.

Thomson, Alistair (2011), *Moving Stories*, New South Wales: University of New South Wales Press.

Toowoomba Regional Council (2012), *Toowoomba Regional Council Area Estimated Population*, available at http://profile.id.com.au/toowoomba/population-estimate

Van Luyn, Ariella (2010), 'Fictionalising oral history: Narrative analysis, voice and identity', *Oral History Association of Australia Journal*, 32(1), 68–74.

Van Luyn, Ariella (2012a), 'Jogging alongside or bumping off? Oral history and fiction in dialogue', *Oral History Association of Australia Journal*, 34(1), 62–70.

Van Luyn, Ariella (2012b), 'The artful life story: The oral history interview as fiction', PhD thesis, Queensland University of Technology, Brisbane, accessed 26 February 2014, available at http://eprints.qut.edu.au/60921/

Van Luyn, Ariella (2013), 'Artful life stories: Enriching creative practice through oral history', *Text*, 17(1), accessed 26 February 2014, available at http://www.textjournal.com.au/april13/vanluyn.htm

Note

1 For more details on this project, see http://www.youtube.com/watch?v=-jZEX_aEBSA&feature=youtu.be and http://www.mackay.qld.gov.au/about_council/newsletters/content/council_connect_april_202

Chapter 10

Vicarious Heritage: Performing Multicultural Heritage in Regional Australia

Robert Mason
Griffith University

The heritage tour began at one of the high points of Australia's Great Dividing Range. Situated at the top of 'The Crossing', the tourists looked down over the steeply inclined federal highway, which weaves its way through dense vegetation and steep cliffs to reach the peak before crossing into the vast agricultural hinterland beyond. Visitors walked around the immaculately manicured gardens for which the viewing site and the local City of Toowoomba are well-known. Gathered on the viewing platform, tour participants politely admired the spectacular vista of the Lockyer Valley down below. Interrupting their thoughts, the performer-guide asked them to imagine the site 170 years previously, and proceeded to describe a significant and deadly confrontation between white settlers and Indigenous Australians. Few participants were previously aware of the conflict, which was rarely discussed in the city. Many on the tour were unsure how to respond.

The tour formed part of Toowoomba's well-known annual Carnival of Flowers (discussed elsewhere in this collection by Andrew Mason). The heritage tour had been created to diversify the tourist experiences for visitors to Australia's 'Garden City' in a collaboration between the local University of Southern Queensland, regional government and industry partners. The Carnival of Flowers is a major event in the commercial and social life of Australia's second largest inland city, with over 100,000 spectators to key Carnival events each year. In addition to attracting tourists, the celebration is the premier expression of civic pride for local residents. Repeated annually for many decades, it represents continuity, stability and a sense of cultivated agrarianism from which residents draw great pride.

The heritage tour centred on the gregarious persona of a performer-guide and sought to provide a marketable product of interest to visitors and locals alike. Within this mandate, it explored how people perceived the city of Toowoomba and their place within it. The city's architectural heritage of sandstone civic buildings and wide streets is well-known, but there has been little exploration of how locals relate these nineteenth- and early twentieth-century buildings to the contemporary community. Rather than re-affirm a legacy of wealthy white landowners, we hoped to recapture the city's ethnically diverse past and to connect this to an environment that has frequently proved violent and unpredictable. In so doing, we sought to reintroduce a sense of vulnerability and difference as a continuum in the city's history, and to explore how this might be viewed as something other than negative.

Regional Heritage

The heritage tour sought to explore perceptions of community belonging and difference in a city that has undergone rapid demographic changes in the past decade and a half. From the start of the creative process, this led to a productive tension between the commercial needs of industry and the research interests of the University. The project team encompassed myself as a historian, Janet McDonald (a colleague at the University, co-editor of this collection and specialist in regional arts), the regional council with oversight for the Carnival, a tourism consultant, the local theatre, the bus company running the tour and the performer-guide himself. The potential difficulty posed by this range of partners working on a relatively contained project was mitigated by a clear commitment to the project vision: for a marketable tour that complemented the Carnival of Flowers and that explored ways to transform the experience of heritage and community.

The tour was focused on the figure of a performer-guide, who would interact with participants around a loosely scripted narrative. Participants would periodically disembark the bus, which drove around the city centre and its environs on a predetermined route. It was important that the performer-guide (who was a local man active in amateur theatre) was comfortable with the historical narrative and competent with the deployment of his personal experience within the wider context. This was especially important if his gregarious persona was to connect appropriately the issues of Indigenous massacre, forcible exclusion of non-whites and deaths by natural disaster. The script was produced through an iterative process of historical research, script writing by McDonald and a series of meetings with the performer-guide, theatre professionals, McDonald and myself. With time, the process expanded to include industry stakeholders and various rehearsals on the tour bus. Crucially, the performer-guide's capacity to remain credible and in-character throughout the tour was central to whether he could meaningfully connect discontiguous heritage sites into a coherent narrative able to transform community preconceptions.

Participants were invited to reflect on their experiences at the end of tours in semi-structured interviews with volunteer research assistants from the University. In addition, each participant selected a number of 'feeling words' that best represented their emotional response to the tour. This technique was developed by Jan Packer (2011) to capture emotional engagement in heritage, and focuses on the important feelings people have at the end of a museum or heritage experience. For this project, it also enabled exploration of how the 'possessive intimacy' (Lowenthal 1997, cited in Jackson 2008: 375) associated with local heritage could be disrupted while still being experienced as an authentic reflection of community.

The city of Toowoomba offered an ideal locale in which to explore disruptions to accepted notions of heritage and inclusive community. Situated approximately two hours from the state capital of Brisbane, it has a steady number of visitors who seek the tranquillity and cool temperatures associated with the city. At the same time, its population is self-consciously 'regional', encompassing a quiet disdain for cosmopolitan attitudes in favour of championing

agriculture, social stability and rural economic development. The city acts as the unofficial capital for the Darling Downs, a region of well over 75,000 square kilometres that is among Australia's most fertile agricultural land.

The Toowoomba area was settled from 1840, in a process of frontier conflict that encompassed the dispossession and death of many of the area's Indigenous Giabal and Jarowair peoples (French 2009). Over time, and as part of a pattern common in the Australian interior, a 'squattocracy' of agricultural landowners forcibly took possession of large tracts of land. By the time that Toowoomba was officially declared a municipality in 1860, the region's agricultural potential was clear and farming was developing apace. However, such farms' profitability relied on the presence of marginally employed workers drawn from socially excluded ethnic groups. Toowoomba's affluence increased through the early twentieth century at the same time as the country's White Australia policy removed many non-whites and prevented the further arrival of others. The city's inhabitants progressively re-imagined themselves as an affluent all-white city, which legitimately represented the pinnacle of Australia's agricultural elite. The region experienced little demographic change until a visibly different population returned in the late twentieth century, as Toowoomba became a designated settlement centre for refugees and the University attracted increasing numbers of international students.

In 2011, the Toowoomba region experienced serious flooding that killed 16 people. The event understandably shocked and horrified many, who had been told that 'Toowoomba will never flood' (McWilliam 2013). Such advice demonstrated a widespread amnesia of the fact that the city was built on a former swamp on the top of a mountain range. In common with much of regional Australia, the city had embraced a notion of agricultural stewardship in which the land could be inexorably tamed for the progress of the farming and national community. As with elsewhere in Australia, this vision of continuous stewardship of land tended to marginalize outsiders and emphasized cultural whiteness as the community norm. Migrants had settled in regional Australia in large numbers, most notably after the Second World War. However, there was an unmistakable expectation that they would rapidly accrue whiteness to the point when they would assimilate into the community. The recent arrival of visibly different refugees and international students raised important questions for the city's future imagining of itself, as well as the role of its heritage and imagined past.

While not hostile to new arrivals, communities in regional Australia experience what has been usefully summarized as a wariness caused by geographical 'isolation, lower levels of essential services, population outflow to the cities, lower skill levels, unemployment, and […] a distinctive social structure' (Grimwade and Carter 2000: 35). Together, these elements form a particular framework in which any re-imagining of the local community must occur. Museum and heritage sites in regional Australia are frequently focused on a hardy settler past, with a strong local focus in terms of sites' vision and content. Given the long distances, sites predominantly rely on local volunteers to maintain and preserve cherished community narratives. Within this context, there is little interest in the histories of ethnic minorities (Grimwade and Carter 2000). Where recognition of culturally and linguistically

diverse communities occurs in heritage spaces, it tends to position people as noteworthy for disrupting accepted narratives, rather than being core to the history of regional Australia.

Scholars have noted the importance of local histories to communities' sense of self and belonging, frequently contrasting them to the 'vapid candy floss' of commercialized heritage (Royle 1998, cited in Jackson 2008: 363). Local histories are positioned as producing new knowledge that connects with broader trends, rather than the 'candy box nostalgia' of demarcated heritage destinations where actors dress in costume (Jackson 2008: 371). Local history is vibrant in Toowoomba, with a local history association that conducts occasional small tours and has a regular newspaper column and radio segment. The city's obvious architectural heritage is a source of civic pride, which is often the focus for community engagement in local histories. With only moderate demographic change during its European settlement, community members have invested significant emotions in their local histories.

There is a recognized body of literature regarding the benefits that can flow from community engagement in local heritage (Grimwade and Carter 2000). Notwithstanding this, there is a tendency to focus on the tangible heritage around which community mobilization and engagement is easiest. Yet, without 'appreciation of what is being conserved [and what is not], cultural heritage sites potentially become meaningless, and understanding of human history is lost' (Grimwade and Carter 2000: 34). It is notable in Toowoomba, as elsewhere, that those sites that have been preserved are the beautiful sandstone civic buildings and wartime monuments. Within the city, the network of Japanese laundries has been lost, the state's first synagogue demolished and the former Chinese market gardens have been 'returned to nature' as a Bicentennial Bird Park. This is partly a reflection of the emphasis on demarcated heritage sites, but also reflects the local community's capacity to imagine vicariously.

People's relationship to place reflects deep emotional investment in spaces that represent tangible connections between present and past communities. It was particularly important for us to re-find a sense of Toowoomba's spaces as ethnically diverse and to reflect on the social habits that centred on the spaces. The historical presence of (non-Indigenous) visibly different others has been forgotten, with the result that the city's contemporary visibly different population has been positioned as new, historically abnormal and potentially unsettling. I argue that the careful use of performer-guides may offer one way to re-imagine stories and sites of community diversity and inclusion.

Heritage Performance

Heritage performance has been defined as 'the use of theatre and theatrical techniques as a means of mediating knowledge and understanding in the context of museum education' (Jackson and Rees Leahy 2005, cited in Kidd 2011: 22). This broad definition captures a range of heritage performances and draws attention to the human stories that connect

historical sites and objects (Kidd 2011). One of the great strengths of heritage performance lies in its capacity to challenge notions of a single historical truth and instead to recognize that historical meanings are conferred through fluid social interactions (Garden 2006). In this manner, the heritage experience can be understood as a unique interaction between site, performer-guide and tour participants.

Although the tour was designed for visitors to Toowoomba, a significant majority of the tour participants were from the local region. The fact that people lived in the heritage spaces every day is important, as was the fact that they were participating in the tour as part of the celebratory Carnival of Flowers. These were not value-free heritage spaces, and participants knew the subsequent histories of what the sites had become. The performer-guide was not crafting an isolated narrative, but had to overlay people's own cultural knowledge of site and place. Many in the local community feel great pride in the city's early multi-ethnic past, citing examples of commercially and politically successful migrants to demonstrate Toowoomba's inclusive heritage. These everyday experiences of the spaces need not mitigate the potential impact of the heritage tour. Indeed, powerful affective experiences can re-signify commonly experienced heritage spaces and contribute 'in some meaningful way to transforming the people themselves' (McCarthy and Ciolfi 2008: 250).

The sites and spaces through which the tour moved were inherently social, with heterogeneous meanings that had to be recognized. The tour continued from the viewing platform overlooking the site of Indigenous massacre through the Bicentennial Gardens (and former Chinese market gardens) past heritage buildings, including the former gaol, courthouse, theatre and train station. From the start, we sought to use these well-known spaces to foster recognition for a multicultural heritage that would help to normalize the city's diversity. As Ballantyne argues, heritage 'should seek to uncover, deconstruct and acknowledge the contests and struggles that characterize most social spaces, rather than shy away from potentially controversial or problematic issues' (Ballantyne 1998, cited in Markwell et al. 2004: 465–466). As one stakeholder commented, 'there's nothing funny about dying of typhus in 1888 because they ate stuff from the Chinese markets […] But I think hysterically funny when you find out the typhus came from them using what [the performer-guide] called "you-poo"' (Stakeholder Interview 1). An industry partner's request to frame the story through this reference to human faeces and the performer-guide's decision to discuss the Chinese presence (and absence) through light-hearted banter are symptomatic of the difficult balance between accessibility and empathy in this debate.

The performer-guide's persona was of a gregarious larrikin (a well-loved Australian stereotype of a boisterous and irreverent male). The original plan to have a sequence of historically specific personas was replaced as the tour developed. This posed some difficulty to the performance of the tour's content, since the performer-guide now offered a representation of Toowoomba that was not always critically reflective. The language available to the larrikin character also structured how knowledge was communicated. Yet, it also positively influenced most participants' willingness to engage in good faith with his persona, and many found that he 'made it fun' (Participant Interview 8), 'light-hearted and

entertaining' (Participant Interview 9) and that 'just the overall friendliness of the tour was what made it the best for me' (Participant Interview 10). The stories that engaged people the most were those with which they had most in common. For a number of participants, their interaction with the performer-guide and tour became a dialogue focused on emotional reminiscence. Opportunities to interject family memories were frequently taken, as participants interrupted the performer-guide with their personal stories of presence in local space. A typical example was the participant who recalled, 'my great-grandfather ran a boarding house opposite the railway. There was a lady on the bus whose grandmother's parents, her great-grandparents ran a boarding house not far from my mother's [laughs]' (Participant Interview 2).

Importantly, meaning-making was a social process in the heritage spaces, drawing on the tours' own particular social dynamics. The more confident participants felt able to interact directly with the performer-guide, both in the bus and in the heritage sites. Participants (and the performer-guide) who reminisced and articulated memories did so in the belief that they would be supported by others in the group, who shared similar collective memories of the past. Their story-sharing risked excluding other participants, such as middle-aged and young adults who felt marginalized by the emphasis on direct reminiscence (Stakeholder Interview 3).

The larrikin persona encouraged many participants to share their views because they were confident that they understood the discursive rules around this framework of Australian identity. Thus, one participant confidently disclosed that 'my great-grandparents were some of the early pioneers in Toowoomba [and that she had attended] because of my roots' (Participant Interview 2). Yet, these are typical of 'preferred models of identity', which tend to be emphasized in communities' heritage engagement (Newman and McLean 2006: 60). Such models are based on contemporary understandings that fashion the past as a reflection or equivalence of the present. The sociability meant some participants were less confident in sharing stories that may have challenged dominant narratives and that risked being misrecognized in the group (Participant Interviews 5 and 14). Less well-known stories of the city's non-white past were listened to respectfully, with a typical response being that 'I've lived in Toowoomba for a long, long time, I did not know about the Japanese population' (Participant Interview 5). An exception to this polite indifference was the interest shown in the story of Hunter Poon, a turn of the century Asian Australian cricketer who went on to play nationally. The story positioned him within a quintessentially white Australian sport and praised his service in the First World War. Positioning Poon in this way emphasized select entry points through which the community could choose to grant a privileged access to whiteness, but it did not normalize his difference.

In many ways, participants' hesitation to identify with a multicultural heritage as their own was understandable and site-specific. The tour's stop at the train station, for example, prompted prolonged reminiscence of soldiers leaving to fight in World War II, with many participants anchoring their discussion in the poem that was read of an Anglo-Australian woman knitting socks for her husband and sons (Participant Interview 5). Participants

enjoyed the performer-guide and bus driver's impromptu singing of war songs. Yet, it was also the site from which German and Japanese Australians were sent to internment camps or deportation. This fact elicited only comments that further othered them by marginalizing their Australian-ness (such as, 'I knew about the Germans' as opposed to the 'German Australians'). The emotional engagement of the war era was amplified by the performer-guide's decision to share his personal war stories, after which people interjected with 'their' stories of the war. The performer-guide himself felt uncomfortable discussing the deportations and preferred his own family history in wartime. The specific persona chosen for the performer-guide may have created this equivocation, given the centrality of his biography to the character. In so doing, his own story became central to the groups' '"emotional mapping", and thus perceptions of the authenticity of the story [he told were] aided by the authenticity of the feelings and memories engendered' (Kidd 2011: 30).

The larrikin performer-guide offered one way to develop the emotional connectivity needed to explore whether the heritage sites were authentic parts of the community's past. His tendency to insert his own stories into the landscape clearly positioned him as a contemporary local. This meant that his performance could not bear witness to a lost or invisible heritage; it also limited his capacity to perform past interactions with space. Rather, he acted as a representative of the community, retelling its own history to itself. He had to be an insider to be credible in this regard, but in so doing he was caught in the awkward complicity of historical amnesia. The script sought ways to accommodate vicarious imaginings in heritage spaces by weaving the continuity of cultural diversity in public spaces through emotional stories. In the performance, however, such imaginings were through the referent point of the white performer-guide's personal biography.

Community understanding of what constitutes authenticity is complex and multi-layered according to context. Often, community is most satisfied that the narrative is an authentic reflection of themselves when they have been involved in the project design, scoping and storying of the tours (Perkin 2010). This was beyond the purview of this project, not least because of the absence of deported non-whites. Yet, the community still had to be able to insert themselves into the narrative articulated by the performer-guide, viewing it as an authentic reflection of the past; albeit one that incorporated and involved them in previously unknown elements. As Rickly-Boyd (2012: 129) notes, while sites 'provide tourists with an historical narrative of place, tourists ultimately form their own narratives about heritage sites through their experiences with its landscape'. Importantly, the same process is involved in a performer-guide who acts without a formal script or fixed character.

Vicarious Heritage

Heritage provides an important site to explore regional society's perceptions of contemporary multiculturalism. The widely accepted paradigm for regional heritage perpetuates an imagined juxtaposition with the supposed cosmopolitanism of metropolitan Australia. This

has tended to emphasize regional narratives of struggle and dominance over nature, incorporating a hierarchy of legitimate identifications with local space that centre on Anglo-normativity. The rendering of a contested past into a normalized landscape of everyday interactions has thus created a sense of uncontested whiteness within regional communities (Guthrie 2010). The passage of our tour sought to offer an alternative iteration of the landscape and a re-reading of common relationships to place.

Regional heritage can exist only through regional communities. This draws attention to the influence of the 'thick seams of power' and values that bind communities (Waterton and Smith 2010: 8). Regional Australian heritage focuses on the white, masculinized artefacts of the struggling settler, drawing attention to the aesthetic heritage of rural homesteads and a celebrated national identity as a precariously triumphant underdog. Participants emphasized the importance of this process of social recognition. Some felt cheated that the tour had not focused on buildings (Participant Interviews 6 and 10), while others argued that the references to natural disaster were inappropriate in a heritage tour (Participant Interviews 10 and 14). Such instances do not deny society's capacity to recognize multiple narratives in heritage sites, but do emphasize that any discursive or performative creation 'heritage' relies on community recognition (Waterton 2010).

The absence of socially recognized heritage relating to non-white Australians highlights this quandary. The dominant community narratives did not recognize the Bicentennial Park as a site of multicultural heritage. Similarly the Empire Theatre was discussed extensively by participants in relation to white sporting heroes, firefighters and visiting royals (all part of a national iconography), but was conceptually disconnected from the erased synagogue across the road. The naturalized assumptions that underlay the community's lack of recognition were based on the racialized, gendered and sociocultural norms of regional Australia. The consensus on legitimate Anglo-normative heritage re-affirmed locals' security in their sense of self and community, legitimizing certain imagining of the city and discrediting others (Waterton and Smith 2010).

The centrality of the performer-guide's storytelling tended to fold historical time in on itself during the tour, as his personal experience created a sense of historical equivalence. In contrast, participants demonstrated a sense of detachment from the erasure of the Asian Australian presence in their landscape. Various sites of Asian presence were pointed out during the tour, with a focus on recounting the sites' human stories. The content ranged from the nineteenth-century Chinese Australian businessman Hock Singin to the 'golden triangle of cleanliness' formed by the cluster of Japanese laundries. The long-standing presence of Chinese shepherds and Japanese laundries was initially treated as a curiosity; however, by the end of the tour, some participants expressed appreciation that the tour had taken time:

> telling stories about local people from the variety of different backgrounds … umm … and their businesses and how they were engaged in the community … umm … I thought that was all really wonderful.
>
> (Participant Interview 11)

The focus on personal stories by the performer-guide opened a space for vicarious reflection. By the end of the tour, participants commented that 'we heard about the … umm … cultural diversity of the area […] So it wasn't looking at just a couple of old buildings, it was much more than that' (Participant Interview 11).

Wartime tensions proved an important catalyst for engagement with the Other. Tension existed in discussions of the Japanese laundries and their owners' removal during the Second World War. The emotional resonance of the tour (especially those aspects that evoked death, such as the First and Second World Wars) can provide a framework through which tourists can engage sites. Echoing this, participants recalled that 'the most moving part was when we went to the train station and they told us this story about the mothers and their sons [going to war]' (Participant Interview 4). In so doing, and in the context of the White Australia policy, emotions have the capacity to 'transform symbols of national weakness and vulnerability into symbols of national renewal' (Selwyn 1996, cited in Breathnach 2006: 113). This was not the case for the largely older tour participants. The majority of participants discussed deportations in terms of the war with Imperial Japan and family stories of loss at the hands of the Japanese. With more time, better community engagement would result in stronger narratives of diversity that intersected with local war stories.

It is in this context that the performer-guide offers pathways for recognition of people's presence in the landscape. While understanding formalized discussion of heritage requires literacy and education as well as insider knowledge of local histories, understanding people's stories does not. It was obvious that the most actively engaged tour participants were those who knew that their personal interjections would be recognized within accepted narratives of regional and national identity. Thus, stories of fire burning through the theatre were experienced as 'just very moving' (Participant Interview 4). Moreover, the most common feedback from the 'feeling words' focused on reflexive emotions connected to the thought-provoking nature of the stories, as people wanted to feel 'the story of Toowoomba' (Participant Interview 2).

A performer-guide cannot alter the broader social structures that influence community recognition of heritage. Yet, there is a potential to open pathways for emotional empathy with those who live in the community but are imagined as separate from it. As one participant recalled, the performer-guide 'got very emotional when he was reading the poem about the sons and I think that then flowed through to the rest of us' (Participant Interview 5). It was this emotional response that allowed people to 'see a different side of Toowoomba' (Participant Interview 18) and to reflect 'about the town you drive by everyday […] and you just don't know' (Participant Interview 14). The conceptualization of civic landscape as infused with multiple stories, produces spaces 'where our abstracted, homogenising national stories are called into question through the daily telling and living of our unique and overlapping individual stories' (Lehrer 2010: 283). It is in this capacity to imagine and relate empathetically that performer-guides' utility may lie.

Australians have not engaged in a national process of sustained reflection on the consequences of the White Australia policy. National discussions around historical injustice

In the 1960s and 1970s, when government subsidy to cover theatre production costs became available, the competition for this financial support seriously undermined the function, status and value of these little theatres.. The terms of this competition were observed by theatre companies, practitioners and productions as having to demonstrate their capacities in terms of innovation, excellence and professionalism. The situation for the amateur theatre sector was further complicated, in that 'throughout the twentieth century advanced capitalism brought with it a rapidly escalating emphasis on professionalism both in the economic sense and in the sense of enhancement of specialist skills' (Cochrane 2001: 234). This shift in values had a significant impact across work, leisure and cultural activities. As Cochrane (2001: 234) declares, '"Professional" now carries with it connotations of ultra-competence. The amateur is non-professional and by implication incompetent'.

During the period of my research, the findings about amateur theatre and its value to this community developed from observation of productions by three of the longest running and largest amateur theatre groups on the Gold Coast. These groups were Gold Coast Little Theatre, Spotlight Theatre Company and Javeenbah Theatre Company, and their productions were, consecutively: *Showboat* (the 1929 musical by Kern and Hammerstein), *The Boy from Oz* (the 1998 musical by Enright and Allen) and *Sweet Charity* (the 1966 musical by Coleman and Hart). All three were performed on the Gold Coast in 2010. While all three productions were similar in terms of being large-scale musicals, as a group they were representative of the types of theatre produced on the Gold Coast at the end of the first decade of the twenty-first century.

There was diversity between them with regard to production style, directorial approach and cast membership in terms of age, experience and aspiration. *Showboat* was an example of a more traditional amateur theatre production, whereas *Sweet Charity* and *The Boy from Oz* represented different and alternate approaches to production and company composition. Both the latter productions contributed significant information to the study of amateur theatre in terms of these companies being sites of generational change. What follows is an exploration of the qualities I observed that make amateur theatre an essential part of the Gold Coast's theatrical life.

Amateur Theatres as a Pathway to Social Connectivity

> I am passionate about the community aspect of it.
> (Participant 1, 15 December 2009, interview)

Engagement with the local amateur theatre company provided experiences that brought a sense of the communal, of shared purpose and engagement to participants, even a sense of 'tribalization' as one interviewee put it. This meant that for the period of a production, being a member of a particular company brought deeper benefits beyond just being in the production. One cast member spoke of arriving on the Gold Coast in the late 1960s to a very

small, unsophisticated community at Southport and finding the local theatre group to add an indispensable element to his life. He said that 'it became an important and active social part of our lives. With that came new friends, constant theatre parties, all the social interests that follow from being in an active organization' (Participant 2, 17 May 2010, interview). It is in shared social activities such as these that a sense of community can develop.

The Creative Community Index 2002 (Kreidler 2002: 6), devised by Cultural Initiatives Silicon Valley,[2] asserts that 'arts and cultural activities can play a critical role in connecting people across cultures and affinity groups, helping them to identify commonalities and value differences'. Kreidler (2002: 8) describes cultural activities, such as musicals or plays, as the 'neutral meeting ground' where these connections can be made. This 'neutral meeting ground' is a particularly important way of gathering people together who, due to occupational or socio-economic or educational differences, would not otherwise meet to form cooperative, creative entities. The gathering is important and the benefits are amplified by the systems of human interaction involved in the production of a play.

There are many individual and independent elements that need to transform as a result of interaction and subsequent cohesiveness for a successful theatrical experience. A survey of the 41 members of the *Showboat* cast and crew revealed it comprised lawyers, engineers, social workers, accountants, university lecturers, chemists, teachers, career consultants, high school students and retirees. As theatre-makers, the experience and commitment of this cast and crew ranged from the beginner to the expert and from the hobbyist to the theatrically career minded. The challenge for this company was twofold: the first was to make this well-known stage show fresh and engaging for a twenty-first century Gold Coast audience; the second was to bring together the challenges of the script with the broad mix of skills and capacities of its cast and present it within the confines of their physically small local theatre.

Putnam's (2000) concept of 'social capital' is useful here in understanding how actual participation in the arts can be instrumental in building beneficial social relationships. For Cultural Initiatives Silicon Valley, the prospects of generating social capital through cultural participation are increased when people are involved as active participants or producers rather than being restricted to a passive observer role (Kreidler 2002: 6). This re-emphasizes the qualities mentioned at the beginning of the chapter in terms of amateur theatre's capacity to offer its participants viable opportunities to participate, try things out and to 'practice for life'.

Amateur theatre provides the opportunity for active participation at all levels of its endeavour. This participation also has a resonating effect upon the wider community. Cochrane (2003: 170) writes 'in the case of amateur theatre the viewing public may well have entirely different expectations of performance predicated on entirely different relations with the performers'. Many of the Gold Coast research project participants emphasized the significance of their particular communities, families and friends not only being aware of their participation, but supporting and attending performances as well.

For a number of participants, involvement in amateur theatre augmented their relationships with their family, friends and their community. Indeed, the secretary of the

Gold Coast Theatre Alliance, a long-time local theatre worker, emphasized the importance of families and the engagement of family members in productions as vital ingredients in the longevity of the region's amateur theatres. He described Spotlight Theatre Company as having third and fourth generation family members involved. The founders of this company in 1955 had been followed by their children and grandchildren, who then established a youth theatre as part of the Spotlight Theatre Company. For him: 'You cannot get more community than that' (Participant 3, 29 October 2009, interview).

In a similar vein, the Gold Coast Theatre Alliance secretary described the communal relationship between a particular local theatre group and its audience as being one where the audience books tickets almost regardless of what the plays are. This is because the audience has a commitment to this particular company and the social and theatrical experiences that it provides. The shows are presented in cabaret mode with tables and chairs set up around the stage. Audience members arrive early, sometimes an hour before the show begins, and supply their own dinner. They share food and conversation with friends, and the performance almost 'evolves' out of this easy familiarity between audience and performers.

Amateur Theatre and Pathways to Belonging

In discussing the relationship between art and community, Leicester and Sharpe (2010: 28) describe the arts as being able 'to relate us to each other in a way that allows us to share our unique experience of the world'. While these experiences can be singular in the first moment, they are also part of the shared condition of being human. For them, 'art is the currency of experience' (Leicester and Sharpe 2010: 12) and has the capacity to act as a medium through which our individual experiences can be shared in a broader pattern of community experience. Considered in this way, the arts enable us to put our individual experiences into motion as shared meaning. Art thus 'intertwines with all our culture, infusing it with the means to express what we find to be the general experience of being human, and the particular path of our own life' (Sharpe 2010: 28).

One research project participant understood why people wanted to hold on to the local theatre companies and keep them relatively unchanged:

> because in a landscape where everything else around us continually changes, that's one thing we can depend on [...] to be the same. You are talking about really important things like identity, and if you get your sense of identity from regular meetings, regular auditions, regular interfaces with people involved on a more regular level, it's a holistic perspective.
>
> (Participant 6, 15 October 2009, interview)

This participant highlights the continually changing landscape of the Gold Coast as a challenge for people living here. In this context, amateur theatre offers local people

connection points and a continuity of engagement in activities that provides a sense of belonging and familiarity.

Amateur Theatres and the Value of a Theatrical Life

The director of the *Showboat* production avowed that the most important benefit amateur theatre offers its members, individually and collectively, is the opportunity to personally experience a creative process. For her, it was a 'magnificently transforming experience' and that experience is often magnified through the selection of 'great scripts' such as *Showboat* that stimulate many theatrical, imaginative and skill challenges for cast, crew and producers.

The amateur theatre workers in this study sought to successfully coordinate a complex activity combining the differing skills and experiences of the various cast and production members over a period of usually three to five months. It is the value of the creative experience, the personal challenge, the attractions of the art form and the sense of personal and collective accomplishment, of joining with others and being part of something larger than themselves that continues to attract people to this participatory art form.

In the *Showboat* production, the director, cast members and production staff were asked to discuss their reasons for being involved with amateur theatre and what the benefits were to themselves and to the rest of the community. Responses placed emphasis on the capacity of amateur theatre to provide opportunities to lead an expressive or creative life, experience social connectedness and engage with events that were meaningful in terms of increasing participants' sense of self-worth and value to others. The Gold Coast Theatre Alliance secretary described the decision to actively participate in amateur theatre as having 'sprung from an inner need to express themselves, to go beyond the daily duties, the daily lives and necessities, I call it the soul, it's my definition of soul' (Participant 3, 29 October 2009, interview). A *Showboat* cast member spoke of her successful involvement in theatre as providing a necessary lift to her self-confidence after having left school early to work, then marrying young and raising a family:

> For me it [theatre] was recognition […] my goodness, I am doing something well and I am getting all this positive feedback. And I knew I was doing it well. And for me it was a huge boost to my self-esteem.
>
> (Participant 2, 17 May 2010, interview)

There was also sensitivity among participants about the perceived quality of the experience and the use of the word 'amateur' when describing the theatres and the productions they were doing. Early in the research, I discovered that many people do not use the word 'amateur' and now refer to their theatres as 'community theatres'. This avoids the pejorative connotations in terms of competence and attitude as Cochrane (2001) notes, and engages with the more positive and constructive associations that come with the word 'community'.

A *Showboat* cast member stated very strongly that 'We don't like that, because I think we do a professional show but we don't get paid' (Participant 2, 17 May 2010, interview). A number of participants believed such a distinction was a way of accepting poor standards:

> I have removed amateur from the picture so those members of the theatre fraternity who perform but do not get recompensed […] they would be known as community theatre and the range of abilities in directors and performers is huge from way up here to way down here […] its huge and I have seen that in professional theatre as well.
> (Participant 4, 11 May 2010, interview)

These attitudes resonate with concepts such as Stebbins 'serious leisure' (2007) and Leadbeater and Miller's (2004: 20) depiction of the emergence of the 'Pro-Am' who 'pursues an activity as an amateur, mainly for the love of it, but sets a professional standard'.

The Gold Coast research participants spoke of wanting creative engagements that were demanding and therefore satisfying, despite not being paid for their time or skills. Another participant argued that local companies were working for higher standards with each successive production:

> I cannot believe people can be satisfied with an amateur show […] 'We didn't do too bad considering the leading actor had one leg and the female couldn't sing' […] what sort of show are we putting on when we say that is our aspiration?
> (Participant 2, 17 May 2010, interview)

Amateur Theatre: A Pathway for Young People

A misconception of amateur theatre on the Gold Coast is that it is essentially a retirement village, a haven for the over 60 year olds. Although a survey of the *Showboat* cast found that a majority of the company were aged in their 50s and above, observation of the casts of *Sweet Charity* and *The Boy from Oz*, as well as attendance at other amateur theatre productions around the region, demonstrated that there is a very healthy engagement by young people in the local amateur theatres. The *Sweet Charity* director said of this engagement: 'Well musical theatre is cool now, you know *Wicked* and *Legally Blonde* are cool to young people now' (Participant 8, 23 May 2010, interview).

The Creative Community Index 2005 (Kreidler and Trounstine 2005) emphasized the importance of amateur experience towards a professional career and engagement with professional services. Amateur theatre was shown to be a significant transition point for a number of young performers who aspire to work professionally, providing a place for them to gain experience and prepare themselves through skills development. The three productions I observed were part of a pathway that began with schools, moved to the amateur theatres and then to specialized training and onto paid work in the professional sector. One production director noted that one of the purposes of the amateur theatres is

to serve as a training ground: 'This is where people get how it works, the rehearsals, how a theatre building works, the stagecraft, all of it' (Participant 5, 26 May 2010, interview).

When I first attended *Sweet Charity* rehearsals at the Javeenbah Theatre Company, I was astonished to find a room full of young people ready, energized and focused on their work. The majority were high school theatre and performance graduates who, through school and youth theatre training, had a shared language and a common literacy and experience. Working with a director expert in training young people, most of the *Sweet Charity* cast saw engagement with this production as a further experiential step on the pathway to a career in the music theatre industry. The *Sweet Charity* director said of young people's engagement in amateur theatre productions: 'It puts them in front of an audience so that they get that essential theatrical experience: actor and audience in transaction' (Participant 8, 23 May 2010, interview). One director, who was also a high school drama teacher, emphasized the particular opportunities that amateur theatre offered young performers looking to develop a professional career: 'You cannot learn just from a class room the sort of lessons you get from being involved in a large-scale production that runs for 17 shows and rehearses for three months' (Participant 9, 28 June 2010, interview).

The secretary of the Gold Coast Theatre Alliance points to another important connection between amateur theatre and schools, in that 'you will find school teachers always amongst every [theatre] group' (Participant 3, 29 October 2009, interview). This is supported by the example of four drama teachers on the management committee of Javeenbah Theatre Company in its 2009–2010 season. Teachers are a key guide and contact along the training pathway between the high schools, training centres and youth and amateur theatres. Students have been developed as performers by involvement with the amateur groups and these experiences have benefited their overall school performance. For students, the presence of drama teachers in amateur theatre was important because 'they are preparing them and most drama teachers are aware of what the students need to do' (Participant 8, 23 May 2010, interview).

In response to their increasing drama activities, many Gold Coast schools have built superior performance auditoriums and present major productions each year. Productions from most of the local high schools, public and private, are now significant annual theatrical and social events, both within the school and for the wider community. For young people living on the Gold Coast and looking for experience and professional development, there are also annual school drama competitions, two of Australia's largest eisteddfods and an increasing number of post-school public and private sector training opportunities. The interconnectedness between these, the drama teachers and the amateur theatres provides clear pathways for students to advance their theatrical and career aspirations.

Amateur Theatre and the Gold Coast

In her study on the participatory arts in Silicon Valley, Alvarez (2005: 30) considers the links between Silicon Valley's 'idiosyncratic entrepreneurial ideology and particular modes of

artistic engagement and disengagement'. She suggests that 'informal arts practitioners in Silicon Valley pick up ideologies emanating from the Valley's corporate discourse, and refashion them into proposals for individual and collective participation in the arts' (Alvarez 2005: 31). Alvarez's consideration is of ideologies or belief systems that shape the attitude, spirit and endeavour that art practitioners bring to their own work and their engagement with the broader community through their work. There is an essential relationship between the nature of a community and the amateur theatre that has emerged from it.

In this context, it is the place of the arts, and theatre, to most directly reflect and be shaped by the interests, experiences, aspirations and composition of its host community. In this mode, theatre seeks not only to reflect accurately, but to affirm, those interests and experiences. Here, innovation and excellence, while not necessarily key values, have a part to play. However, more meaningful are the many linkages that provide reassuring knowledge that we are members of a specific community with shared interests. Theatre is looked to by its audience and creators for affirmation of values, for solidarity in terms of shared experience through relationships, for encouragement and for entertainment. A participant spoke of theatre in this mode as serving 'an incredible need in society for those people that need to connect […] because society can be very lonely if there is no connectedness […] for the audience and also for the cast members' (Participant 7, 16 June 2010, interview). This purpose continues to underpin the amateur theatre's function today in providing pathways to social, creative and meaningful experiences for its members and audiences.

Unlike a number of other Australian urban and regional communities, theatre companies on the Gold Coast did not have a practice of creating theatrical productions from local stories, characters or events. A visit to any of the amateur theatres and their productions would take audiences to places a long way from the Gold Coast and did not appear to reflect the world just outside the theatre's door. A relationship between theatre and its host community does not have to result in productions set in and/or about the region. Terracini (2007: 11) argues that theatre's response to place must do more than locate a performance in familiar surrounds: 'It should be about fundamentally understanding what resonates within the people who live there, left there, or died there; and about translating those deep local associations for the benefit of a much wider audience'. This emphasizes a conception that theatre does not exist of its own volition but is dynamically called into being and sustained by the aspirations, energies and creative passions of motivated individuals and groups. As a corollary of this, a theatre company's choices about programming, content and representation are directly shaped by interactions with the values, experiences, resources and aspirations of its members and its audiences.

Amateur theatres have been operating consistently since the 1950s in Queensland's regional towns and cities such as Cairns, Townsville, Charters Towers, Rockhampton, Ipswich and the Gold Coast. The value of these companies to their members and the wider community is demonstrated by the fact that they have been maintained by the constant participation of local residents for over half a century. Indeed, in 2010, the Gold Coast Little Theatre celebrated 60 years of continuous operation, no small achievement for any organization on the Gold Coast.

Conclusion

My experience of amateur theatre on the Gold Coast encouraged a much deeper appreciation of its qualities, achievements and of the values and meaning that underpin its members' reasons for participation. Amateur theatre provides a value to the community that goes beyond art-making and aesthetics, by offering opportunities to broaden the social, creative and career horizons of its participants. It is enacted, and therefore valued, through a network of relationships that comprises residents, like-minded people, friends and family. Critically, this network includes students and staff from local schools who contribute to the sustainability of Gold Coast theatre through a long-term diffusion of knowledge and experiences between schools and the amateur theatres. Local theatre-making, therefore, provides and sustains the particular networks and pathways that Finnegan (2007: 4) suggests are vital 'for the ways people manage and make sense of modern urban life or, more widely, for our experience as active and creative human beings'. Indeed, it can be observed, as one key research participant did, that the value to the community of the work of amateur theatres and the people within them could well be framed by the concept of 'pro bono publico' or 'for the public good'.

Viewed in this way, the amateur companies may be seen as members of this community organizing themselves and taking significant social action to contribute to the broader social and cultural life of this community. Practical action is taken by these companies and individuals to provide diverse theatrical activities, access to creative cultures and traditions, and essential facilities to house the gathering of casts, production teams and audiences from across the community. This type of theatre works inclusively and calls into relationship a spectrum of theatre-makers and audiences. For both, it provides secure access to a diversity of classical, popular and contemporary theatre that large commercial producers from the capital cities can bring only rarely into this region.

This application of the 'pro bono publico' principle would recognize, as a similar area of community value and contribution to the greater community good, the work of volunteer theatre participants and their organizations, in line with members of surf lifesaving clubs and local sports coordinators. It would encourage a dignifying of the activities of amateur theatre through acknowledgement of its contribution to the cultural life of the Gold Coast. This re-framing of amateur theatre would certainly be provocative in terms of how it, and indeed all theatre, is understood and appreciated at government and policy level, particularly if the 'pro bono publico' concept were embraced as seriously as it is in legal circles. The activities of amateur theatre would be revealed as providing essential resources needed for the stability and the continued growth of the region's social connectivity and creative infrastructure.

References

Alvarez, M. (2005), *There's Nothing Informal About It*, San José: Cultural Initiatives Silicon Valley.

Breen, S. (2005), 'Future frontier: Ante up', PhD thesis, Griffith University, Gold Coast.

Burton, P. (2009), *Growing Pains: Adolescent Urbanism on the Gold Coast*, Gold Coast, Australia: Griffith University.

Clark, T.N. (2004), *The City as an Entertainment Machine*, London, England: Elsevier/JAI.

Cochrane, C. (2001), 'The pervasiveness of the commonplace: The historian and amateur theatre', *Theatre Research International*, 26(3), 233–242.

Cochrane, C. (2003), 'The contaminated audience: Researching amateur theatre in Wales before 1939', *New Theatre Quarterly*, 19(2), 169–176.

Davidson, J. and Spearritt, P. (2000), *Holiday Business: Tourism in Australia Since 1870*, Melbourne, Australia: The Miegunyah Press at Melbourne University Press.

Finnegan, R.H. (2007), *The Hidden Musicians: Music-Making in an English Town*, Middletown, England: Wesleyan University Press.

Government Statistician, Queensland Treasury and Trade (2014), *Queensland Regional Profiles*, Brisbane, Australia: Queensland Government.

Ivey, B. (2009), 'Expressive life and the public interest', in S. Jones (ed.), *Expressive Lives*, London, England: Demos, pp. 23–35.

Kilner, K. and Tweg, S.A. (eds) (1995), *Playing the Past: Three Plays by Australian Women*, Sydney, Australia: Currency Press.

Kreidler, J. (2002), *Creative Community Index 2002*, San José: Cultural Initiatives Silicon Valley.

Kreidler, J. and Trounstine, P.J. (2005), *Creative Community Index 2005*, San José: Cultural Initiatives Silicon Valley.

Leadbeater, C. and Miller, P. (2004), *The Pro-Am Revolution*, London, England: Demos.

Leicester, G. and Sharpe, B. (2010), *Producing the Future: Understanding Watershed's Role in Ecosystems of Cultural Innovation*, Bristol, England: International Futures Forum.

McCallum, J. (2009), *Belonging: Australian Playwriting in the 20th Century*, Sydney, Australia: Currency Press.

Putnam, R.D. (2000), *Bowling Alone: The Collapse and Revival of American Community*, New York: Simon & Schuster.

Salt, B. (2005), 'Forword', in G. Burchill (ed.), *Passion, Power & Prejudice: A Remarkable Untold Account of a Magic City in the Making, Gold Coast, Australia*, Bundall, Australia: Golden, p. 12.

Sharpe, B. (2010), *Economies of Life: Patterns of Health and Wealth*, Fife, Scotland: International Futures Forum.

Stebbins, R. (2007), *Serious Leisure: A Perspective for Our Time*, New Brunswick: Transaction Publishers.

Symes, C. (1997), 'Strange alchemy: The gold coast as a cultural phenomenon', in R. Allom, P. Lovell and P. Marquis-Kyle (eds), *Gold Coast Urban Heritage & Character Study Gold Coast*, Gold Coast, Australia: Gold Coast City Council, pp. 29–35.

Terracini, L. (2007), *A Regional State of Mind: Making Art outside Metropolitan Australia*, (Platform papers: Quarterly essays from Currency House), Sydney, Australia: Currency House.

Wise, P. (2006), 'Australia's Gold Coast: A city producing itself', in C. Lindner (ed.), *Urban Space and Cityscapes: Perspectives from Modern and Contemporary Culture*, New York: Routledge, pp. 177–191.

Notes

1 In this chapter, the terms 'amateur' and 'community' are used interchangeably to describe a theatre activity whose performers, production staff and management are not recompensed financially for their contribution.
2 The Cultural Initiatives Silicon Valley (CI-SV.ORG) in California developed *The Creative Community Index 2002* and a follow-up document, *The Creative Community Index 2005*. The CI-SV.ORG argued that creativity in the broader community had been a significant ingredient in the social and financial success of Silicon Valley and decided to establish an ongoing framework for understanding, measuring and growing the contribution of the arts, culture and creativity to the Silicon Valley area. The 2005 Index found that there is a distinct and sustaining relationship between cultural literacy, as developed in such places as schools, and participatory cultural practice, as experienced through such entities as amateur theatres and professional activities. The Index was a significant resource for this study because it emphasized that participation was an essential contributor to the creative and social health of a community.

Chapter 12

Artist-Run Initiatives as Liminal Incubatory Arts Practice

Janet McDonald
The University of Southern Queensland

The chapters of this book offer serious consideration of how examples of arts practices in the regions create a nexus of connectivity, story and transformation across community/ies. This chapter offers a similar trajectory that is informed by my own pedagogic practice as an enabler of emerging artists through a Bachelor of Creative Arts offered at the University of Southern Queensland (Toowoomba, Queensland, Australia). From 2008 to 2013, I was the Head of the School of Creative Arts, overseeing the management and administrative guidance of five creative disciplines: Music, Theatre, Visual Arts, Creative and Applied Media. Ultimately, I believe our role as a regional university is to promote an overall resilient attitude in students' art-making, located in a community that supports them. The active presence of art-makers in regional areas creates a perception that a community values culture, and therefore quality of life. Artist-run initiatives (ARIs) are nothing new per se; they are considered a rite of passage for many artists bridging their tertiary studies and preparation for the arts industries. In Australia, they have not been documented or researched in any major detail, with authorial voices tending to come from the national Australia Council for the Arts, which seeks to support ARIs through grants,[1] or papers commissioned by state-supported metropolitan arts organizations (Goodwin 2011). I have noticed a change in the visibility and respect for ARIs in Toowoomba, which warrants further investigation, as this challenges the assumption that ARIs are only 'connected' or 'efficacious' in metropolitan cities.

Toowoomba is a large, diversely populated regional city 120 kilometres from Brisbane, the state capital city of Queensland. It currently has six functioning ARIs, all situated in the centre of the city. I will argue that, compared to urban areas, incubatory arts practices (through ARIs) can be more focused and germane in a town like Toowoomba, where arts and community events can bring employment (paid or volunteer), united interest and seasonal release from boredom and other 'regional' tribulations (e.g. floods and drought; see Chapters 7 and 10 by Andrew Mason and Robert Mason respectively in this collection). Since 2009, there has been an increased 'buzz' from local community artists, students and graduates who reside in Toowoomba. By 2011, this zeitgeist ushered in what has been an unprecedented growth of ARIs in Toowoomba, reaching its zenith in the Range Festival in November 2012.

Marginal or Liminal?

In 2012, I attended a conference dedicated to youth culture, where I gave a paper revealing the extent of the innovative practice of ARIs in Toowoomba. My aim was to try to describe

what I had experienced and to diagnose the impact the shift was generating among emerging artists in Toowoomba. About ten minutes into giving the paper, I realized that I sounded evangelistic in offering very positive opinions about what I had experienced as a participant observer. This had not occurred to me when putting my transcribed evidence together because it is clear in the data how positive the artists/artsworkers are in building a genuine and organic cultural 'newness' in a relatively conservative, post-drought, post-inland tsunami Toowoomba. At the end of the presentation, well-intentioned criticisms came from my audience, suggesting my findings were possibly naïve and clearly biased towards the positive. Overwhelmingly, the attitude was one of disbelief, rather than of consideration that what I was describing could be possible in the given regional context. My mostly British and Australian metropolitan-based colleagues seemed to display perhaps an unintended regional cringe; metropolitan ARIs have been described as tribal and proudly isolated from each other. Could it be that emerging artists in Toowoomba were just an amateur anomaly that would soon 'wake up' to the way the 'real art world' is and descend into becoming a self-loathing bunch of tortured wankers? As previously mentioned, there is very little written about ARIs in Queensland or Australia because they are perceived as temporary and thus as amateur and anomalous rather than the industry 'norm'. It is difficult for governments and funding bodies to capture data on this phenomenon, as there seems to be no agreed methodological practice in place for gathering this data over a long period. ARIs of course deny this kind of analysis, as their very nature demonstrates active transformation in very short timeframes.

It is important to interrogate the absence of making this phenomenon visible as incubatory practice. While the arts sector is aware of the importance of ARIs, especially in metropolitan settings, further studies must gather the evidence of how they are actually relevant before it is possible to advise on how existing practice may be transformed to stimulate new healthy arts practices in regional and metropolitan areas. However, the conference experience mentioned above gave me reason for concern due to the obvious cynicism and distrust of phenomena that might be presented as positive. I felt that my enthusiasm may have added to the regional cringe that many of the interviewed artists already felt from engaging with artists from non-regional ARIs. I am familiar with the rhetoric of 'youth' in cultural, economic and governmental discourse, as I chaired Youth Arts Queensland (a peak-body for youth arts in the state) from 2008 to 2012 and was in a position to advocate for youth arts initiatives across many applications. The term 'marginal' is often used to describe the notion of 'youthness', with the term 'regional' often layered over this to represent a cultural double-jeopardy for young people living outside metropolitan centres. Marginality assumes that regional youth are 'the other' and they are often perceived to be removed or invisible and thus excluded from institutional and commercial opportunities. However, re-reading Victor Turner's (1979 [1964]) anthropological studies into youth transitions or 'rites of passage' suggests that a youth's maturing journey through initiations is more succinctly 'liminal' (from the Latin word *limen* meaning 'threshold'). The transitional beings he terms 'liminal personae' (or threshold people) occupy a transformational space (liminal period) through

which they pass (beginning with being separated from that with which they are familiar) to a liminal place of possibility (what Turner calls 'betwixt and between'). This begets a third stage, where they re-join (reassimilation) the society from which they came. I believe the ARIs provide an example of a 'liminal period' in the lives of the practising artists who reside in these non-structured enclaves or communitas. In this case, 'liminality represents the mid-point of transition in status-sequence between two positions' (Turner 1974, cited in LaShure 2005), as they are a mostly temporary investment from emerging artists who believe that ARI experiences are good for their long-term career trajectory, which 'lead somewhere'. Liminality can provide an enhanced discourse able to articulate the connections between youth, regionality and innovative art-making by Toowoomba ARI artists, without implicating a deficiency that may come from focusing on marginality. My use of Turner is not simply to impose him on this phenomenon, but to honour his own reflexive approach to his evolving theories; what he learnt from watching ancient initiation rituals used by African tribes, he applied to the processes he observed in hippie culture, the Catholic Church and history in general (Gilmore 2008, cited in St John 2008: 222). I shall continue to extrapolate on this theory throughout this chapter.

Incubating a Liminal Regional Space

The notion of ARIs is not new. Since people began congregating into communities, the arts have been used as a way to enhance a sense of 'us'; for example, music, dance, imagery and storytelling are all ancient forms of corroborated and mediated experience that a group shares. Artist 'collectives', enclaves and special-interest arts groups flourished, especially in Germany and France, between the First and Second World Wars, where cross-disciplinary experimentation was at an all-time high. Movements such as Surrealism, Dadaism, Futurism and Constructivism were shaped and manifested by dancers, actors, writers, musicians, painters and film-makers. In 1960s Europe and the United States, collectives such as Fluxus, Allen Kaprow's Happenings, Jerzy Grotowski, The Open Theatre and The Living Theatre all embodied the emerging critical theoretical stances of openly making visible that which had always remained hidden (particularly nudity, in many cases). Thus, what may have begun as experimentation, agitation and exploration begot contemporary arts practices and methods that were adopted, assimilated and analysed around the world, and particularly in major metropolitan centres. In a sense, these 'collectives' were enablers of artistic innovation; sometimes heated, always dynamic and vibrant art-making, designed to be transitory, often created through a critical mass of like-mindedness and then disassembled. It was during the social turbulence of the 1960s and 1970s that Victor Turner was observing and applying his theories about liminality and communitas; his conceptualization of communitas reflects these experiences, in that he felt it exhibited 'anti-authoritarian, anti-structural and subversive sites of free expression' (Gilmore 2008, cited in St John 2008: 222).

Toowoomba has a very long history of artistic innovation and festivals that are part of the locals' knowledge, rather than available through public broadcast. The city had the first Literary Society in Australia and also has long-standing eisteddfods; Historical, Choral and Philharmonic Societies; community arts societies; and the McGregor Summer School, which remains the longest running arts retreat in Australia. Since the 1970s and 1980s, a variety of arts collectives not endorsed by local government have been initiated, funded and run by members of the community. Arts practice and organization in Toowoomba has therefore occupied a 'threshold' of potential, growth, diminishment, re-growth, re-casting and re-framing of the arts through non-structured communitas. I argue that most regional towns that have a critical mass of permanent population could be considered liminal; regionality in Australia contains threshold-dwellers who innovate (some might say 'make do') with what is available to them, to create culture and community to express their unique position of being 'betwixt and between' the invented binaries of regional/metropolitan, art/craft, community/industry. This regional liminality may have more permanence than the 'liminal period' of transition that Turner articulates; however, within it, phenomena such as ARIs can develop, transform, dissolve and re-constitute without the anxiety of being semi-permanent or temporary.

The six artists I interviewed came from the Red Door, Made, Raygun, Ashleigh Bunter and Play on Play ARIs in Toowoomba. I knew them all as arts colleagues or as graduates from the University of Southern Queensland and see them regularly at exhibition openings and other arts-related functions. The interviews were undertaken individually and in groups to help to formalize some of their thinking about how they saw their practice as being specifically related to Toowoomba. Metropolitan-dwelling Queenslanders may perceive Toowoomba as a town without a culture, as the only event of major and continuous cultural significance to the State of Queensland is the annual Carnival of Flowers (September) and associated Food and Wine events (see Chapter 7). This perception is probably founded in the fact that, until 2011, the Toowoomba Regional Council had no clearly defined policy or agenda on the direction of arts and culture to drive initiatives for enabling arts. This is concerning, given the local population is close to 100,000 people. The Queensland Arts Council (now known as Artslink) announced on 9 May 2012 that Toowoomba would be the recipient of a $15,150 Regional Arts Fund grant (through Ashleigh Bunter) to hold the inaugural Range Festival: Toowoomba's Independent Contemporary Art and Culture Festival, in November 2012. Artslink valued this project at over $38,000, as a way to engage new audiences to be 'educated and engage with local contemporary arts practices' (Norton 2012). This festival attempted to change the perception of contemporary arts approaches in Toowoomba, with the ARIs being the particular locus of difference (to metropolitan ARIs) and dissemination of their particular incubatory practices.

Although there is a palpable communitas demonstrated in the Toowoomba ARIs, they seem to offer a reduced agitational or anti-authoritarian bias towards cultural inclusivity and community vibrancy compared to more intense historic examples. Despite this, all interviewees articulated a proud sense of 'non-compliance' in their evolving ARI

conceptual space. In fact, in defining their practice, several of the ARI artists I interviewed began by explaining that regionality (for them) was not evoked as a capitulation or as a tired euphemism for 'less than' metropolitan. Rather, being regional, and therefore upon a permanent threshold, was central to their practice and thinking about how they 'do it'. When asked about the difference between urban ARIs and those in Toowoomba, one interviewee replied:

> it really felt like [there] wasn't a sense of cohesion [in the metropolitan ARIs] […] there were a whole lot of ARIs who said 'we're too good for that and you're too low brow […] we don't want to be involved'. I just went, 'hey, that sucks. You should see what it feels like in Toowoomba'. So I came back up [here] […] I think what's happening here is really amazing […] all of these initiatives are very different but they're very supportive of one another.
> (Participant 4, 12 October 2012, interview)

> when talking to other people who are running the city-based ARIs, their discussion was based more around how to reinvent the wheel and 'how do we define ARIs and what kind of work are we going to show and which artists do we engage with' […] Whereas networking with other regional ARIs […] it's more about survival and it's not about which artists can we pick and choose. It's about trying to get artists on board in the first place and getting that support from the community […] trying to create the wheel in the first place in a regional area.
> (Participant 8, 8 October 2012, interview)

The perceived 'cultural isolation' of regional ARIs by metropolitan-based colleagues is again a symptom of a predominant assumption of deficiency – a regional cringe – that can deny the perception of legitimacy for sustained regional arts development. Yet, it is exactly the geographical lack of direct access into the larger institutional galleries and commercial arts dealers in the regions that begets a desire to work together with peers to support and show artistic works. Perhaps the need is greater and therefore more immediate; perhaps it takes a communitas of like-minds to create a critical mass of focus to enrich the potential for artistic growth, not just commercial success:

> it's not about putting it [artwork] out there to sell it but I think when you are working towards ideas, unless you exhibit and seek feedback, which I think is the point of exhibiting, then you're not going to progress.
> (Participant 3, 12 October 2012, interview)

What has emerged is a discrete model of incubation of new work which, I believe, is fundamentally linked to the connectivity and desire for transformation exhibited by these regionally located ARIs, which are geographically outside government or private institutional spaces.

ARIs as Transformational Regional Spaces

Incubatory practice is a necessary part of the rhetoric of arts development in Australia, particularly for emerging and mid-career artists. The National Association of Visual Artists defines a requirement for an emerging artist (as different to a recent graduating artist) as having 'no more than five years of professional experience' (Goodwin 2011: 2). One way, of course, to gather this professional experience is to participate in incubatory practice that will foster career pathways for emergence. However, there are no set rules to guide or monitor the use of such a strategy. ARIs attempt to build incubatory methods that embody the cultural context (physical and conceptual) of where they reside. As such, sustenance is directly related to personalities and friendships between artists who work together. In this setting, incubation conjures practices that are more than mentoring, assistance or guidance, as many ARIs have no direct funding but rather rely on goodwill, sociability and collaboration to establish themselves. In contrast to institutional and commercial arts spaces, ARIs are less about product and more about the processes of growth, development and collaborative initiatives. I would argue that incubatory practice is a key method of manoeuvring within the liminal period that ARIs may exemplify; it is a 'place' where artists stand upon a threshold of what was and what could be, where they have the potential to make significant changes and growth in their emerging artistry, where their own social communitas sustains this exploration for various periods. According to LaShure (2005: 4):

> While in the liminal state, human beings are […] in between the social structure, temporarily fallen through the cracks, so to speak, and it is in these cracks, in the interstices of social structure, that they are most aware of themselves.

A further example of this transformational quality that is present in the ARIs is the hybrid space of cross-disciplinary arts collaboration/communitas. Play on Play is such an example, where the artists have combined dance, multi-media, film, performance art, music and painting to create two- and three-dimensional works for exhibition in flexible ARI spaces (as well as smaller regional institutional galleries). This cross-disciplinary notion of how traditional isolated studio practice is conceived and applied becomes transactional and located between the physical and conceptual space known as The Grid in central Toowoomba. This space is a converted dance hall set above other shops in the main street of the town, which has become an 'arts hub' housing several different ARIs, who all share the rent and studio spaces in the building. At the time of writing this chapter, Play on Play, Oh Darling Downs Short Film Collective, Kontraband Urban Arts Collective, the GRID Dance and Performance School, Made and Raygun were the ARIs using the premises. The economic reality of cohabiting spaces and interacting with artists on a daily basis in a city location that is within walking distance of other ARIs is key to the critical mass of creative activity that is being demonstrated in Toowoomba at this time.

Certainly, the downtown area in Toowoomba, like most regional centres in Queensland, offers cheap rents in central converted stores and buildings; ARIs in Australia, Canada,

Europe and the United Kingdom have long been associated with urban renewal and community cultural development. Incubation is scaffolded by affordability and the need for ARIs to congregate together, not only to work across disciplines but also to support the differences between them:

> The cool thing about all the different ARIs in Toowoomba is that we all focus on very different things and function in quite different ways […] we support each other by trying to get to each other's events […] we often […] make sure that we coordinate opening dates […] Raygun would open between 6–7 pm and then at 7 o'clock [we go to] Made, or The Grid might open. So people could bungy-jump from one space to the next […] during the week, it's one night out. Everyone doesn't have to go out three nights to catch something. Then that's kind of like creating a stronger vibe and culture again.
> (Participant 12, 8 October 2012, interview)

In early 2012, Made decided to close its leased physical space in Toowoomba due to it being unsustainable in terms of their personal circumstances (both artists are new mothers) and because the 'response was a lot more overwhelming than we ever could have anticipated' (Participant 15, 8 October 2012, interview). They created an online ARI to maintain their visible presence, and also host their exhibitions at other ARI's physical galleries, thus increasing the utilitarian yet affable network across Toowoomba. The Made artists stated that The Grid remains a very important physical space that helps to relieve some of the stress of the individual ARIs, as they can share spaces and keep an online visibility that allows them to maintain their lifestyles and art-making ventures (Participant 19, 8 October 2012, interview). The Grid might be a physical manifestation of what Victor Turner calls communitas, where there is articulation of something new for the community. Collaborative 'in-between' liminal activities blur the lines between traditional private art-making in 'closed-off' studios and more public arts practice: ARIs may indeed create a 'sense of community by being a space that's not public, I mean, it's private but it's not really, it's between public and private […] I think makes the community feel really rich' (Participant 20, 12 October 2012, interview).

No Structure and Other Organic Strategies for Cultural Growth

The 'structure' of these emerging ARIs in Toowoomba appears to be informal and loose and demonstrates a kind of transactional osmosis driven by connectivity to social media, Twitter and Facebook, as well as the close geographical location of the ARIs. There is an absence of any sense of obligation (indeed, there is resistance) to 'crank out' products, exhibitions or commercial activity. ARI artists were clear in pointing out that they structure their ARIs according to 'knowing what we can manage' (Participant 16, 8 October 2012, interview). The apparent sociability I observed between these artists is what makes the loose combination of ARIs decidedly successful at this point in time. However, they are also aware of the risks of running out of artists to show: 'if you've been through all the people that are around you

and your focus is local [...] do something new' (Participant 7, 12 October 2012, interview). Only favouring 'your own kind' can make ARIs potentially boring and elitist; the Toowoomba ARIs thus encourage the wider community of artists to engage with their initiatives, even though the University of Southern Queensland remains an instigator of these initiatives:

> Most of the people that have ARIs now at some stage, through uni [attending the University of Southern Queensland], set up a space just because there was really nothing else happening at the time [...] USQ's really supportive of what we do and it's funny now that we're all actually still doing it.
> <div align="right">(Participant 9, 12 October 2012, interview)</div>

The result is a widening network in which artist-teachers at the local Technical and Further Education (TAFE) College, the University of Southern Queensland and local schools participate in exhibiting their own work and attending the exhibitions of their colleagues outside their institution. University artists also provide ARI artists (several of whom are graduates) with international networks through their own artist-in-residence programmes, with one result being exchange exhibitions of ARI work with Denmark and the United States. ARI artists have also actively sought in-kind connections with other artists' collectives through their own personal overseas and interstate travel, preferring the face-to-face contact with 'like-minds' (Participant 7, 8 October 2012, interview). This behaviour was revealed to and documented by Plowman et al. (2003: 4–5), who suggest that one key to sustainable and resilient regional development is that young people have the chance to travel, experience, study and bring this expertise back to the region for application and development.

Although predominantly a study in leadership, Plowman et al.'s (2003: 2–5) study investigated the importance of cultural growth as an indicator of a thriving population, suggesting that languishing towns have a net outflow of innovation and talent, leaving behind an 'increasingly conservative monoculture'. Other indicators revealed in the study included mobility of population, encouraging newcomers, capacity building for diversity, engaging young people and investing in celebration. These findings, which came out of the School of Business at the University of Queensland and the Department of Primary Industries, are relevant for Toowoomba; however, the reality is that many local government organizations in regional areas of Queensland do not have adequate funding to achieve cultural growth. Indeed, initiatives aimed at such are often dependent upon the tenuous connections between a group of artists who may have reached a critical mass of drive and interest at any given time.

The ARI enclaves in Toowoomba reached a high cultural and visible point in 2012 with the inaugural Range Festival, which was touted as 'Toowoomba's art renaissance' by ABC Radio journalist Peter Gunders (2012). The artistic director and ARI artist Ashleigh Bunter designed the festival to showcase artists, 'working with musicians, film makers and dancers [...] there's a big group of those people choosing to stay in Toowoomba whereas traditionally, if you want to make it, you've got to move to the cities'. A senior advisor from the Local Government Association of Queensland confirmed the grass-roots uniqueness of the Range Festival in

stating 'local governments try to replicate this from the top down, but what Toowoomba's got here is that it's naturally occurring' (Gunders 2012). While to say the festival was 'naturally occurring' belies the amount of time and effort that dedicated artists invested into organizing the festival, it does correspond to the organic and chiefly informal and non-hierarchical structure employed by Bunter. The lack of an embodied or measurable 'structure' remains a defining characteristic because the ARI phenomenon (beyond the Range Festival) relies on connectedness, rather than an imposed expectation. One artist put it this way:

> It's quite emancipatory [...] it's not the structure itself that keeps it together. It's almost like thin, little fibres, the thin little pieces of cartilage that grease it together [...] all the invisible element, I guess.
> (Participant 20, 8 October 2012, interview)

The lack of structure increased entrepreneurial and enterprising activity by local artists, as evidenced by the wide range of participation by ARIs in the Range Festival events. The Range Festival was a temporary event, with key drivers taking on arts-related full-time positions, making visible the enormous amount of cultural and creative activity in the liminal regional space of Toowoomba before, in true ARI-form, dismantling itself into various new projects to exploit new communitas opportunities. The First Coat Street Art Festival (21–23 February 2014) is an example of this diversification, bringing together nineteen artists from around the world to paint on seventeen walls around Toowoomba over one weekend (First Coat 2014). The festival demonstrated that local artists had established connections with local property-owners and businesses (Participant 19, 12 October 2012, interview), and others encouraged architects and city council workers to attend openings and 'happenings' as a way of 'taking the pretentiousness out of art' (17). First Coat was sponsored by the Toowoomba Regional Council, with associated support through Animating Spaces (with federal money from The Australia Council and Regional Arts Australia and state money through Arts Queensland).

Artists interviewed for this chapter (and before First Coat) suggested that there was a committed following of non-arts community members who attended functions and actively engaged with the ARI artists on a regular basis. The conscious yet informal building of pathways and relationships for an audience beyond just the artists themselves achieved an unorthodox approach that was not related to strategic partnerships to complete grant-related key performance indicators. In addition to the funding injected into particular community arts projects, the relative financial freedom enjoyed by the ARIs was largely self-funded through commissions (public and private contracts), teaching/marking contracts and other part-time work:

> We've got a limit as to how much money we put in and then we source things from other places. So it means there's no pressure [...] and if there was financial pressure it would operate in a very different way.
> (Participant 9, 8 October 2012, interview)

Temporary Is Problematic, Right?

Rather than find this financial reality a limitation, the ARI artists fully embrace the notion that ARIs are temporary. Indeed, this is seen as necessarily so, to make this creative space flexible, nimble and ultimately transformative. LaShure's (2005: 4) summary of Turner states, 'liminality is a midpoint between a starting point and an ending point, and as such it is a temporary state that ends when the initiate is reincorporated into the social structure'. The artists did not shy away from this reality; since this research began in late 2011, several key ARI artists have moved on to the next level of work (institutional employment), either through enrolling in PhD programmes, travelling overseas or interstate for work, taking full-time employment with local government (galleries, theatres, libraries) or working for the small-to-medium sector in Arts Queensland (the state's governing/policy body and ministerial portfolio for the Arts). Individuals moving on to their idea of a next step may constitute Turner's third stage of reassimilation, or the final step out of the liminal period, where the liminal personae take the knowledge and experience afforded them during their ARI-life and re-apply them back into the larger social structure:

> [ARIs] spring up in response to something [in] time and place but I think they have a shelf life as well. I think they are a bit [transitory] – like an in between space [...] people burn out and the ones that do have a long life tend to roll through directors [...] I don't think they are meant to last forever. I think they should spring up and be vibrant and then when it's done just cut your losses and move onto the next project.
> (Participant 6, 12 October 2012, interview)

> ARIs will die, unfortunately. You [...] need to understand that, if that is going to happen – you need to change what you're doing dramatically to move on [...] get rid of why it's failing and move on to new successes.
> (Participant 14, 8 October 2012, interview)

It is this collective understanding of the temporariness of ARIs that reveals the desirability of flexible and transitory opportunities for skill development and artistic growth. Channon Goodwin (2011: 20), in her analysis of opportunities for visual arts graduates in Queensland (2000–2011), states that ARIs can have an:

> immediate benefit to the arts sector at a graduate and emerging level and if sustained, these can have positive roll-on effects to commercial and institutional sectors as the quality and rigor of local art practices are improved through experience.

Being temporary, however, is often framed as 'problematic' in terms of 'sustainability', and Goodwin (2011: 20) warns that the inherent 'instability and ephemerality of these spaces [...] can prove unreliable' and that the lack of 'consistent, professional and accessible exhibition

programmes for emerging artists means that local career development becomes increasingly difficult'. I would argue that the example of ARIs in Toowoomba shows that the artists involved did not consider the initiatives' temporariness a hindrance to their participation in them; rather, the artists that I spoke to embraced their liminal period in a way that recast their understanding of sustainability and success. Liminal personae in the ARIs thus utilize instability and ephemerality as a necessary part of their particular organic communitas and liminal period; temporariness is inevitable and therefore potentially rejuvenating and vital. One of the articulated differences between regional and metropolitan ARIs was that the regional ARI artists felt they had more freedom than their metropolitan counterparts: 'we just don't have the parameters around us as creative individuals and also then we become a strong kind of a community that encourages this really dynamic approach' (Interview 8 October 2012: 5).

Conclusion

Incubation for the artists in this study is a process for emerging artists to create a space of their own making, driven by their input into their own given contexts. While this rhetoric does not convert immediately into dollars, this may be to the benefit of the art community, as there is no structure imposed upon artists regarding how they should construct, deliver and evaluate their art-making initiatives. What is clear from this case study is that if artists want an innovative arts culture in a regional area, they need to make it themselves; they need to build a culture of like-mindedness and be prepared to pass their knowledge and skills on to the artists that follow once the time comes for members to move on to a 'next step'. Using a term such as 'liminal' rather than 'marginal' in discussing this process opens up a space for transformation, rather than defining a difficult/problematic space that is 'other to' the dominant methods. There will always be 'dominant' traditions in the arts and artists who will and will not concede to their parameters over the course of their careers. Liminal periods that take place organically and 'in-between' established traditional parameters are therefore to be encouraged for the incubation of emerging artists, with the regional context providing some added benefits to the communitas that begets the fabric of the arts experience and development.

The relevance of context: liminal regional positioning, cohesion and collaboration has the potential to increase how artists interpret and redefine what they understand as 'space' for making art. Space is temporal and conceptual, but above all 'actual'; partially opened spaces, entrepreneurial spaces, social spaces, experimental spaces, digital spaces, collectively shared spaces and borrowed spaces all seem to be linked to the relevance of Toowoomba's cheaper rents and the phenomenon of what one artist stated as 'still having time to speak to your neighbour'. Recent correspondence from a previously interviewed ARI artist not only reiterated and highlighted the freedom that the regional ARIs have in contrast to their metropolitan peers, but also described a new initiative for supporting ARI-style spaces for

secondary school students (e-mail communication, 30 September 2012). In this plan, ARI artists will 'teach' the entrepreneurial aspects of managing an artist-run space that can be themed for their own needs and ideas (e.g. graffiti, music and performance or skateboard art). An online presence through Facebook will parallel the developing work and exhibitions, thus creating a further sub-plot of peer-mentoring to deepen the ongoing transformational potential of the liminal personae in the liminal space. Here, at the regional coal-face, the artists are connected together by their shared stories in art spaces that are innovative, not because of their longevity or tradition, but because they simultaneously evolve and dissolve the dynamics of the space around them. They are geographically and artistically liminal: choosing to be at the threshold of potential that is betwixt and between.

References

First Coat (2014), First Coat, accessed 1 May 2014, available at http://firstcoat.com.au/

Goodwin, C. (2011), 'An overview of opportunities for visual arts graduates in Queensland, 2000–2011', Brisbane: Metro Arts.

Gunders, P. (2012), 'Toowoomba's art renaissance', ABC Southern Queensland, accessed 13 November 2012, available at http://www.abc.net.au/local/stories/2012/11/06/3626961.htm?site=southqld

Hardwick, P. (2014), 'First coat of street arts transforms Toowoomba CBD', accessed 28 February 2014, available at http://www.thechronicle.com.au/news/art-lovers-get-a-treat/2178767/

LaShure, Charles (2005), 'What is liminality?', accessed 8 July 2013, available at http://www.liminality.org/about/whatisliminality/

Norton, L. (2012). 'Eight Queensland Community arts projects supported by the regional arts fund', Media Release: Artslink, 9 May 2012.

Plowman, I., Ashkanasy, N., Gardner, J. and Letts, M. (2003), 'Innovation in rural Queensland: Why some towns flourish while others languish', University of Queensland and Department of Primary Industries Queensland ARC Linkage Report, accessed 8 August 2013, available at http://www.rapad.com.au/research

St John, Graham (2008) (ed.), *Victor Turner and Contemporary Cultural Performance*, New York: Berghahn.

Turner, Victor (1979), 'Betwixt and between: The liminal period in rites de passage', in William A. Lessa and Evon Z. Vogt (eds), *Reader in Comparative Religion: An Anthropological Approach*, 4th edn, New York: Harper & Row, pp. 234–243.

Note

1 http://www.australiacouncil.gov.au/grants/2014/visual-arts-new-work-artist-run-initiatives2

Chapter 13

Same but Different: Growing New Audiences for the Performing Arts in Regional Australia

Rebecca Scollen
The University of Southern Queensland

Regional Culture/Culture in the Regions – A Brief Recent History

To assist cultural engagement across the vast continent of Australia, federal funding initiatives commenced in the mid-1990s to enable national visual and performing arts touring programmes Visions Australia and Playing Australia to deliver into the regions and to support local product development through the establishment of the Regional Arts Fund (Trotter 2001: 338). This dual external and internal approach to the cultural enrichment of regional Australia was in keeping with the belief that 'regional cultural development involves more than looking to "the bush" for inspiration or "taking art to the country"; it is about cultural development *in* the regions and taking that regional culture *to* the cities' (Trotter 2001: 338, original emphasis). By the year 2000, the Australia Council for the Arts declared: 'The future of the arts depends on finding new supporters/markets outside of current traditional support e.g. non-theatregoers and regional populations' (Woolcott 2000: 19). This prompted a federally supported national research investigation (2000–2002) into regional audience development by Regional Arts Australia. The 2002 *Regional Audience Development Specialists National Overview Report* (*RADS Report*) suggested a number of recommendations to improve regional arts organizations' engagement with their local communities. Some of the key findings across the sector were that 'audience development objectives need(ed) to be considered in the planning of all programmes and events' (Regional Arts Australia 2002: 34). Thus, it was noted that many of the organizations operated under a product-centred viewpoint (Rentschler 1999: 3), focusing their attention chiefly on the artworks rather than considering their audiences. The *RADS Report* (Regional Arts Australia 2002: 27) stressed this point clearly by arguing that the 'arts organizations that have developed works responsive to audience feedback and those with particular thematic relevance to the community are often successful'.

The *RADS Report* (Regional Arts Australia 2002: 33) stated that regional venues needed to target wider audiences. It acknowledged that there were common challenges faced in achieving audience development outcomes in regional areas, including a low awareness of the importance of marketing and arts marketing techniques, particularly among small-to-medium organizations and volunteer-based groups. Therefore, the report highlighted the need for assistance to teach basic research skills and data collection, evaluation of current marketing activities and strategies for community consultation to those working within regional arts to enable greater employment of audience development research. All of the recommendations pointed to the need for increased resources (including skills) and a commitment to audience development in regional areas.

The *Talking* Theatre Strategy for Audience Development

This national decline in audiences for live performance, coupled with federal interests centred on regional Australia, provided a ready research environment to apply the *Talking*

Theatre strategy for audience development. The *Talking Theatre* strategy combines audience reception practice with arts marketing principles to develop knowledge and expectation in new audiences, providing the tools for future paid attendance. This strategy was the outcome of Scollen's (2003) doctoral research whereby an audience reception and development method was created, tested and refined by applying it in Brisbane theatre companies from 1998 to 2000. Following her doctoral qualification, Scollen, with a team of three other researchers, applied to the Australian Research Council to test the method in regional performing arts centres (PACs) to determine whether the positive results from city audiences would be replicated in non-metropolitan areas. Scollen has spent the majority of her life living in regional communities and sought to undertake research in regional Australia to add value to those residing and working there.

Due to the limited cases of audience research outside capital cities, the *Talking Theatre* strategy was embraced as a tool to enable PACs in regional areas to better engage with their communities and to build new audiences. The 'top end' of Australia remains the nation's most regional, with half its population living outside the metropolitan area. It was therefore considered ideal to apply the strategy in Queensland and the Northern Territory for modelling regional audience development to translate to the nation at large. Given the substantial distances and hence travel costs involved, to ensure many regional communities could participate in the research, the necessary investment was obtained via collaboration with Arts Queensland, Arts Northern Territory, Queensland University of Technology, the Australian Research Council and the Northern Australia Regional Performing Arts Centres Association (NARPACA).

Regional Performing Arts Centres: Reflecting Community Interests?

NARPACA is a large theatre network formed in 1983 as an administrative support group focused on the activities and requirements of PACs throughout northern Australia. The great distances between the individual PACs, and between northern Australia and the country's southern states where most of the arts resources were located, meant a strong network was vital to overcome isolation and invisibility. Today, NARPACA is a powerful lobby that presides over an immensely valuable touring circuit. Two-thirds of NARPACA's membership actively participated in the *Talking Theatre* research. NARPACA saw great opportunity to share the data, generated from the individual participating PACs, across its network to enable the collective to act on the findings and strengthen their regional connections with each other and with their local communities.

The fourteen participating PACs[1] were situated in towns or cities that ranged in population size from 9000 to 200,000 people. The locales varied across tropical, sub-tropical, hinterland, grassland and desert; from as far north as Darwin (3136 kilometres from the nation's capital city, Canberra) in the Northern Territory to as far south as Logan (near the state border between Queensland and New South Wales) and as far west as Alice Springs (2675 kilometres

from Canberra) in Central Australia. Such diversity saw a plethora of industries employ local residents, with the main local industries being agriculture, mining, manufacturing, education, health, defence and tourism. Over half of the participating regions were experiencing rapid population growth, mostly due to the mining resource boom bringing new people to live in the townships, and due to metropolitan 'spill' into nearby regions. As a result, the demographics of many of the towns were beginning to change. Half of the regions had a significant proportion of residents earning high disposable incomes. Over a third had transient populations (including backpackers with temporary work visas and 'fly-in/fly-out' workers who were not permanently resident in the region) and/or a heavy reliance upon the rural and industrial employment sectors. Over a quarter had a high proportion of residents aged younger than 30 years, and of multicultural and/or Indigenous descent.

Each participating PAC differed in size (venue, seating capacity, staffing and funding), which directly affected programming, marketing and audience research and development. Although each PAC was different, there were some similarities across all fourteen participating in the *Talking Theatre* project. All of the PACs were interested in targeting specific groups for future audience growth. Mostly, these groups consisted of skilled professionals, young people, early retirees and tourists. Questionnaires and box office ticketing systems were the most common tools used by the PACs to gather information about audiences. Past audience research had been limited in size and duration; however, each PAC desired increased investment for arts marketing and audience development for the future. Interestingly, in more than half of the PACs, General Managers were responsible for the marketing and promotion of performances, but only four of them had marketing backgrounds. Six of the fourteen PACs actively branded their organization within their community. A third of the PACs stated that their venue required urgent refurbishment and upgrades.

Each PAC was publicly owned and as such aimed to present a wide variety of product to the local community in an attempt to cater to everyone's needs and preferences. As well as live theatre, there were music performances (from classical to contemporary), dance (from ballet to hip hop), operas and musicals, stand-up comedy and circus. The majority of each PAC's annual season of events was toured into the region rather than created locally. This was in keeping with one of the key objectives of NARPACA, which concerned maintaining and developing a diverse regional touring network. The PACs enabled residents to experience live professional productions devised in Australian capital cities and overseas. This ensured people living in regional communities did not have to travel great distances at great expense to engage with productions enjoyed by those residing in metropolitan areas. Baylis (2011: 2) states:

> They [PACs] have often become key cultural institutions in their areas, providing communities with high quality work from some of the best performing arts companies in Australia. However, they have had limited opportunities to support the creation of local work.

The ratio of toured to 'homegrown' product presented in the PACs also contributed to the 'cultural cringe' typically encountered in regional centres, as the leaning towards externally produced works reinforced the sense that they were better than the local productions. McCarron (2004: 52) argues:

> One of the ironies of the local is its expression of 'cultural cringe' in that it is not until our creative artists, writers and performers have their work subjected to the processes of the city (such as training, exhibitions, performances, publication or screening) that we are prepared to acknowledge their status as practitioners. We seek experts from outside our community, often forgetting to check whether there is a local who can do the job equally well.

The *Talking Theatre* Project: Connecting Industry with Community

The research project was the result of a successful funding application to the Australian Research Council. This Linkage grant saw the federal government match dollar for industry partner dollar invested in the research. The central aims of the *Talking Theatre* research project (Martin et al. 2006: 6) were:

- To apply the *Talking Theatre* strategy to build new audiences in the short and long term for regional Queensland and the Northern Territory
- To chart a highly significant yet often overlooked section of Australia by mapping audience reception and performing arts repertoire in regional areas
- To further research into a new substantive field of non-theatregoers' reception of live performance
- To ascertain the entertainment and cultural needs of non-theatregoers living in regional areas
- To provide selected PAC staff and volunteers in regional centres with the knowledge required to apply the *Talking Theatre* strategy and to understand its place within the field of audience reception and arts marketing
- To revitalize the international field of audience reception, and to integrate audience reception and arts marketing theories and practices
- To contribute new knowledge to the field of arts education by providing an environment that empowers and educates non-theatregoers about theatre and theatregoing, via introduction to live performances and participation in self-directed and peer learning

Essentially, the *Talking Theatre* project sought to assist regional PACs to better engage with their local communities and to build new audiences for the future. In particular, the research aimed to understand non-theatregoers, their reasons for non-attendance and their reactions to a range of live performances that they experienced under study conditions.

Relationship Building, Knowledge Transfer and Transformation

> Audience development is a planned process, which enables and broadens specific individual's experiences of the arts. It involves breaking down the barriers which stop people participating in or attending the arts – physical, psychological, social or lack of information.
>
> (Werner 2003: 23)

The field of theatre audience reception seeks to understand the perceptions and reactions of audience members to performance and to the theatrical event as a whole. It 'essentially deals with the spectator's intellectual and emotional experiences in the theatre' (Martin and Sauter 1995: 29). A range of audience reception methods were applied throughout the project, such as pre- and post-performance questionnaires and focus groups. These methods not only gathered the thoughts and feelings of new audiences to aid the PACs in their decision-making for the future, but assisted the participants to think more deeply about their experiences at the PAC to increase their interest in, and knowledge of, live performance. The combination of quantitative and qualitative data gathering methods generated extensive information, which was then interpreted by applying content analysis, thematic analysis and theoretical sampling.

The *Talking Theatre* strategy's standpoint is that to build new audiences, organizations need to understand their target markets and discover how they experience the product before they can make successful decisions about disseminating advertising and choosing programming. This supports March and Thompson's (1996) assertion that artists or arts organizations cannot really understand their product until they know how the consumer or audience perceive it. Indeed, it can be argued that the patron is central to the arts experience. Therefore, it is vital for organizations to also initiate relationships with non-theatregoers to understand better their needs and perspectives and to share with them the organizations' products and objectives. Such a relationship would benefit both parties and inform their future decisions and actions. At the heart of the *Talking Theatre* strategy is relationship building, knowledge transfer and transformation to create a partnership that works to overcome the barriers to attendance and to switch people on to the arts. This partnership develops through face-to-face communication and by repeat visits to the venue. This sharing of information leads to an increased understanding of new audiences and their needs by the organization, as well as an increased interest by the participants in live performances and a greater confidence to attend outside research conditions.

Non-theatregoers and PACs: Connected and Sharing Their Stories

Twenty-four people in each region were sought to participate in the research. A mix of men and women aged 18–55 years who identified themselves as non-theatregoers were recruited

via a call-to-action in the local media. Each of the PACs selected three live performances for the participants to attend free of charge. The three performances enabled the PACs to demonstrate on a small scale the scope of their annual seasons. The diversity also allowed the participants to compare their experiences of the performances to help to form opinions regarding the kinds of performance they enjoy. Each participant gained the opportunity to socialize with other inexperienced theatregoers in the study, to benchmark their reception with those of their peers.

Prior to attending the first of the three live performances in the study, all participants completed an 'About You' questionnaire designed to gather demographic and psychographic data about each person. Immediately following each of the three performances, participants completed a short, closed-format 'Tonight's Performance' questionnaire, to find out their reactions to the shows. Then, in groups of twelve people, they participated in post-performance discussions to share their reception of the performances with each other. The hour-long discussions provided a safe and friendly environment that assisted the participants, via self-reflection and engagement with others' ideas, to learn about theatre and to gain confidence in theatregoing. The unstructured, free-flowing discussions provided insight into the elements of performance and theatregoing that were important to new audiences. A few weeks after attending the third performance, a final 'Feedback' questionnaire was completed at home by the participants to gain their responses to the research and the PAC and their likelihood of future attendance. Return patronage was tracked through the PACs' box offices in the year following participation in the *Talking Theatre* project to find out how many participants had chosen to attend performances outside study conditions.

Similarity of Response Across the Regions

Even though the participants in the research lived in different towns, attended different PACs and experienced different performances, they recorded similar reasons for their history of non-attendance and similar reactions to performance experienced under study conditions. In fact, most of the key findings of the *Talking Theatre* project matched those of a pilot study conducted by Scollen (2003) in the capital city of Brisbane (1998–2001). This indicated that, for the most part, the regional participants' responses were in keeping with those of non-theatregoers in the city, with regional or metropolitan status appearing to have little bearing on reluctance to engage in the arts, or on how one engages in the arts once introduced. Queensland Local Government Arts Advisor, Georgina Siddall (2013: 10) would agree, stating: 'I think they [regional residents] want the same as people living in the city. It's a mistake to think they need something different'.

The research found that the primary deterrent to attendance is fear of the unknown. The performing arts are unknown because non-theatregoers typically do not have a history of arts experience, do not have friends or family who attend and have limited information at their disposal about productions and venues. They fear the prospect of attendance because it

involves risks. These risks include not enjoying or understanding the performance, wasting time and money, feeling foolish and appearing foolish to others and taking part in a leisure activity alone. The non-theatregoers may be interested in going to a performance but with all of the risks associated with attendance decide it is not worth the discomfort to try.

Transformation Sees Stories Change

When given the opportunity by the *Talking Theatre* project to attend three performances free of charge, share the experience with other non-theatregoers and discuss their perspectives about the shows, the perceived risks of attendance were reduced. Via their participation in the study, the non-theatregoers were pleased to discover that they enjoyed the performances and the overall experience of attending their local PAC. The participants made clear that the performances and the social aspect of going to the theatre did reflect their interests. They confirmed that their limited awareness of the performing arts' relevance to their lives, combined with a lack of positive peer influence to attend, had prevented their attendance in the past. Now that they were comfortable with the performing arts experience, they wished to continue their cultural participation into the future and experience new forms of entertainment. The following points highlight the stated cultural needs of the participants residing in the regional centres involved in the research (Martin et al. 2006: 26):

- Good quality performances that are comparable with capital city productions
- Professional, highly skilled and engaging performers
- Comedy (in all its forms), music and musicals, plays
- Product that is relevant to the lives of those living in regional areas
- Pleasurable, sociable and affordable entertainment experiences
- Recreation with friends
- Family-friendly entertainment and environments
- Inclusive and relaxed leisure experiences
- Performances that are stimulating for the intellect, the emotions and the senses.

'It Must Be the B Team ... Why Would They Perform for Us?'

Two points make particular reference to the regional experience. One asks that regional residents have the same opportunities to experience good quality productions as those in the metropolitan areas. This strongly held view reflects the locals' suspicions that they are disadvantaged by living beyond the 'triangle'. This concern was highlighted clearly by Rockhampton-based participants involved in the project. The participants were disappointed that the woman featured on the poster of Opera Australia's production of *Carmen* did not actually appear in the performance they attended. The poster was one of the few informational

sources that they had to help them generate some expectation of the production. None had attended an opera before and had turned to the poster for clues as to what to expect. A striking image of an attractive young woman was the centrepiece of the poster and all made the link that she must be the performer to play the role of Carmen. When they discovered during the show that this was not the case, they felt duped. They immediately questioned whether the production they attended in a regional Queensland centre was different to the one their counterparts experienced in Sydney. Had they been sent the 'B team'? Why place a person so prominently in promotional material when they do not appear to actually be involved?

Further to this, the project uncovered that the non-theatregoers living in the more remote regional centres assumed that all of the performances in their PACs were local, amateur shows rather than professional productions. They were surprised to realize that major performing arts companies and artists would travel long distances to perform in their region. The participants did not believe that the productions touring to their local PAC were 'the real thing'. 'It must be a cover band or an amateur production; why else would they come to our town?' (*Talking Theatre* participant). It seems as if the cultural cringe common to regional towns leads to negative perceptions about the venues and facilities that exist in their own communities, as well as to a general sense of being under-valued by those living beyond their borders. However, once introduced to their local PAC via the research project, the non-theatregoers were pleasantly surprised with what the PACs had on offer apart from the performances themselves: bars, cafes and dining; friendly staff; outdoor areas; a wide range of patrons; and a social atmosphere. They stated that these aspects needed to be actively promoted to inform the community of their existence because they were impressive and an important part of the outing, integral to social interaction with family and friends.

'I Could Relate to Just About Everything in It'

> I just liked the whole play. I could relate to just about everything in it. I like watching things and reading things where I know the places that they're talking about. Like, if it's in my local area, rather than some American thing, in the States or a town that's unheard of.
> (Comment from a *Talking Theatre* participant)

The other point stresses the need for performances relevant to the lives of those living in regional areas, indicating that the regional experience is understood to be different to the metropolitan. However, the project found that in most instances those aspects in performance identified as relevant and relatable pertained to the human experience rather than a specifically regional one. The responses in the 'Tonight's Performance' questionnaires demonstrated that 56 per cent of the entire sample could relate to someone or something in the performances. For the majority, it was the characters and the relationships between the characters to which they related:

Mike: Of all the problems in life, worrying about the problems of ageing barmaids isn't one of them you know? I didn't feel much sympathy, empathy or whatever.

James: I think I disagree. I mean you know, you should have a job but you shouldn't be just kicked out because you reached a certain age.

Fiona: That's right, yeah. And they've had to put up with a lot if that's what went on.

Vicki: Yes. I think it's just a job of uncertainty for the future. I mean, I don't just mean barmaids, it could relate to anything, just sort of not knowing how secure your job is from one day to the next. I mean not everyone's in that sort of situation but I'm sure there are people out there who really have no idea. And there are drama queens as well out there and you can sort of see that in those characters, just little bits and pieces in everyday people sometimes. You know?

Fiona: I agree with you. It showed that quite often in some jobs, or quite a lot of jobs, that you're at the whim of a type of manager that doesn't respect your experience and these women obviously have been around a long time doing this job. As much as it wouldn't be my ideal, but you know at the end of the day they had to leave and there was no sympathy there, no hand out, no redundancy, anything like that.

(excerpt from a *Talking Theatre* post-performance discussion)

'I Have No Idea of Which Show to Go to, So I Don't Go to Any'

The discussions by the participants in post-performance provided a wealth of information to the PACs to assist in bridging the divide between non-theatregoers and the performing arts industry. For example, the participants explained that non-theatregoers require more information and insight into what upcoming performances are about and how they might be relevant to them. In particular, they wished to know the storyline, the central issues, the aspects they may be able to relate to, the details about the genre, the performances' similarity to other popular art forms, how the performances might make them feel, any performers they may recognize and the ticket prices (Martin et al. 2006: 27). Each point builds expectation and understanding of the performance to assist them in their decision-making. As one participant in the *Talking Theatre* project explained, 'I see the shows advertised in the newspaper but because I don't know anything about them [and little detail is provided], I have no idea which one to go to [so I don't go to any]'. Another example from a non-theatregoer living in a different town:

Even still coming here I thought 'Well, basically I'm seeing something'. I've got no idea what it's about even though I actively looked to see what was being advertised around the place and I thought, 'It didn't really say'. The only thing it might have said was adult nudity and that seemed to be pitched as the draw card – full frontal nudity you'll get more people here. I thought 'Well big deal, what's it about?'

(*Talking Theatre* participant)

Unfortunately, it is not easy to locate detailed information or reviews of live performance, particularly when one is living in a regional or rural centre. Reviews are normally published following opening night; however, in regional centres, touring productions do not usually run for more than one or two performances. As local media do not like to print or air reviews of shows that have been and gone, non-theatregoers find it difficult to access regular reviews and recommendations for the performing arts. One instance during the *Talking Theatre* project in which this was not the case was in Darwin when the Sydney-derived theatre production of *Last Cab to Darwin* came to town. This short-running production was of interest to the local media, with the result that a dedicated editorial and a review were printed in the lead up to and during the production season. Such attention was not normally bestowed upon touring theatre productions, but this one was of interest for two reasons. Firstly, the title and the content referred to Darwin and so was understood to be of interest to Darwin residents. Secondly, the play was about voluntary euthanasia, which was a hot topic in Darwin due to outspoken euthanasia advocate Dr Phillip Nitschke working and residing in the area. Residents involved in the *Talking Theatre* project attended this production and spoke afterwards about how helpful the information in the newspapers had been in enticing their interest and preparing them for what to expect from the experience. They longed for all productions to have the same level of attention from the local media.

Learning and Transformation

The post-performance group discussions also equipped the non-theatregoers with the knowledge, confidence and vocabulary to foster further engagement with the performances and with the PACs. This peer learning environment gave the participants a greater sense of agency to make purchasing decisions and to recommend that family and friends attend performing arts events with them. According to the findings of the 'Feedback' questionnaire, the group discussions were popular because they provided the opportunity for participants to listen to others' ideas (78.5 per cent of respondents), to have their own thoughts and feelings valued (62.5 per cent), to have the space and time to think more about the performances (60.5 per cent) and to get to know other people (60 per cent). Many of the participants stated they enjoyed the post-performance discussions as much, if not more, than the performances they were to talk about. Seventy-seven per cent of the respondents stated they had a greater understanding of the performances after taking part in the discussions. Sixty-six per cent also stated that they would be more likely to attend live performances in the future if they knew they could meet other people afterwards for discussion. 'I really enjoyed the group's feedback; it gave more insight into the whole thing' (*Talking Theatre* participant).

Finally, the results of the *Feedback* questionnaire showed that 86.5 per cent of the respondents believed that their local PAC provided the kinds of performances they would like to attend. The findings also highlighted that 73.5 per cent of the respondents had

encouraged others in their community to attend the local PAC since taking part in the *Talking Theatre* project. Not only were 93 per cent of the respondents more interested in live performances since taking part in the project, but 31.5 per cent paid to attend a performance at their local PAC *during* their involvement in the project. These participants brought with them to the performance family and peers who were not associated with the *Talking Theatre* project. After completing the *Talking Theatre* project, PAC box office records showed that 30 per cent of all participants returned to attend a performance, on average more than once, and brought paying guests with them. In other words, the *Talking Theatre* strategy for audience development had created in the short term new audiences for the PACs. To ensure long-term audience growth in the regions, the PACs would need to apply their new-found knowledge of non-theatregoers and their reception of performance to action many of the suggestions provided to them via the participants' responses during the study.

Same but Different

> Artists come from everywhere. Many of Australia's great performers, directors, choreographers and playwrights were originally from regional towns. To survive as artists, they needed to go where the work was, and traditionally that flow has been in one direction: from bush to big smoke. But it doesn't have to stay that way.
>
> <div align="right">(Baylis 2011: 18)</div>

Following from the success of the *Talking Theatre* project, the Queensland State Government, with support from the Australia Council for the Arts, invested in another audience development initiative for building engagement in the performing arts in regional communities. The UK-derived *Test Drive the Arts* (Morris Hargreaves McIntyre) initiative was launched in August 2007, with the state-wide trial running until November 2009. Part of its online promotion to lure non-theatregoers included the statement 'Test Drive can now offer regional audiences an even better choice and a chance to see some "big city" acts as well as talented local performers' (Fuller 2008: 1). The trial had mixed success; challenges chiefly concerned the high level of resourcing required to operate the programme across 31 PACs and companies spread throughout the state and separated by great distances (Arts Queensland 2010).

Born from the results of this initiative and those prior, the Queensland State Government produced the *Coming to a Place Near You Touring Strategy* (2009–2014). This strategy had a strong focus upon delivering performing arts products and experiences to the regions based on residents' desires and requests for particular work, rather than touring events that metropolitan areas thought would be suitable for the regions. The then Premier of Queensland, Hon. Anna Bligh explained (Queensland Government 2009: 1):

> Simply put, communities want to have a choice about what they see and the product recommended through the touring fund will provide those very options […] By enabling

communities to choose what they'd like to host and what best suits their needs, there is the potential to enrich local arts practices and build new partnerships between artists and communities.

Then Minister for the Arts, Hon. Rod Welford (2009: 1) detailed in the *Coming to a Place Near You Touring Strategy* (2009–2014) policy document the government's vision for how it would enable this approach:

> By 2014, Queensland performing arts touring will be a demand driven culture which values ongoing consultation with Queensland audiences, communities, the arts sector and schools to inform touring programming considerations [...] In delivering the strategy, our commitment is [...] to recognise the diversity of Queensland's population in the creation and selection of touring product; and provide effective, efficient and responsive Queensland performing arts touring services.

Growing audiences for the performing arts in the regions was not only addressed by this demand-driven touring approach, but also through investment in homegrown product development. The state and federal governments funded the *Regional Stages* programme from 2010. This programme sought to build audiences in the regions by supporting local artists to create new work for the regions:

> It [*Regional Stages*] aims to build on the local government cultural facilities by giving them the resources to employ a creative producer with an exclusive focus on building partnerships within regional communities to seed, produce and tour locally made work.
> (Baylis 2011: 2)

Certainly, one example of this programme's success was the Toowoomba Empire Theatres' production of *April's Fool*. A young local playwright was commissioned to write the work based on a local family tragedy. *April's Fool* was written and produced in 2010 and the play went on to be nominated for the Queensland Premier's Drama Literary Award in 2011. The production then toured nationally, including to the capital city of Brisbane, in 2012. It is now a published text available for purchase (www.australianplays.org).

It appears that the two points particular to the regional experience, as raised by the non-theatregoers in the *Talking Theatre* project, are being addressed by this combined approach to audience development. Residents living in regional areas seek good quality performances that are comparable with capital city productions, as well as performances that resonate due to their relevance to those who attend. Continuing to ask people living beyond the 'triangle' what they would like to attend informs national touring of metropolitan work. Assisting regional communities to create their own work by telling their own stories ensures relevance, reduces cultural cringe and provides the opportunity to engage metropolitan audiences in the work of talented regional artists. We are after all the same, but different.

References

Arts Queensland (2010), *Test Drive the Arts Online Trial: A Sustainable Model?*, Brisbane: Queensland Government.
Baylis, J. (2011), *Regional Stages: Performance Making in Regional Queensland*, Brisbane: Arts Queensland.
Fuller, G. (2008), *Welcome to Test Drive the Arts*, accessed 20 May 2008, available at www.testdrivethearts.com
Gray, I. and Lawrence, G. (2001), *A Future for Regional Australia*, Cambridge: University of Cambridge Press.
Henningsgaard, P. (2007), 'Regional literature and "the liminal": Exploring the spaces in-between national and international literatures', *Limina: Journal of Historical and Cultural Studies, Special Edition 2007: On the Beach*, pp. 12–19.
Lynn, M. (2005), 'Communities, regions, states: Accountabilities and contradictions', in A. Rainnie and M. Grobbelaar (eds), *New Regionalism in Australia*, England: Ashgate, pp. 181–198.
March, R. and Thompson, B. (1996), *Performing Arts Marketing in Australia: A Study of Marketing Orientation and Marketing Planning in the Australian Performing Arts Field*, Nepean: University of Western Sydney.
Martin, J., Radbourne, J., Haseman, B. and Scollen, R. (2006), *New Audiences, New Relationships ... Three Years in Review: A Final Report*, Brisbane: Queensland University of Technology.
Martin, J. and Sauter, W. (1995), *Understanding Theatre: Performance Analysis in Theory and Practice*, Stockholm: Almqvist & Wiksell International.
McCarron, R. (2004), 'Performing arts in regional communities: The case of Bunbury, Western Australia', PhD thesis, Murdoch University, Perth.
Queensland Government (2009), 'New touring fund creates opportunities for Queensland Arts', Premier's press release, 19 October 2009, available at www.arts.qld.gov.au/docs/funding-premiers-release.doc
Regional Arts Australia (2002), *Regional Audience Development Specialists Program: Report to the Australia Council for the Arts*, Port Adelaide: Regional Arts Australia.
Rentschler, R. (ed.) (1999), *Innovative Arts Marketing*, NSW: Allen & Unwin.
Scollen, R. (2003), 'Building new theatre audiences: Post performance audience reception in action', PhD thesis, Queensland University of Technology, Brisbane.
Siddall, G. (2013), 'Determination and drive define new Local Government arts advisor' in *Arts Update*, Brisbane, pp. 10–11.
Trotter, R. (2001), 'Regions, regionalism and cultural development', in Tony Bennett and David Carter (eds), *Culture in Australia: Policies, Publics and Programs*, Cambridge: Cambridge University Press, pp. 334–355.
Welford, R. (2009), *Coming to a Place Near You: Touring Strategy for Performing Arts in Queensland 2009–2014*, Brisbane: Queensland Government.
Werner, T. (2003), 'Entrepreneurship and marketing in audience development within New Zealand performing arts companies', *Asia Pacific Journal of Arts and Cultural Management*, 1(1), 22–34.
Woolcott Research Pty Ltd (2000), *Australians and the Arts*, Sydney: Australia Council.

Note

1 Araluen Centre in Alice Springs; Burdekin Theatre in Ayr; Cairns Civic Theatre; Caloundra Cultural Centre; Darwin Entertainment Centre; Empire Theatres in Toowoomba; Ipswich Civic Hall; Logan Entertainment Centre; Mackay Entertainment Centre; Mount Isa Civic Centre; Nambour Civic Centre; Pilbeam Theatre in Rockhampton; Townsville Civic Theatre; and the World Theatre in Charters Towers.